THE ART OF
NI NO KUNI™ II
REVENANT KINGDOM

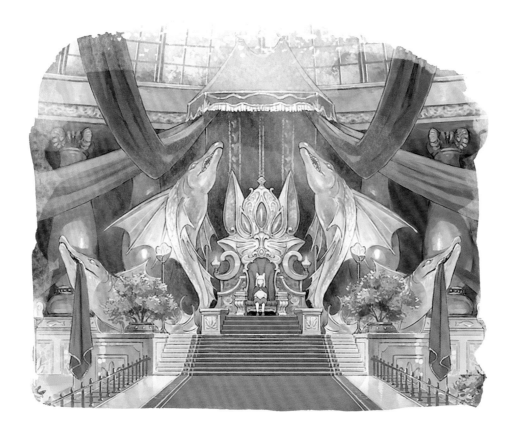

TITAN BOOKS

CONTENTS

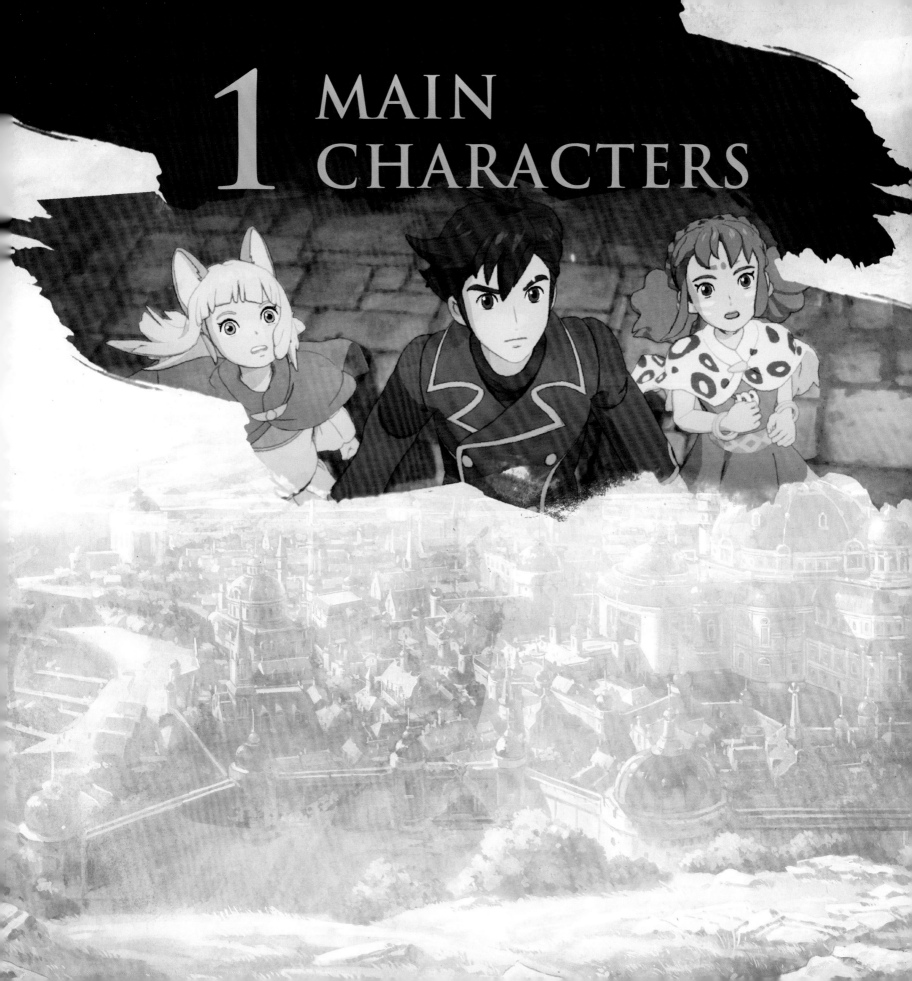

1 MAIN CHARACTERS

EVAN

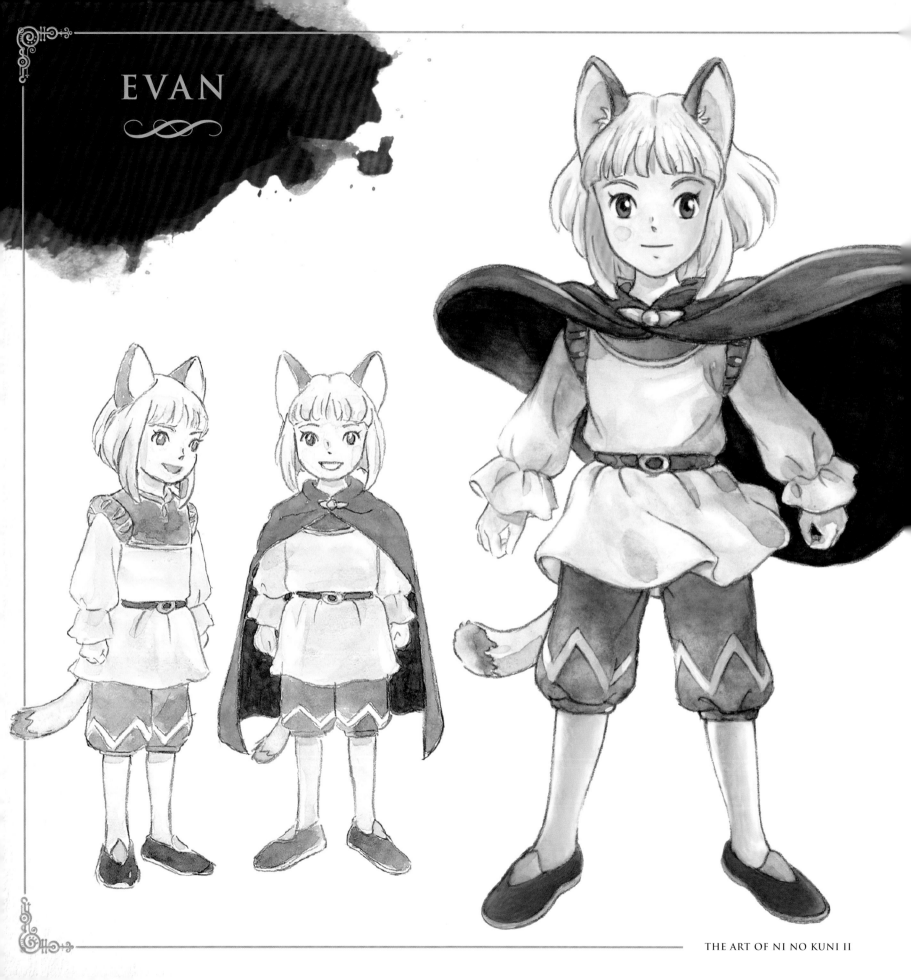

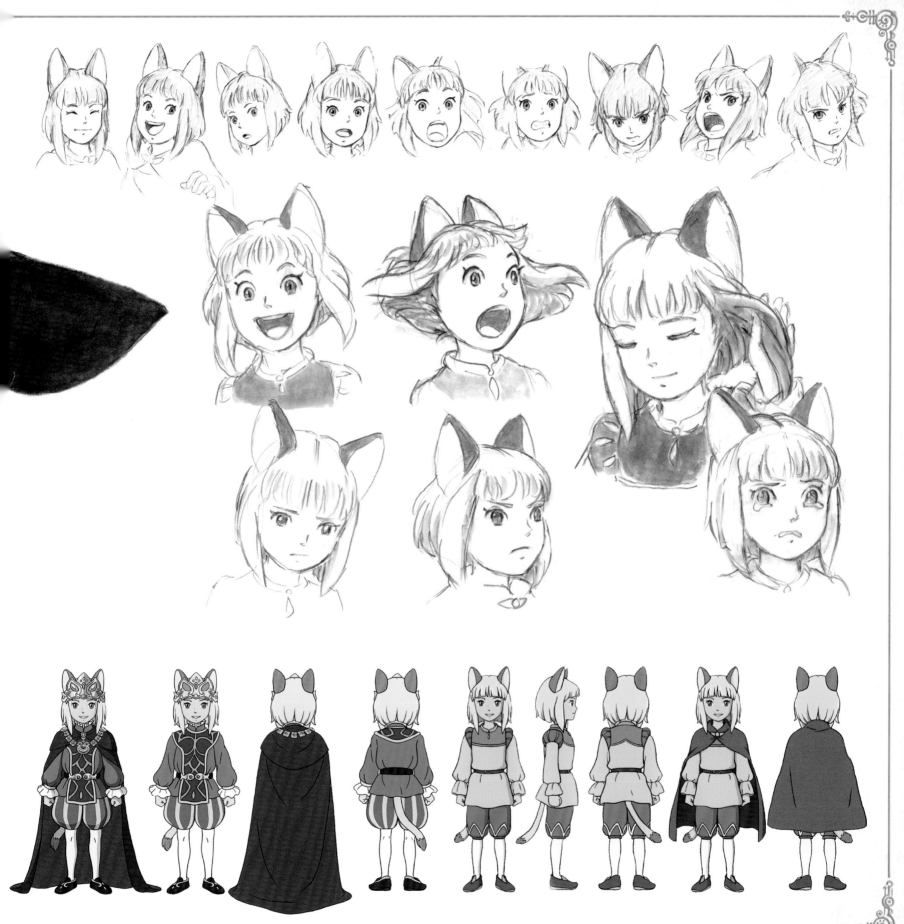

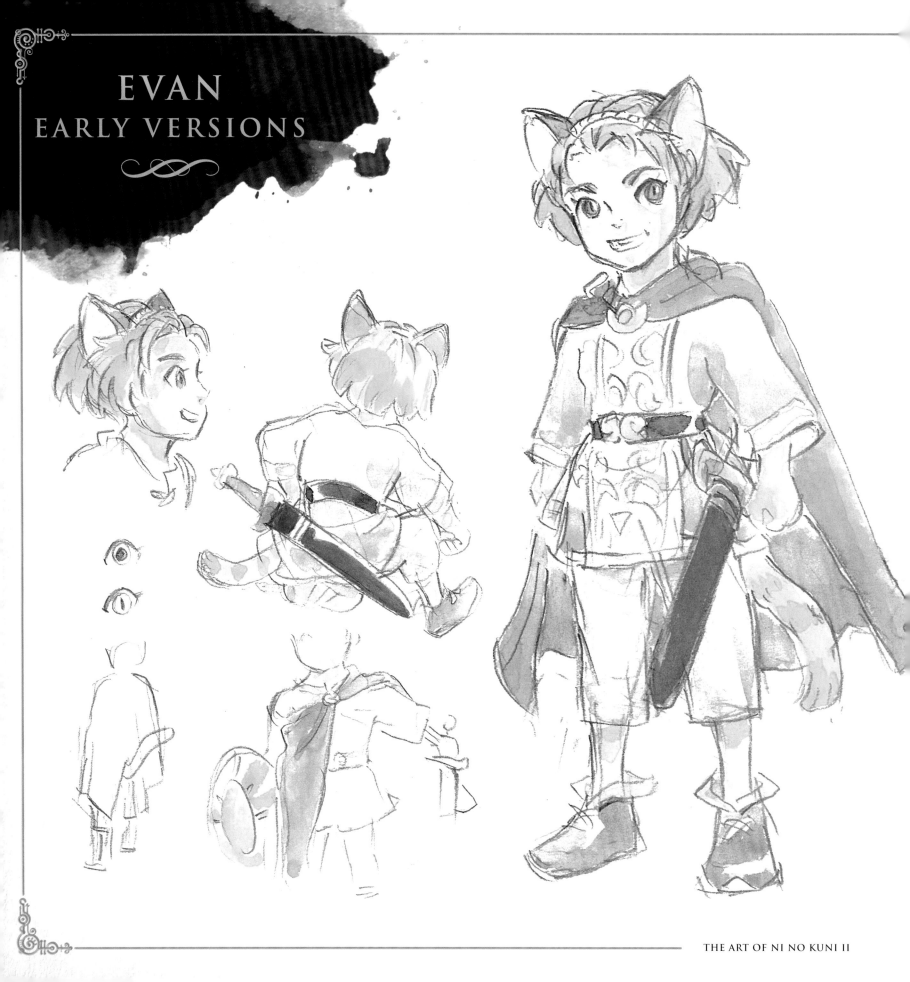

EVAN
EARLY VERSIONS

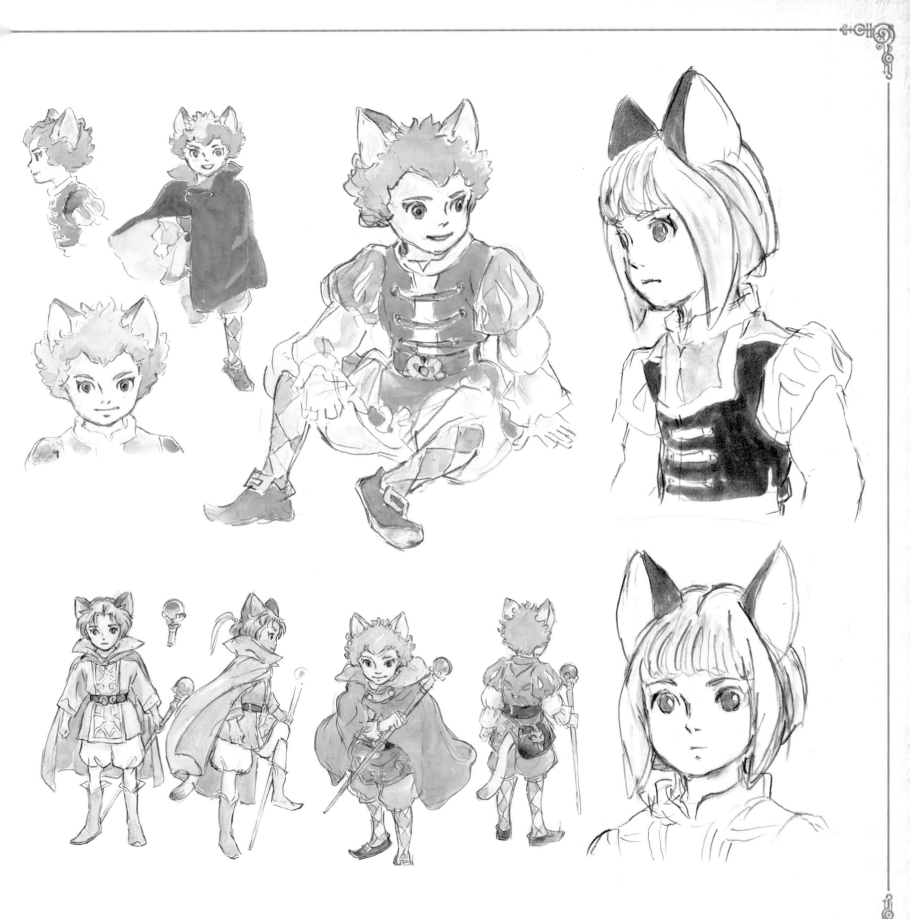

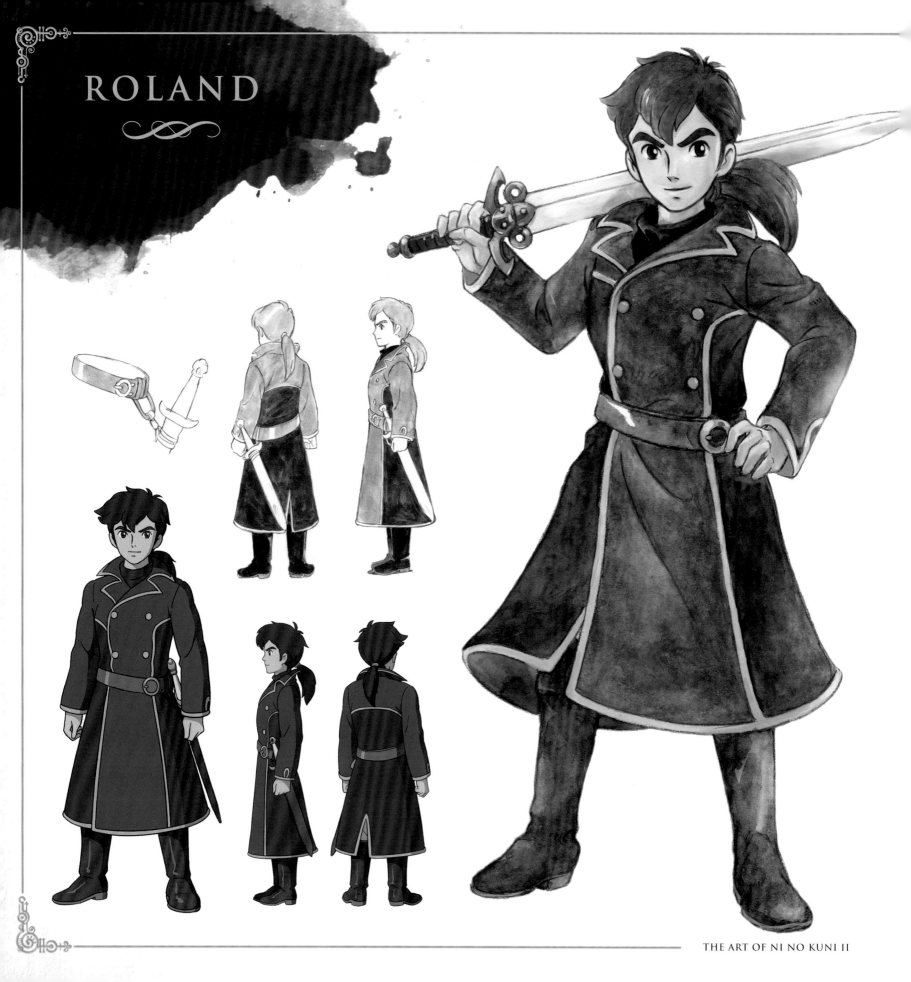

ROLAND

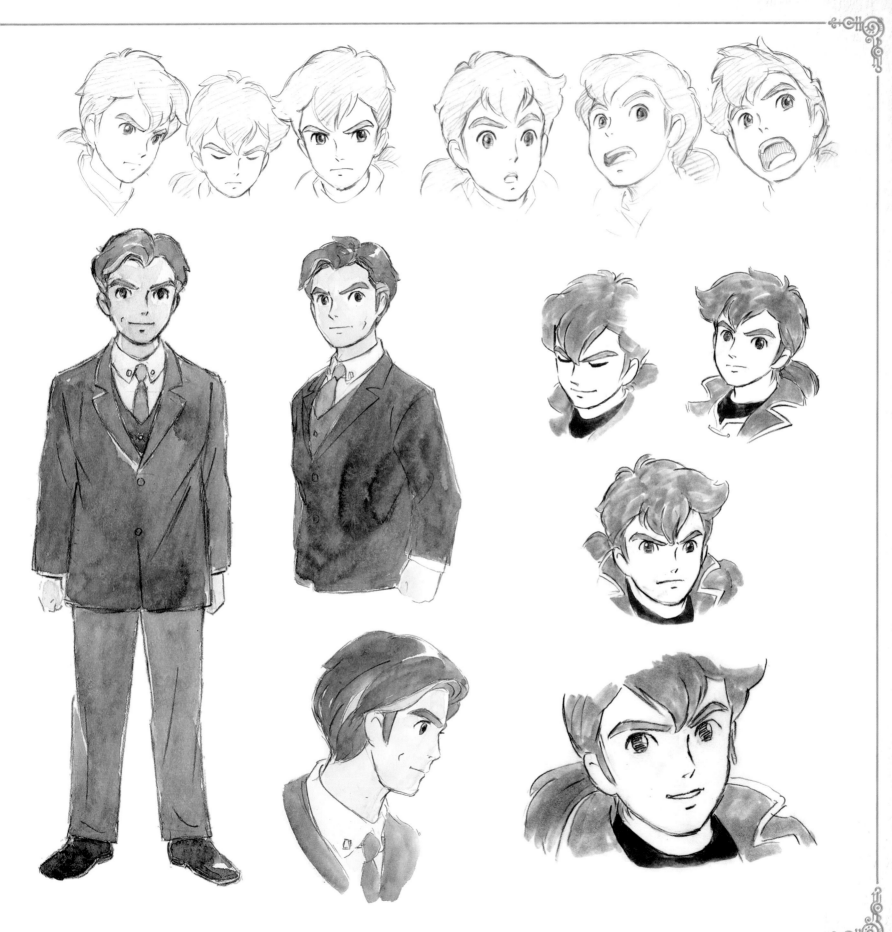

TANI

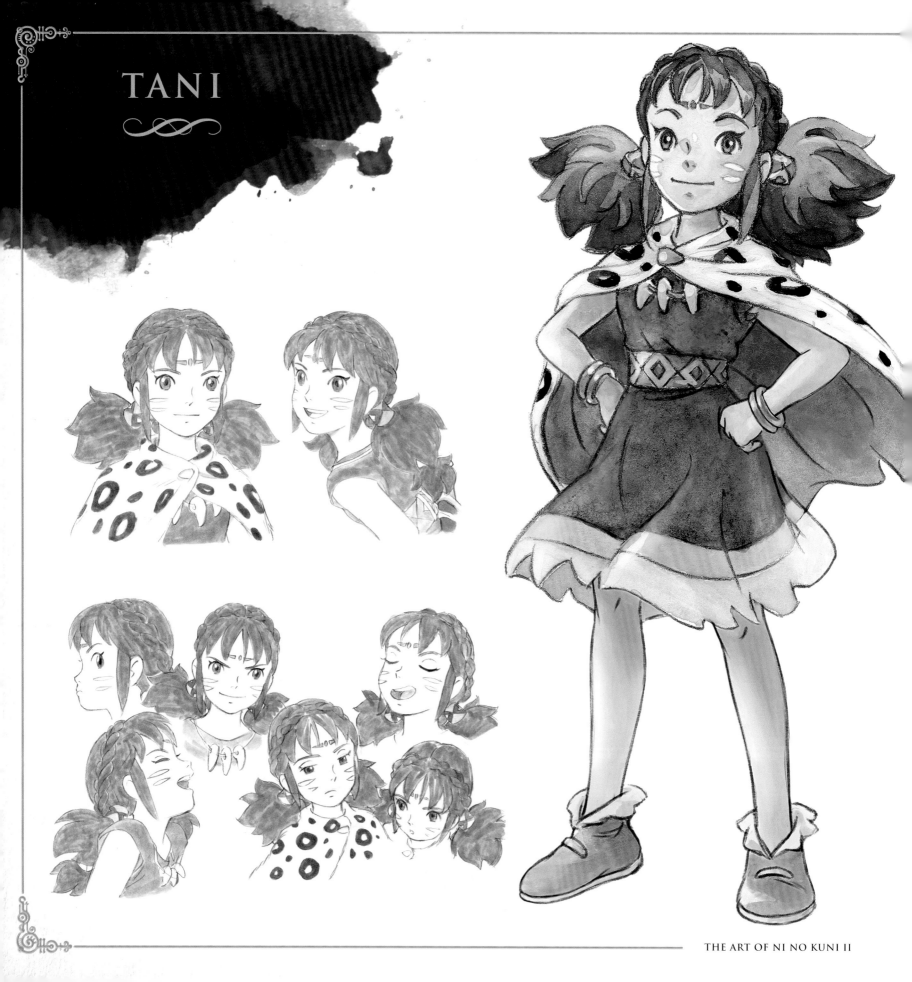

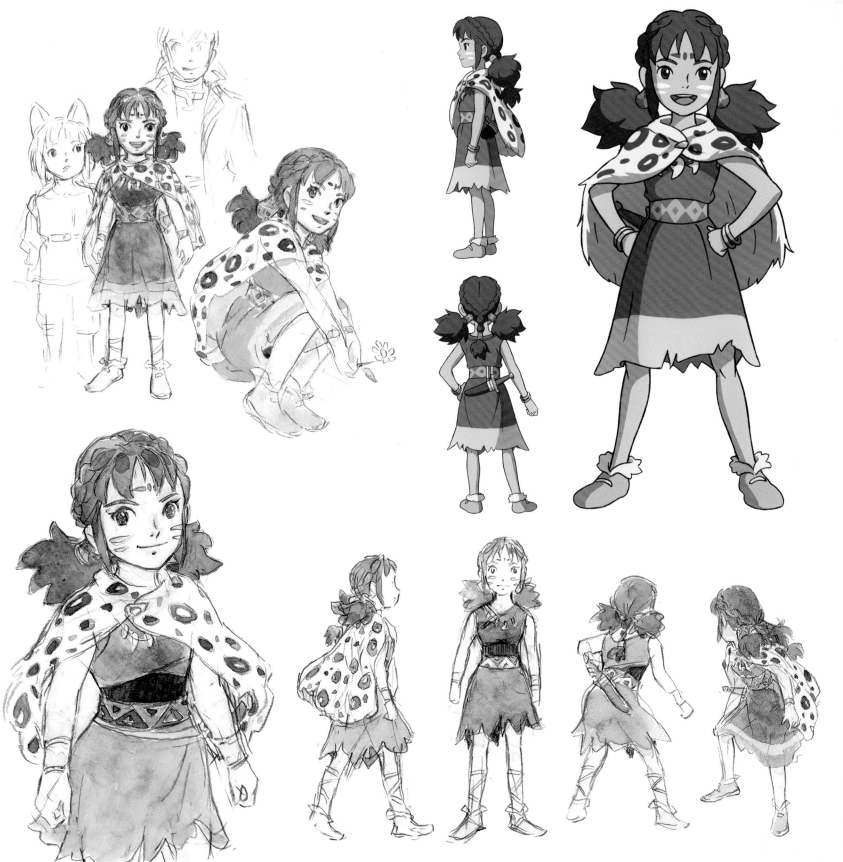

BATU

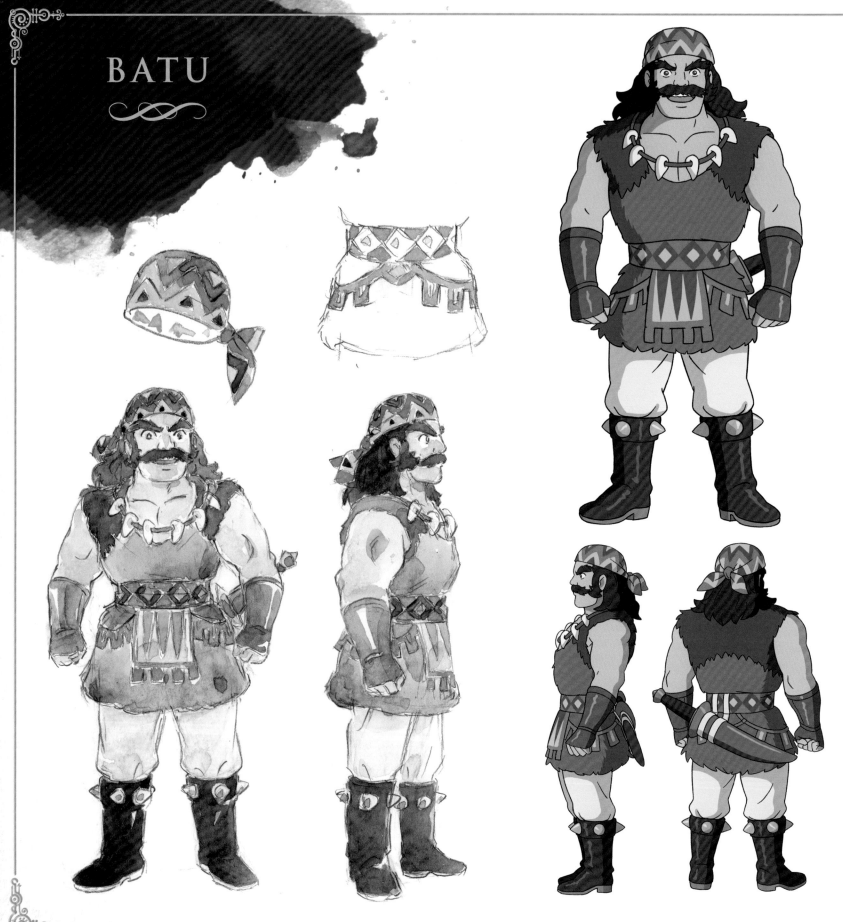

LEANDER

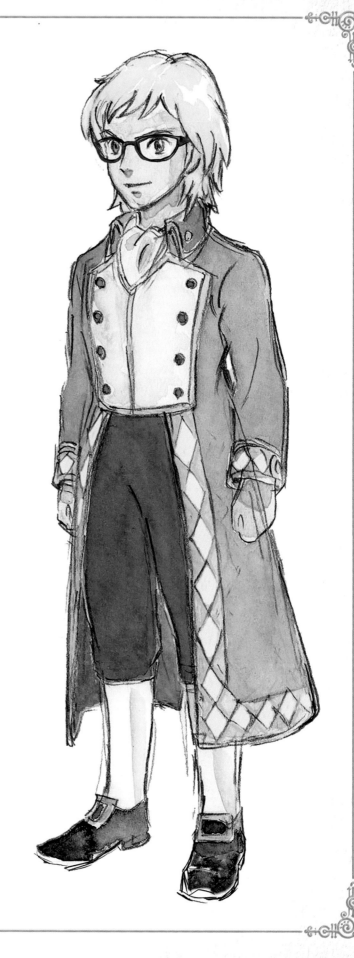

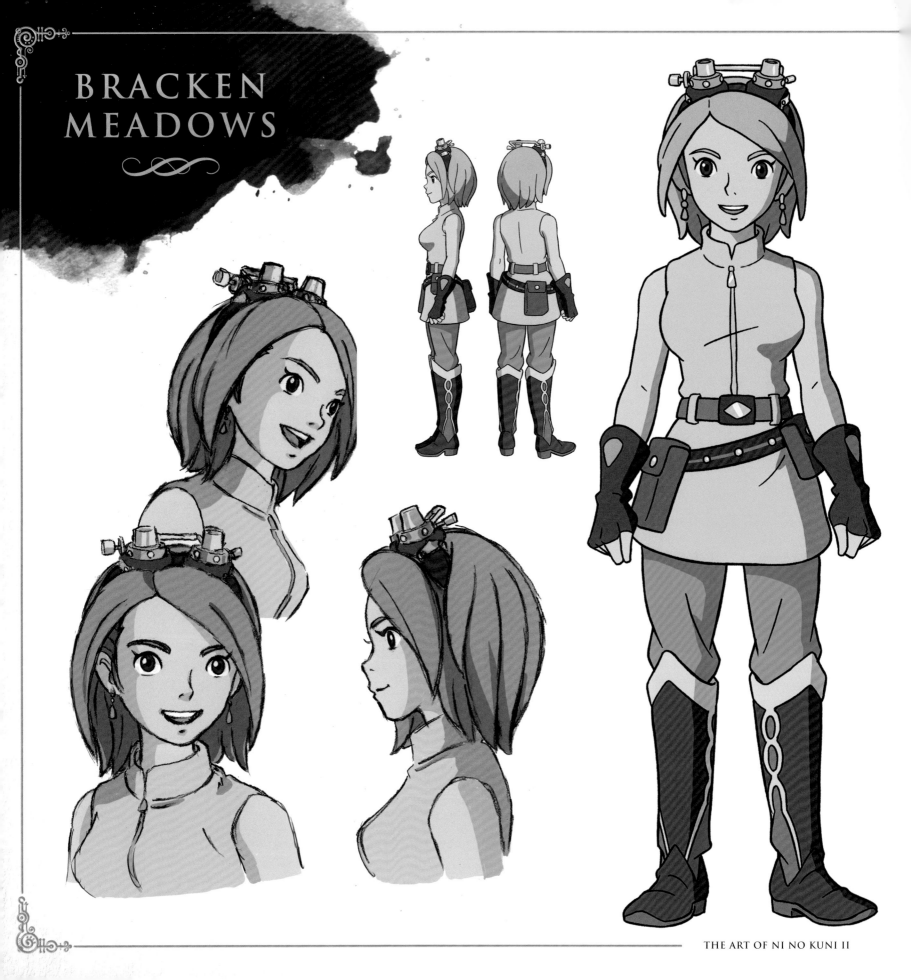

BRACKEN
MEADOWS

LOFTY

CHIBI VERSION
MAIN CHARACTERS

 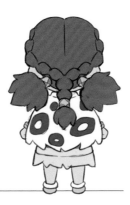 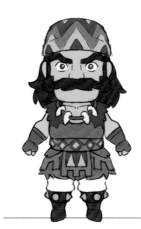 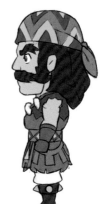 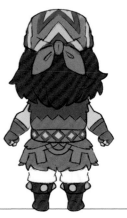

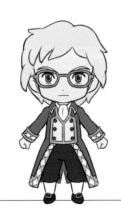 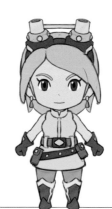

2 OTHER CHARACTERS

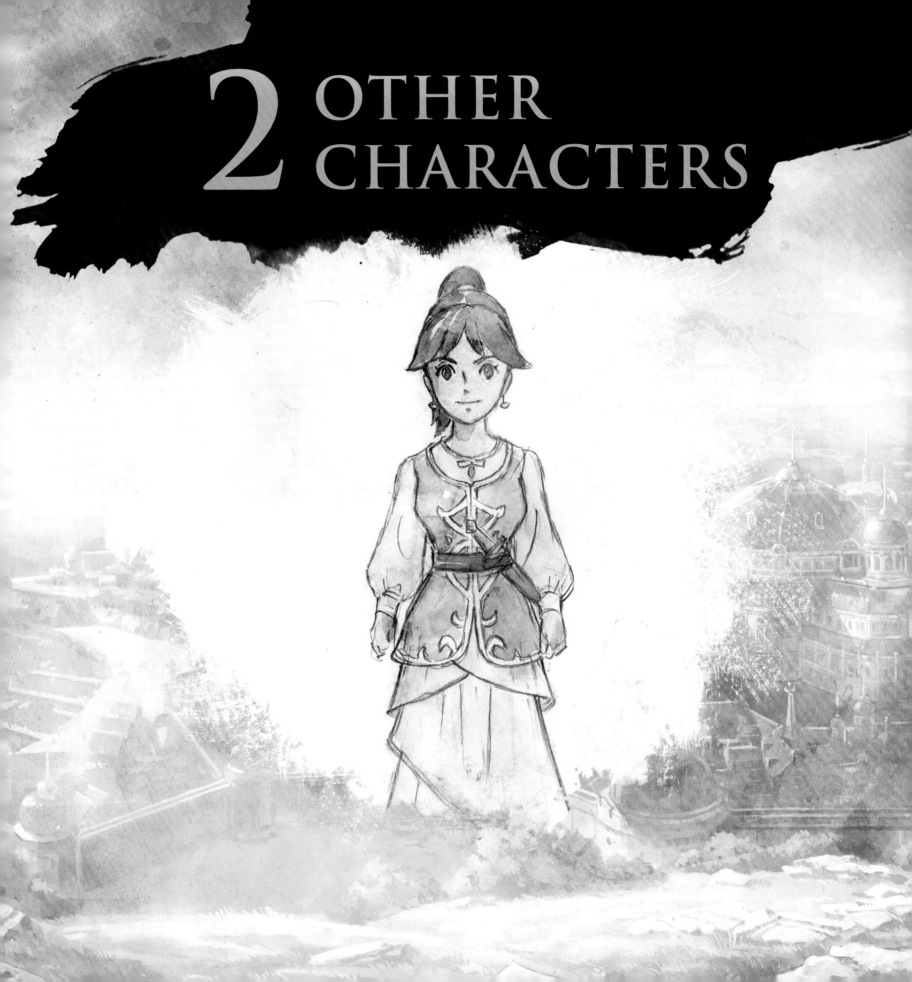

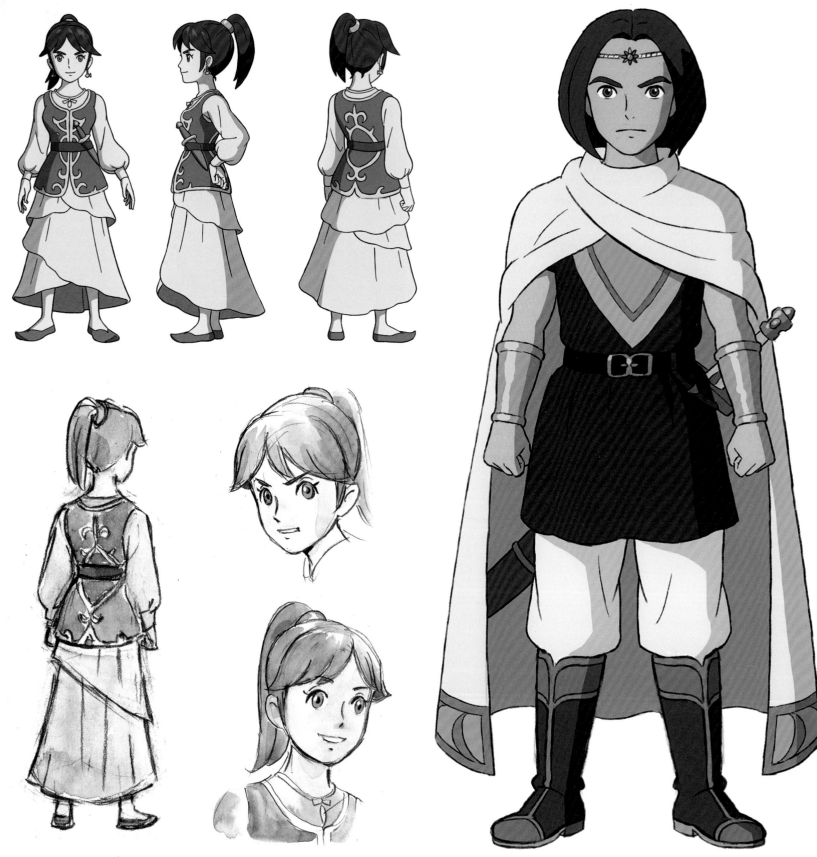

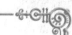

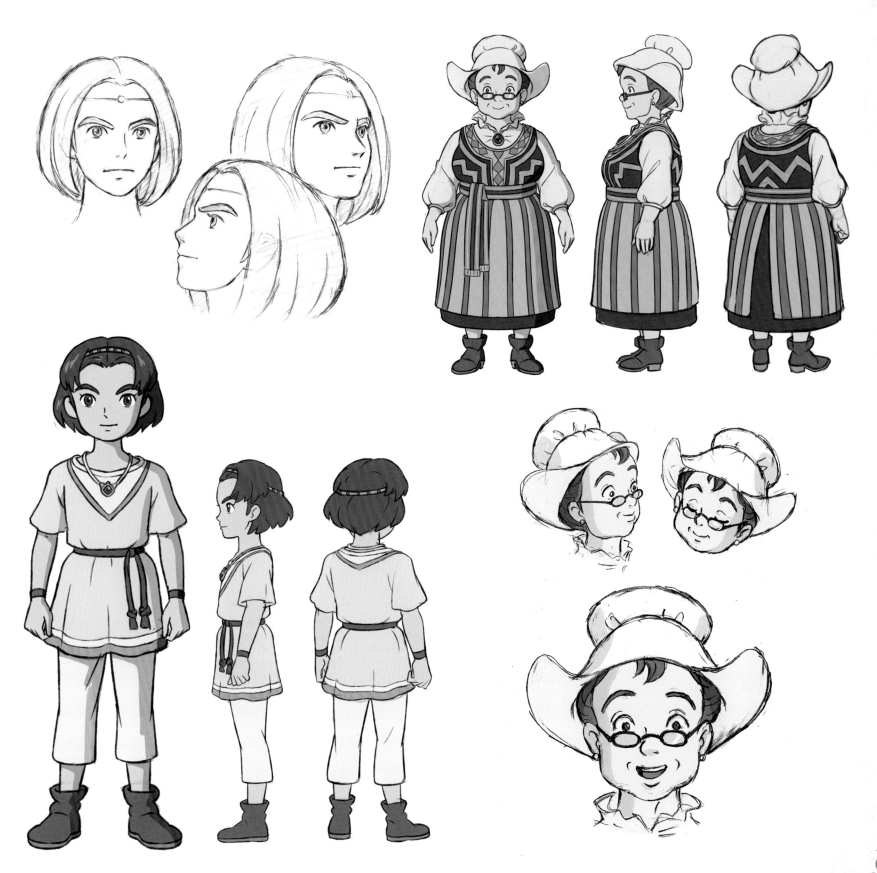

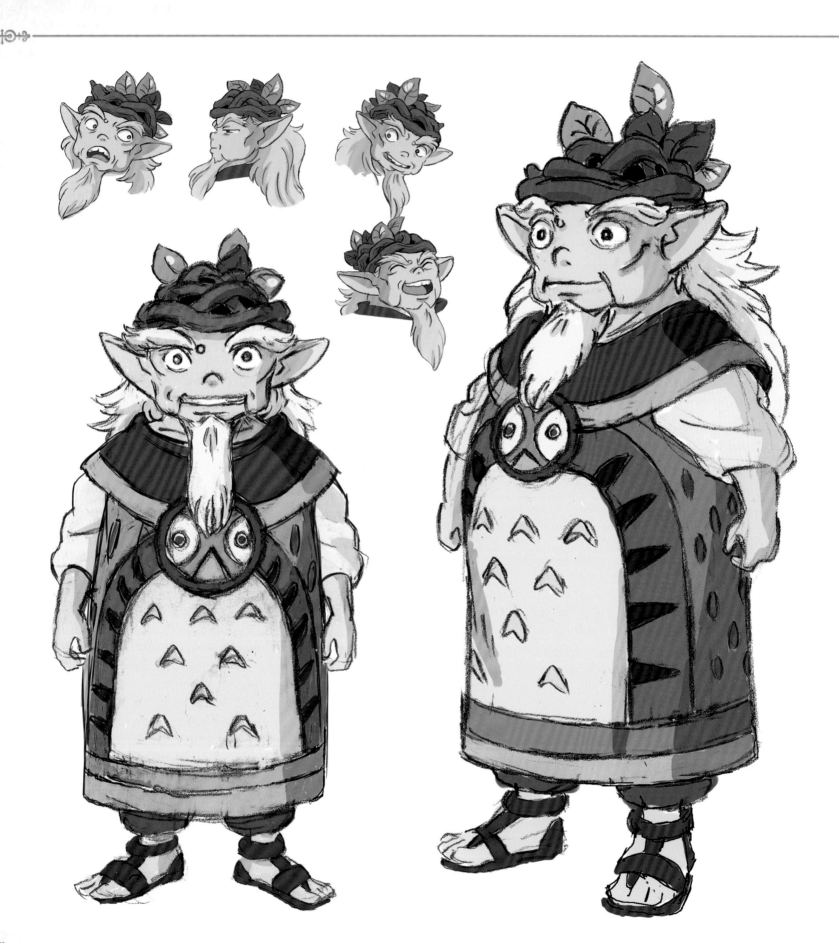

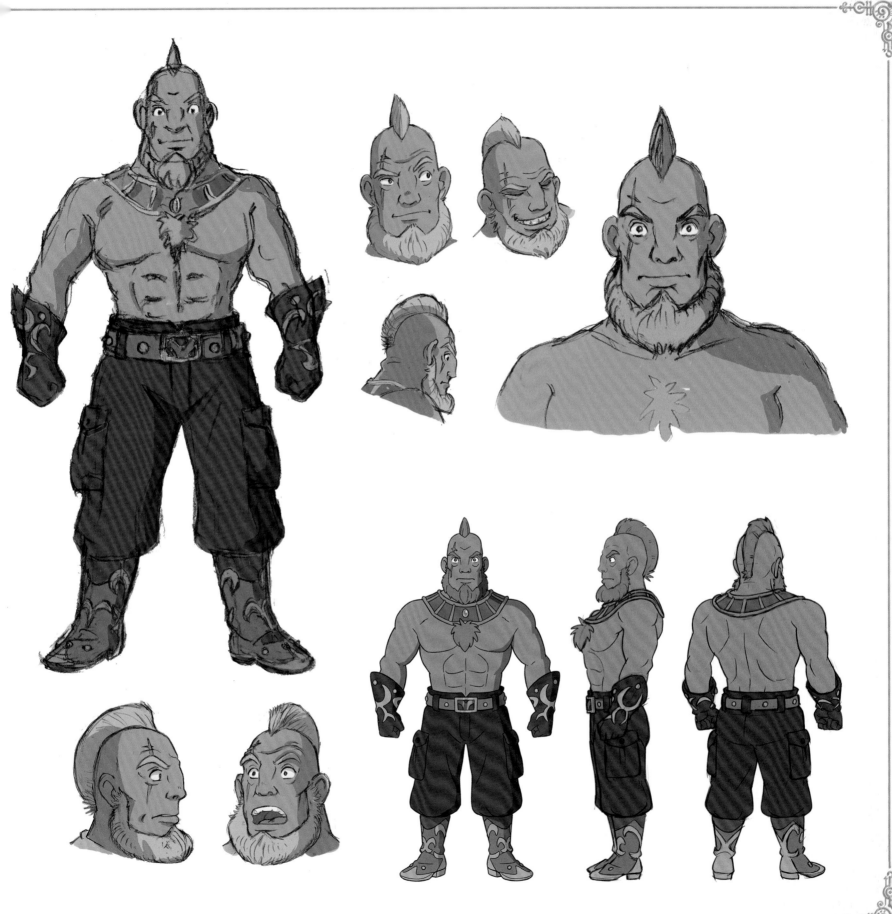

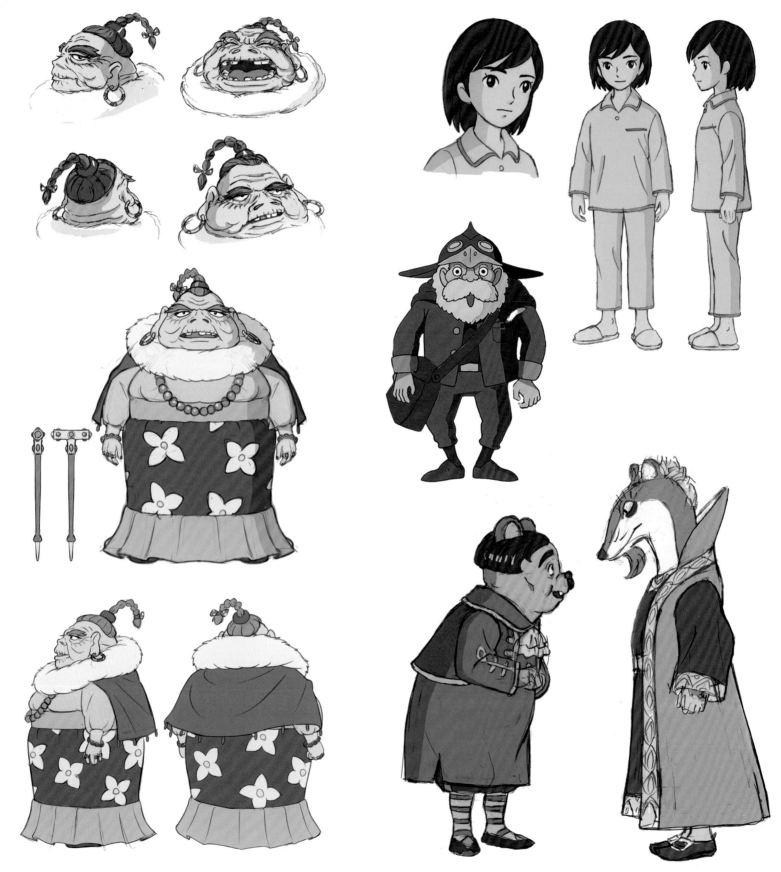

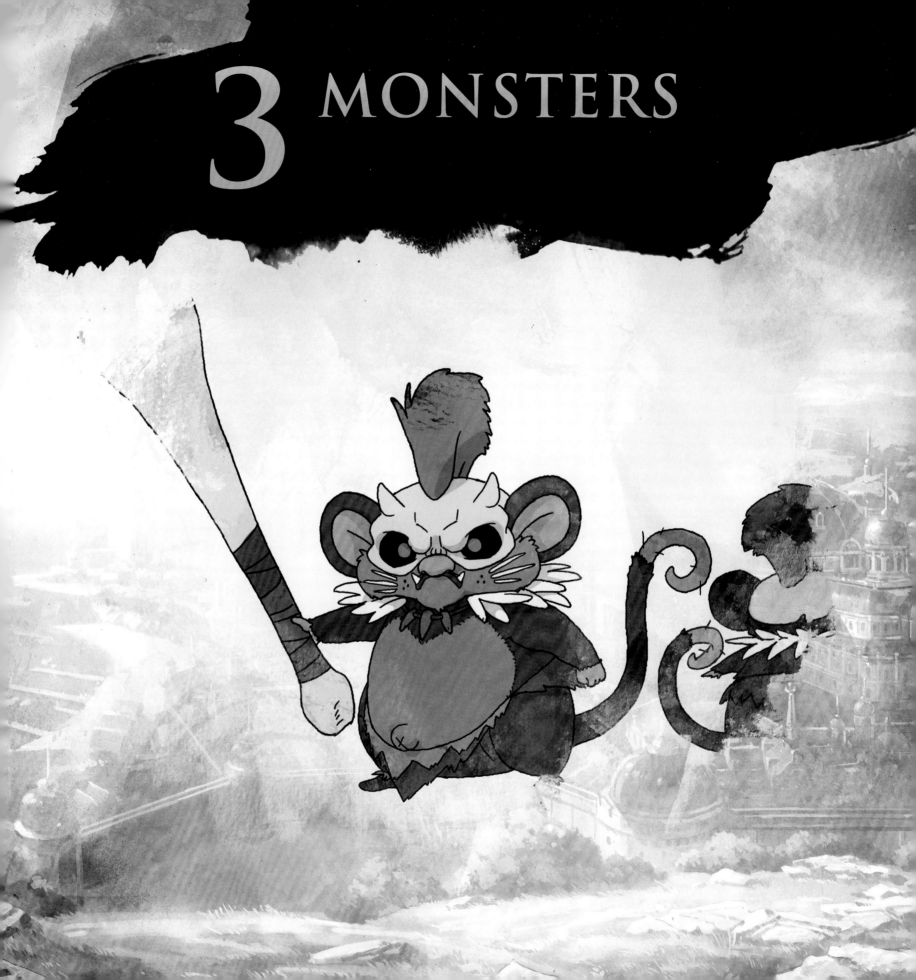

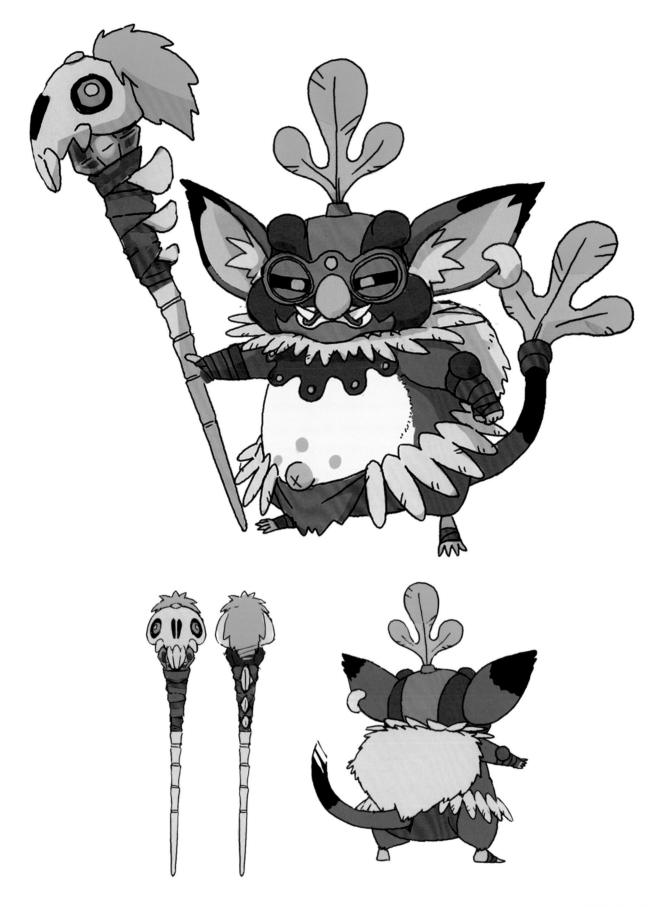

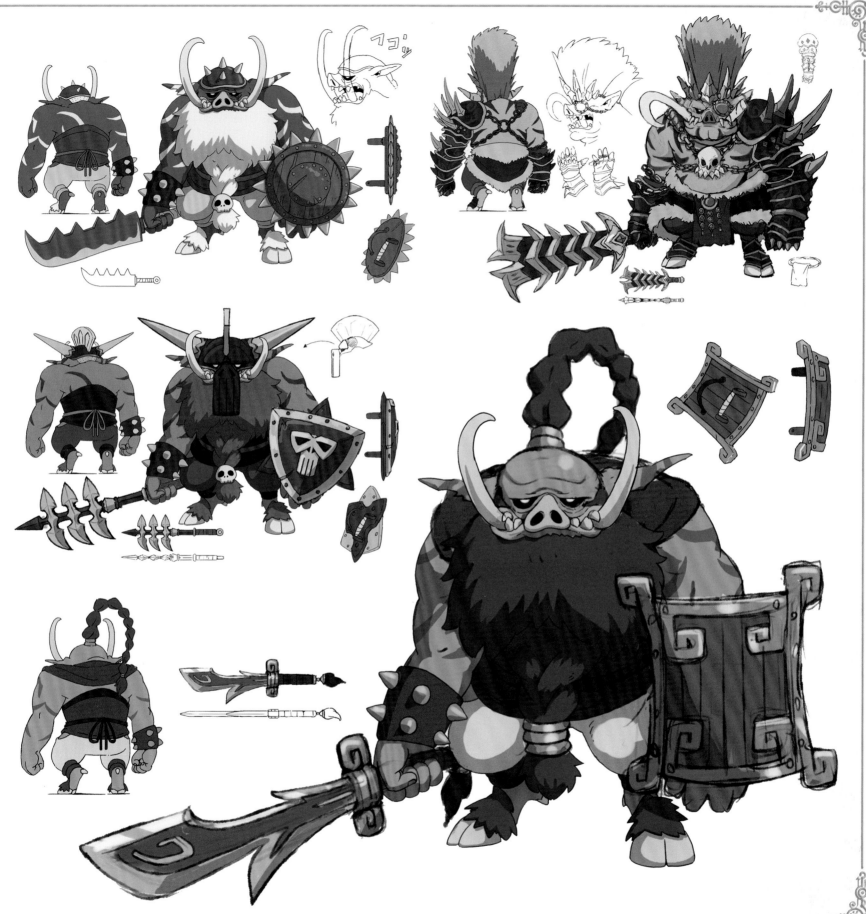

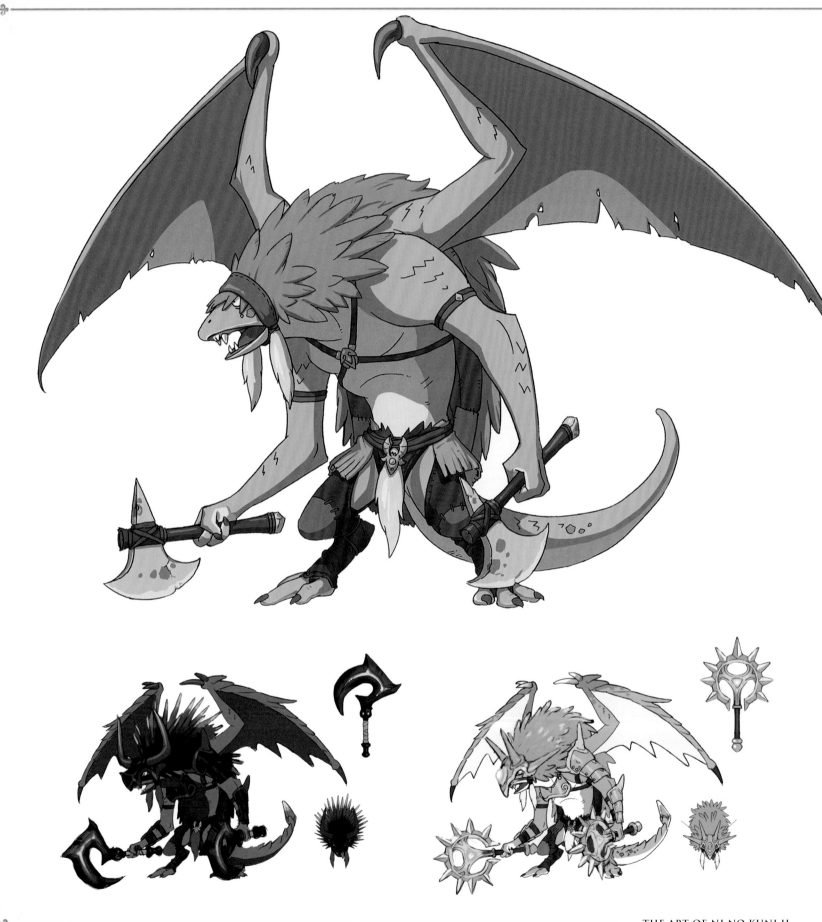

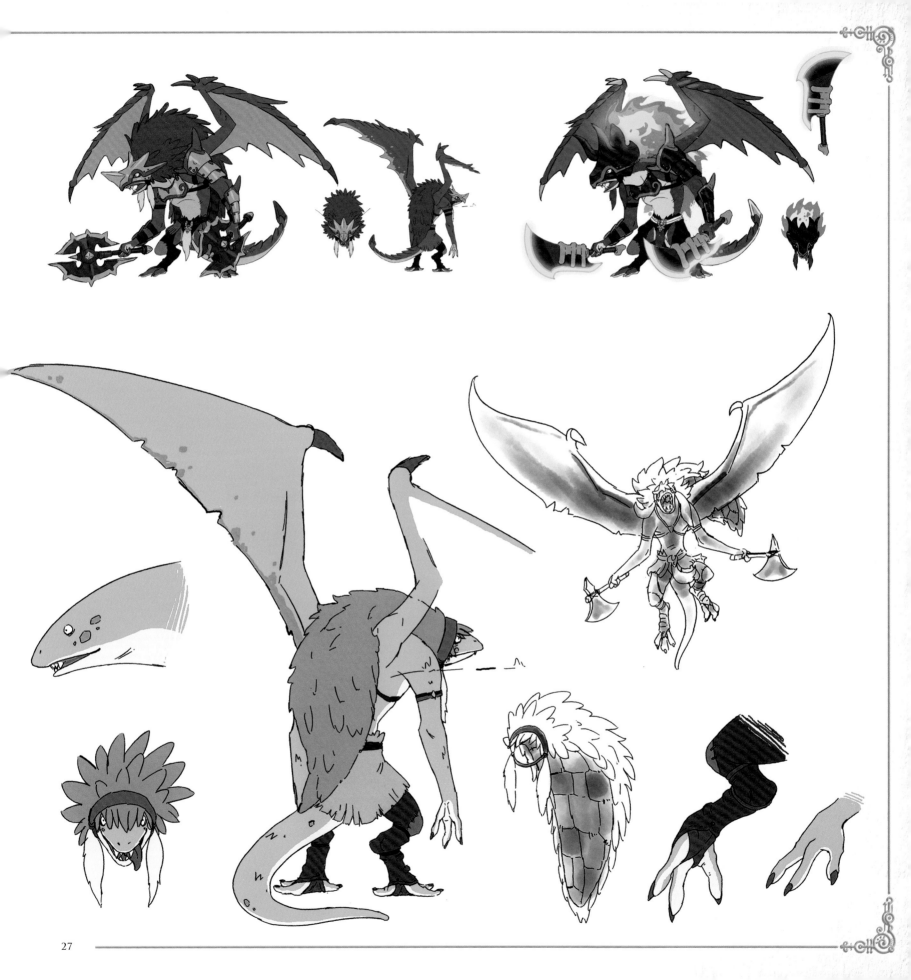

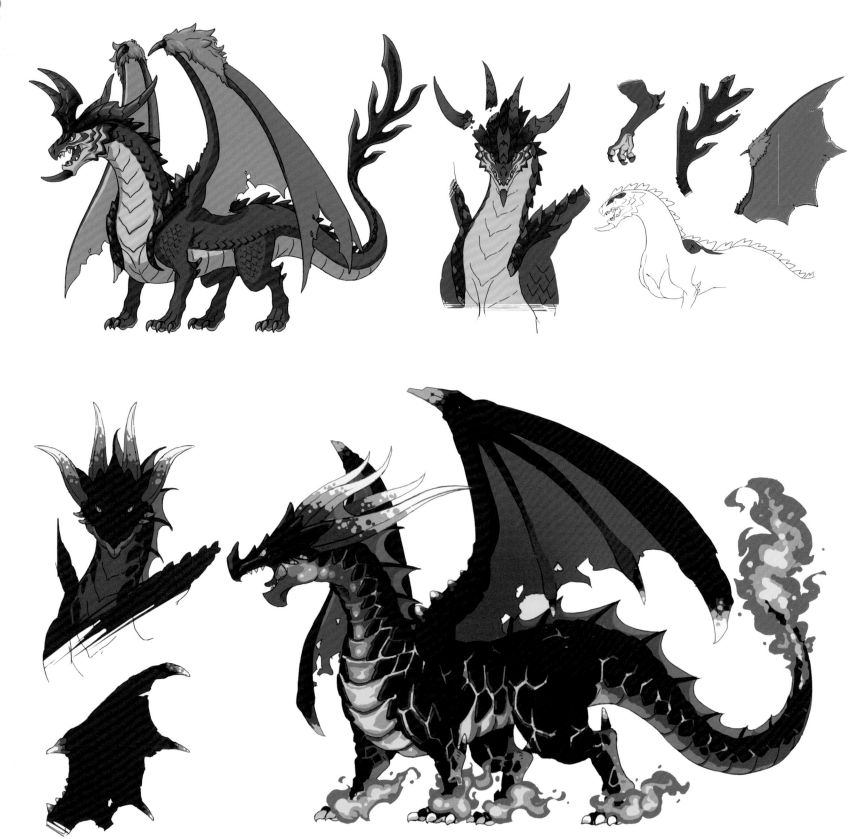

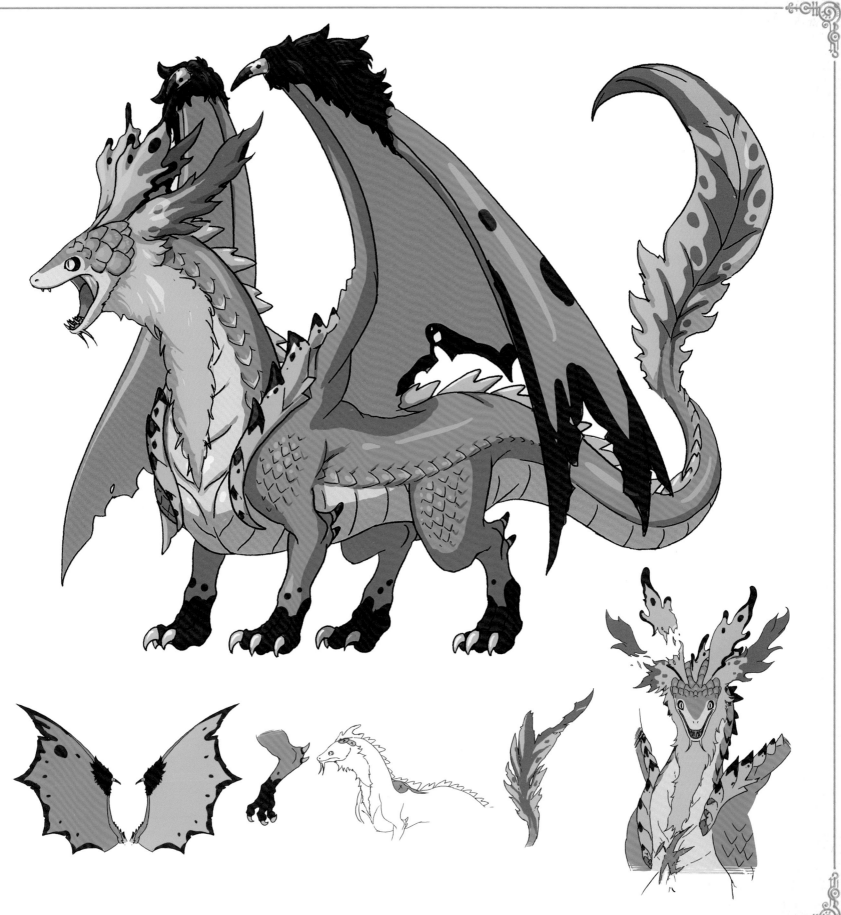

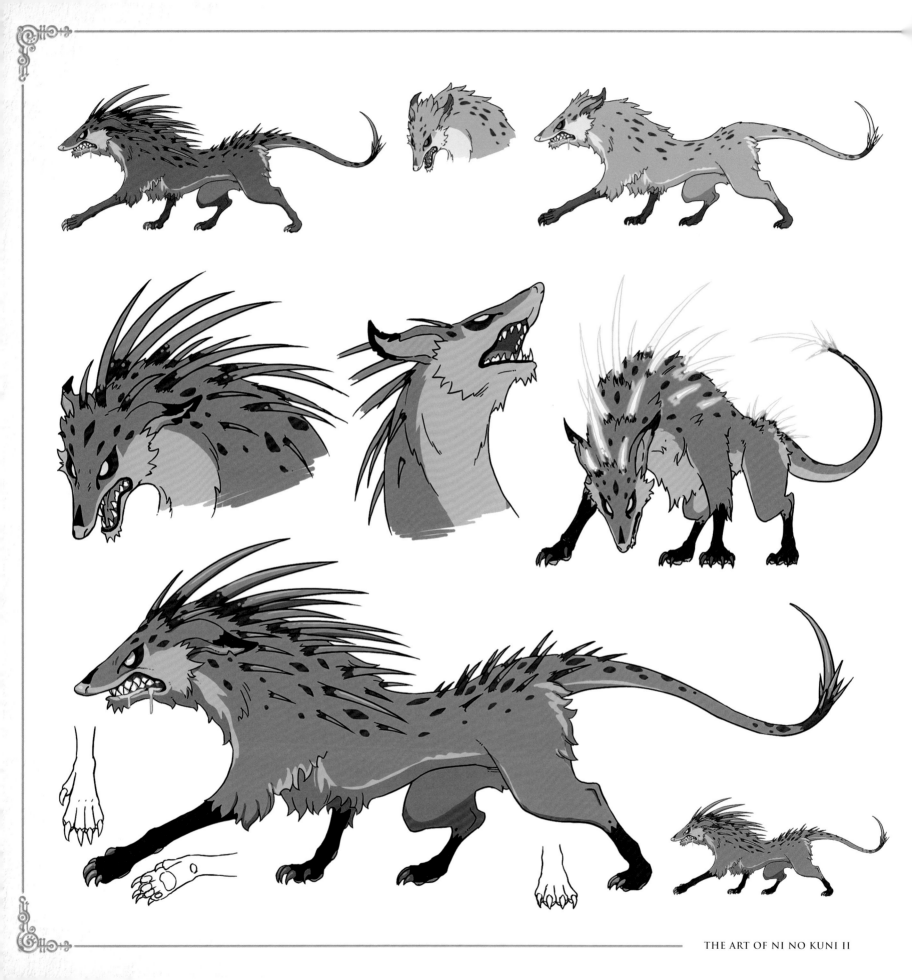

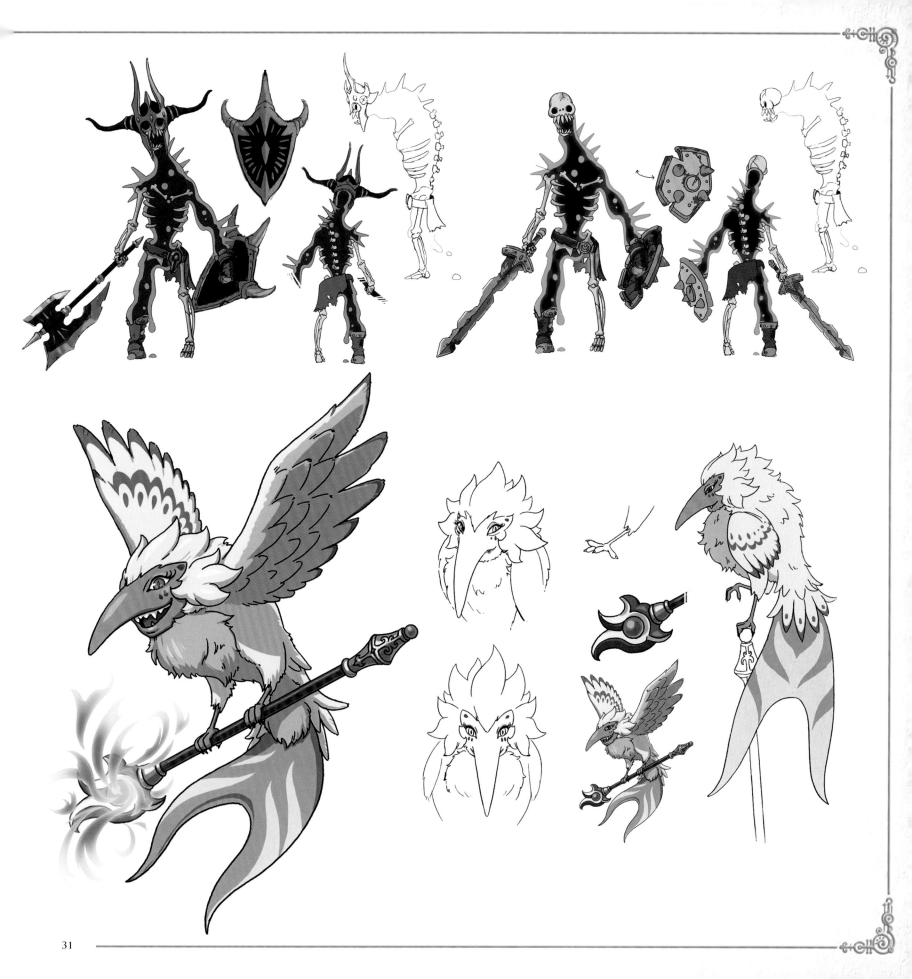

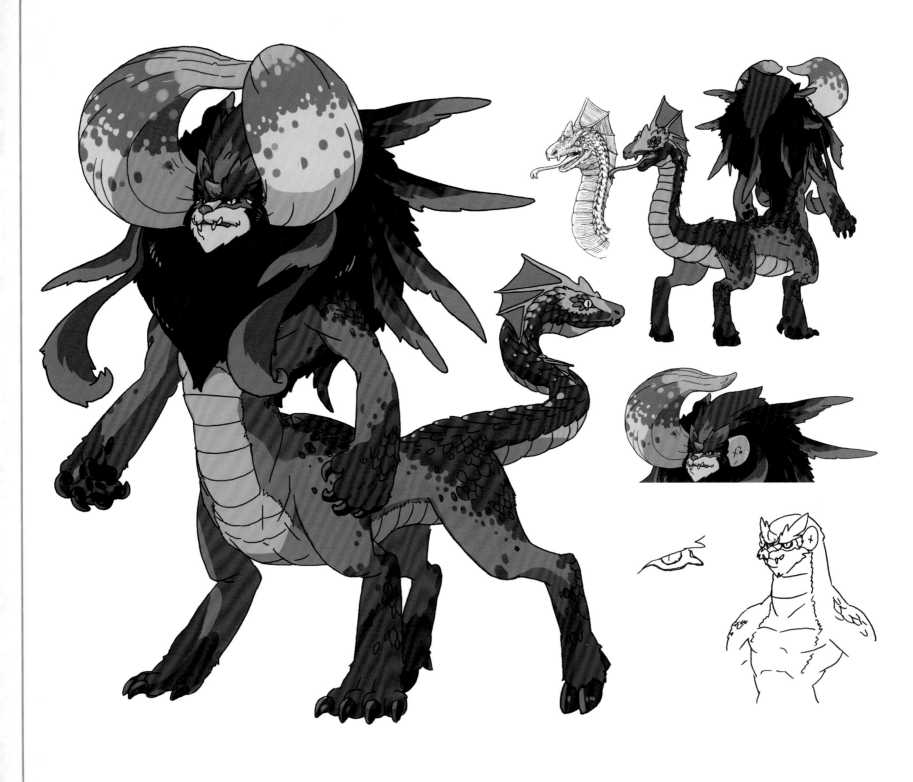

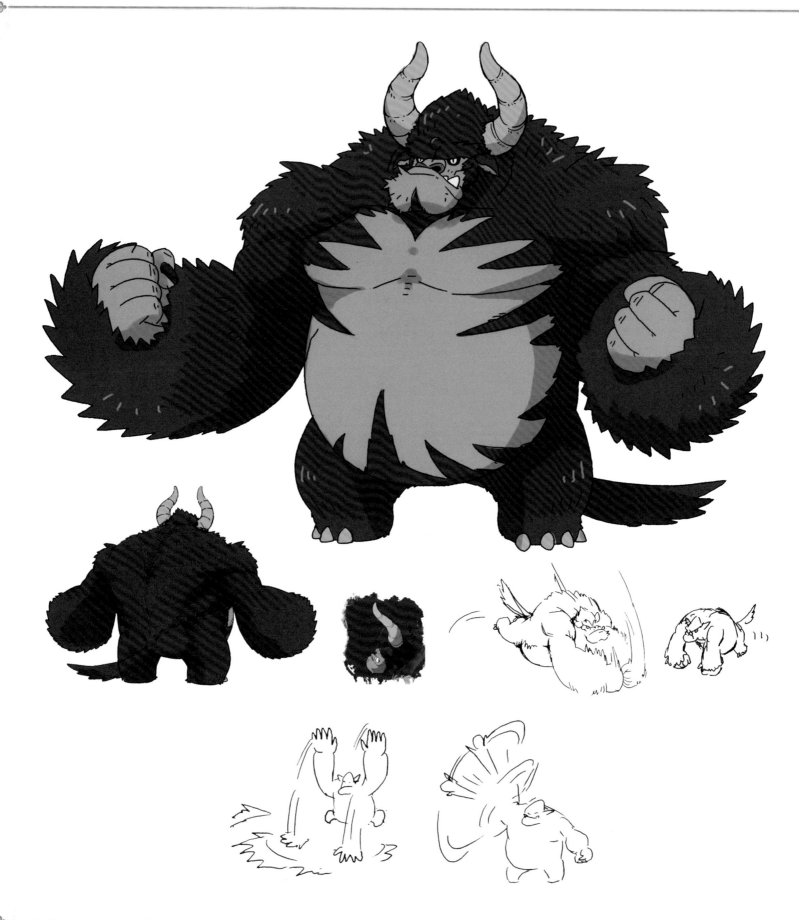

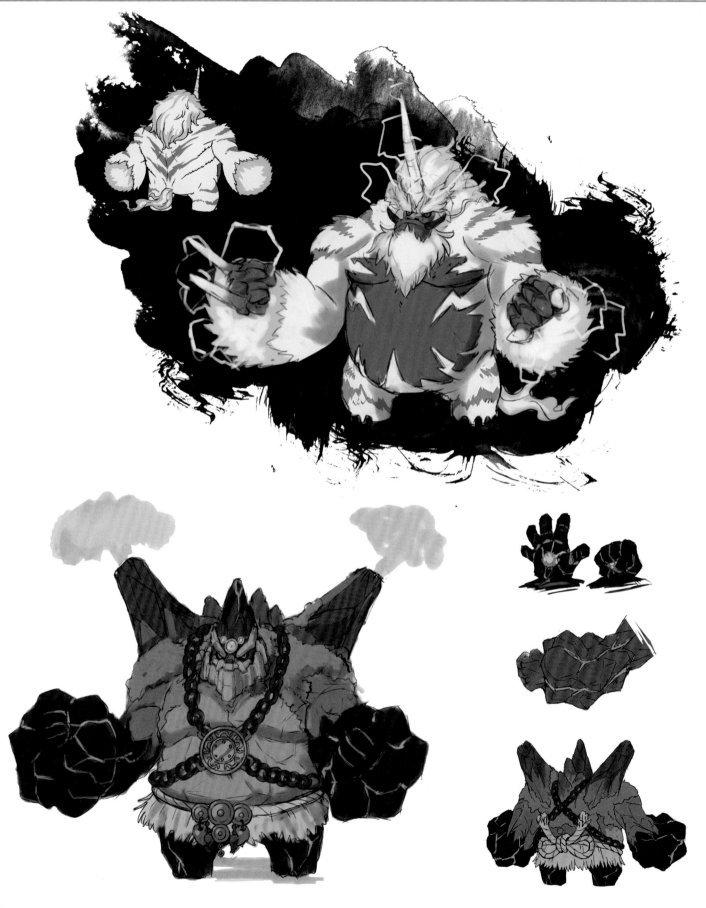

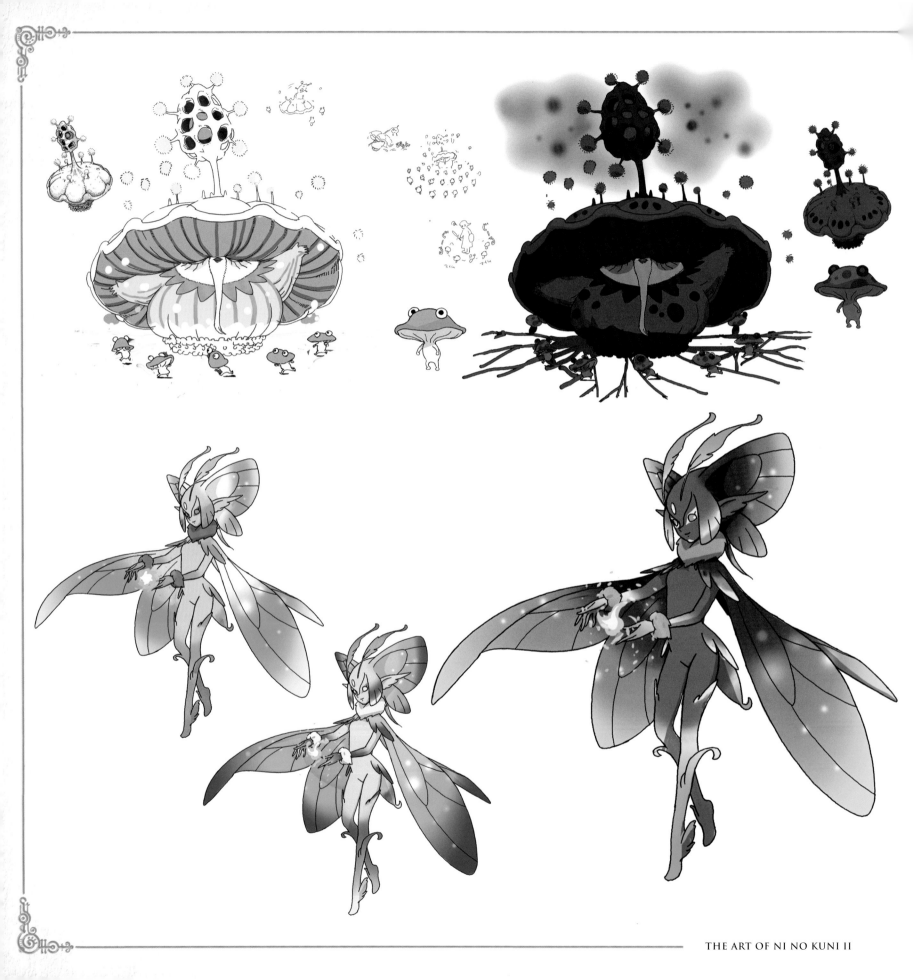

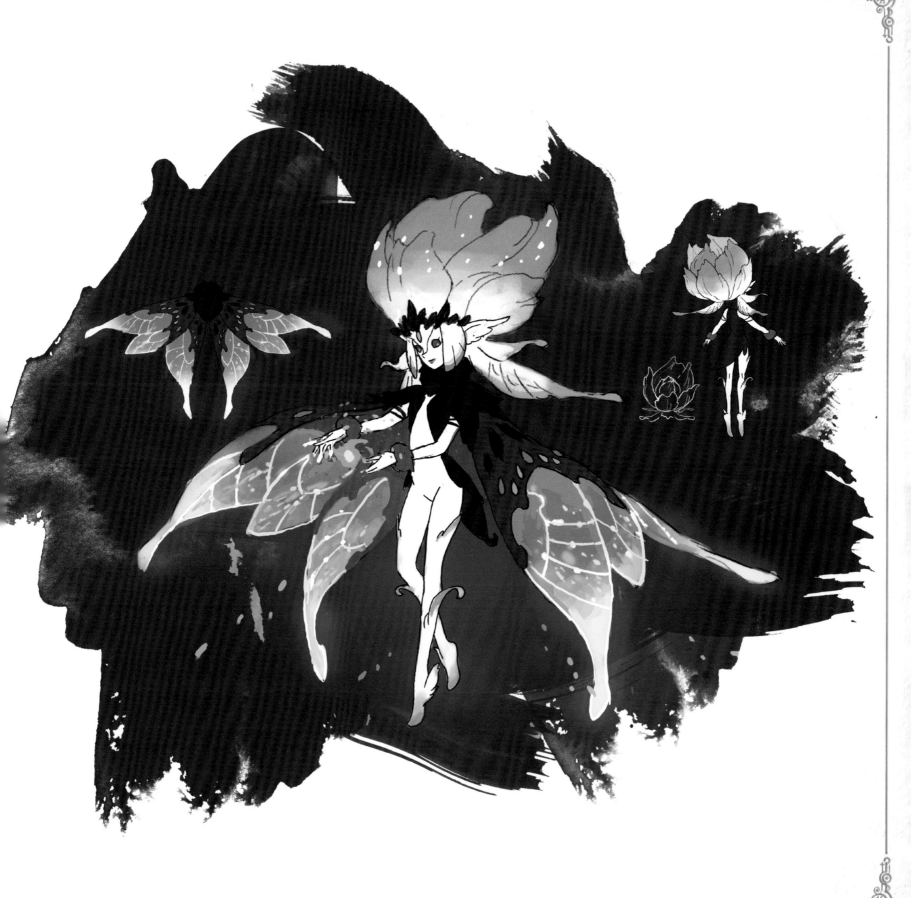

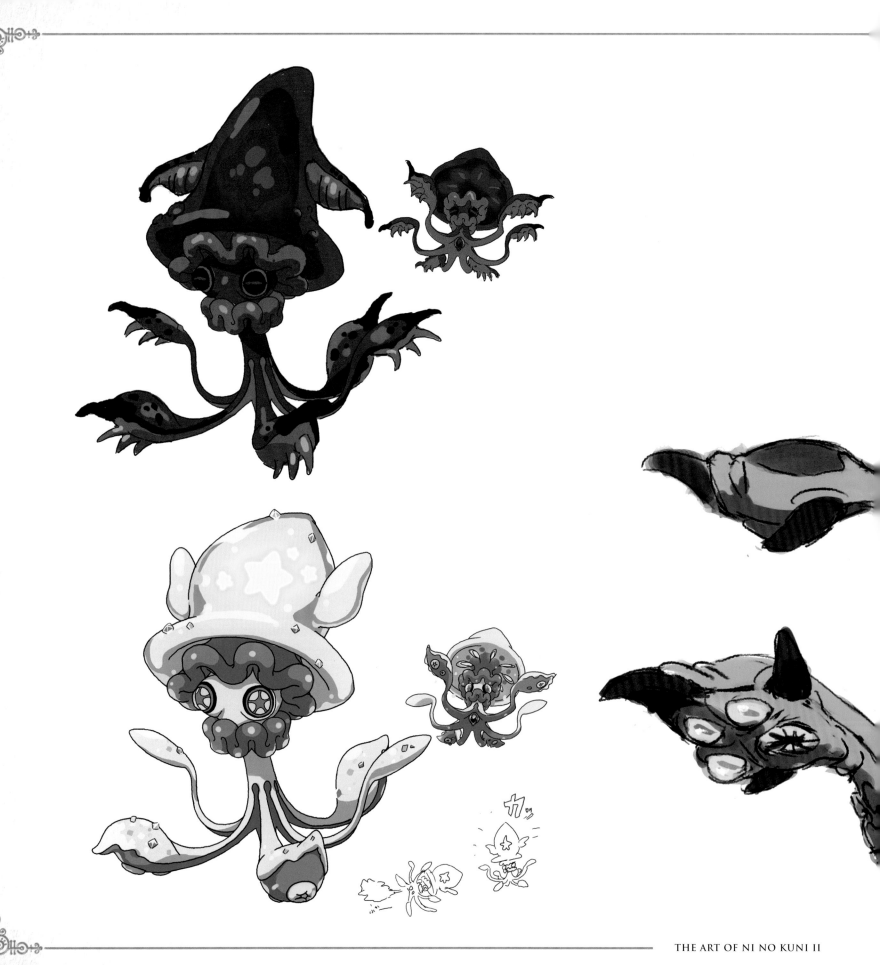

カ

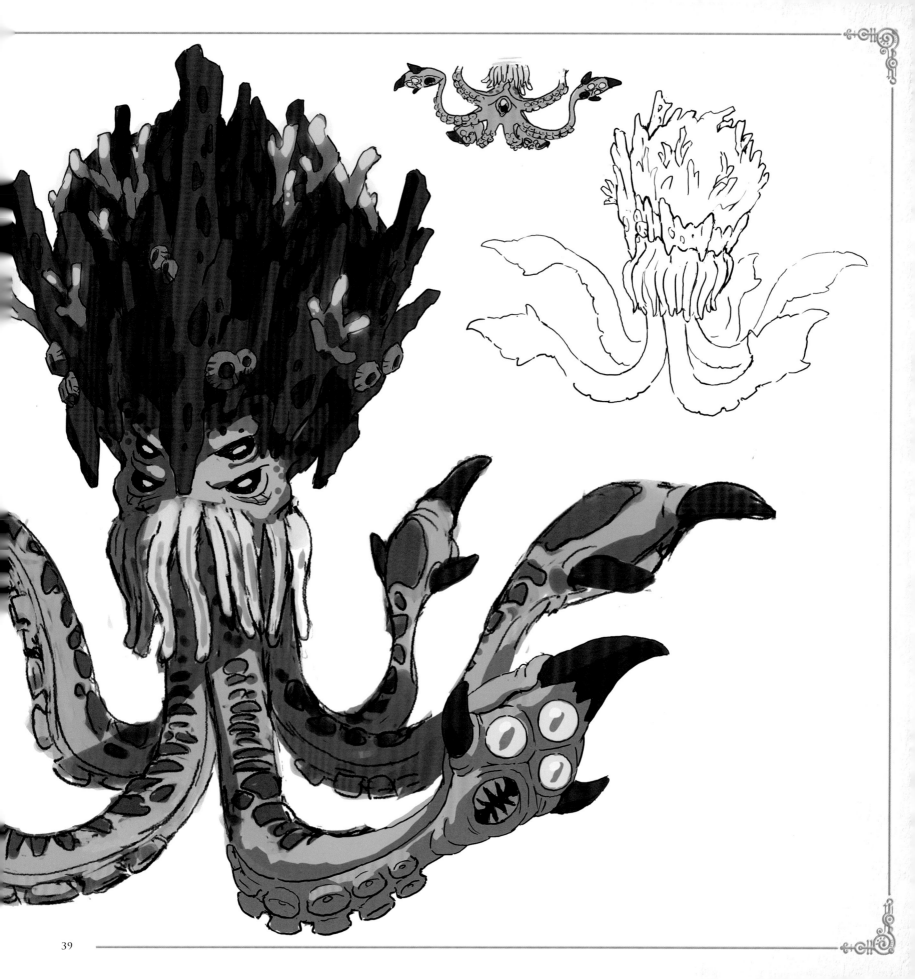

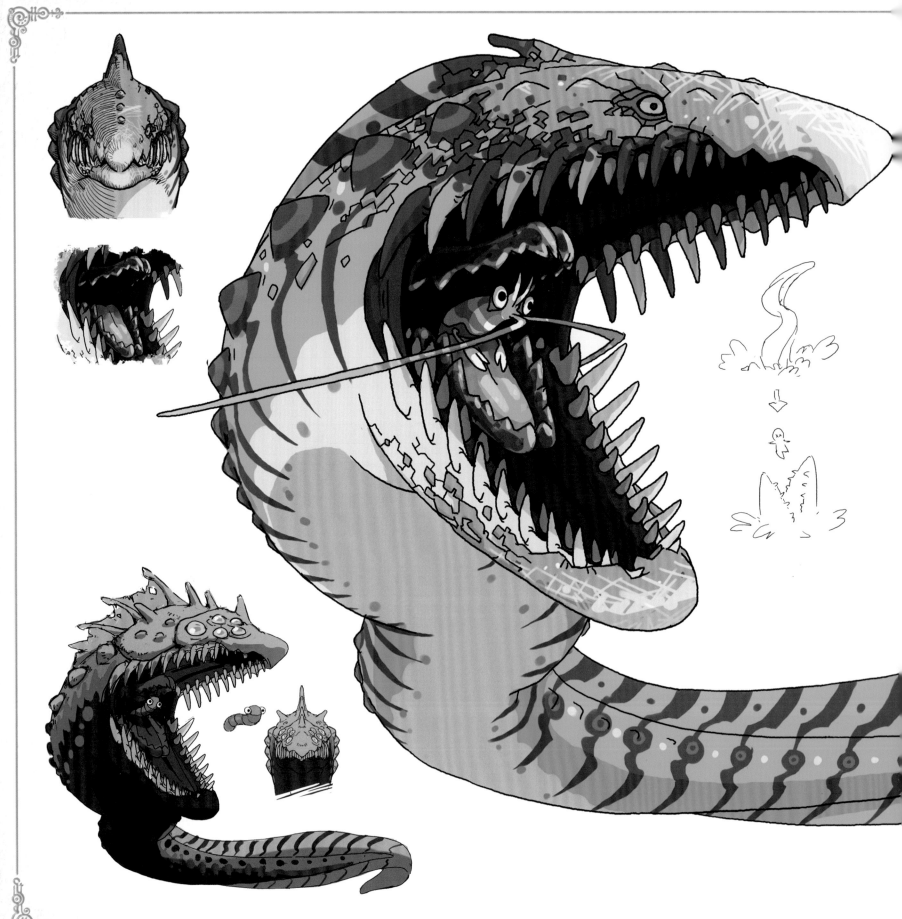

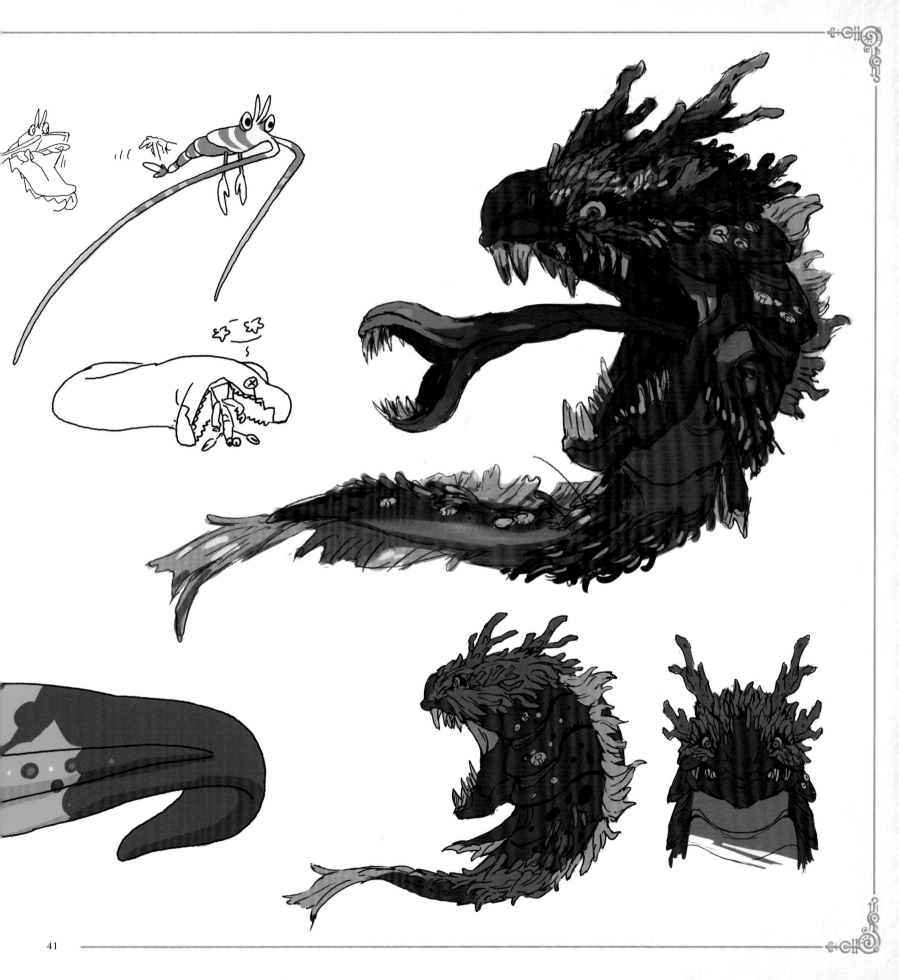

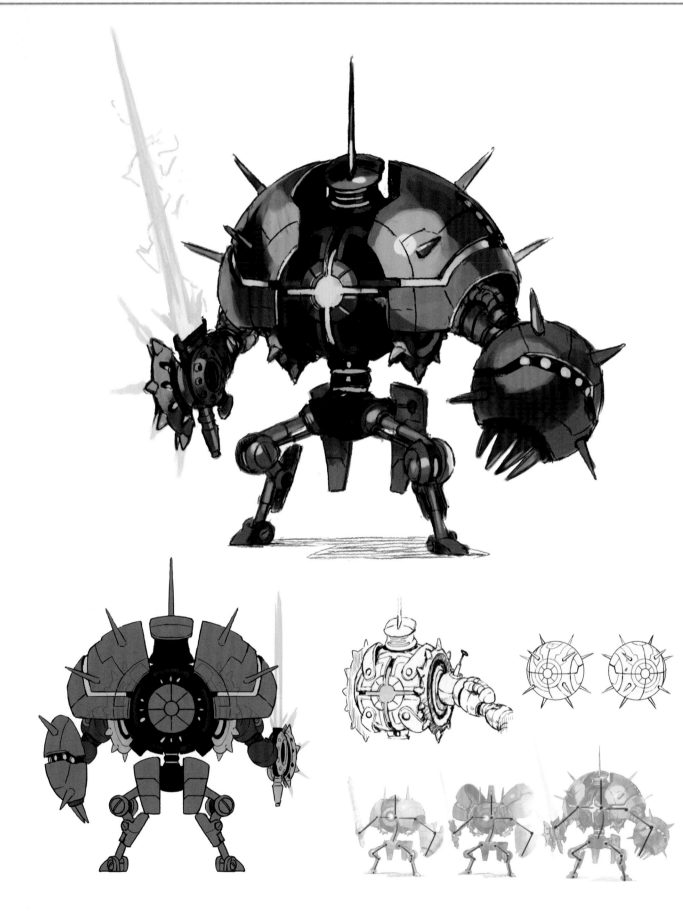

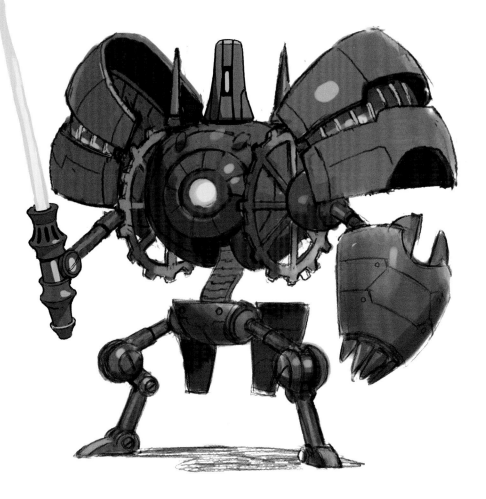

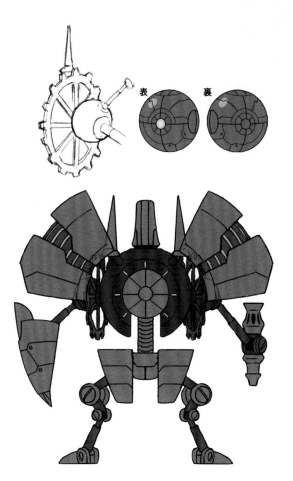

表　裏

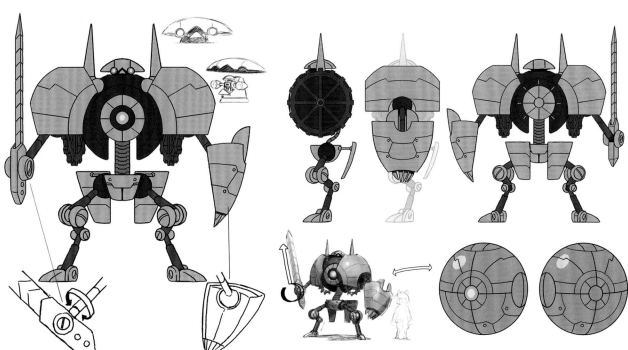

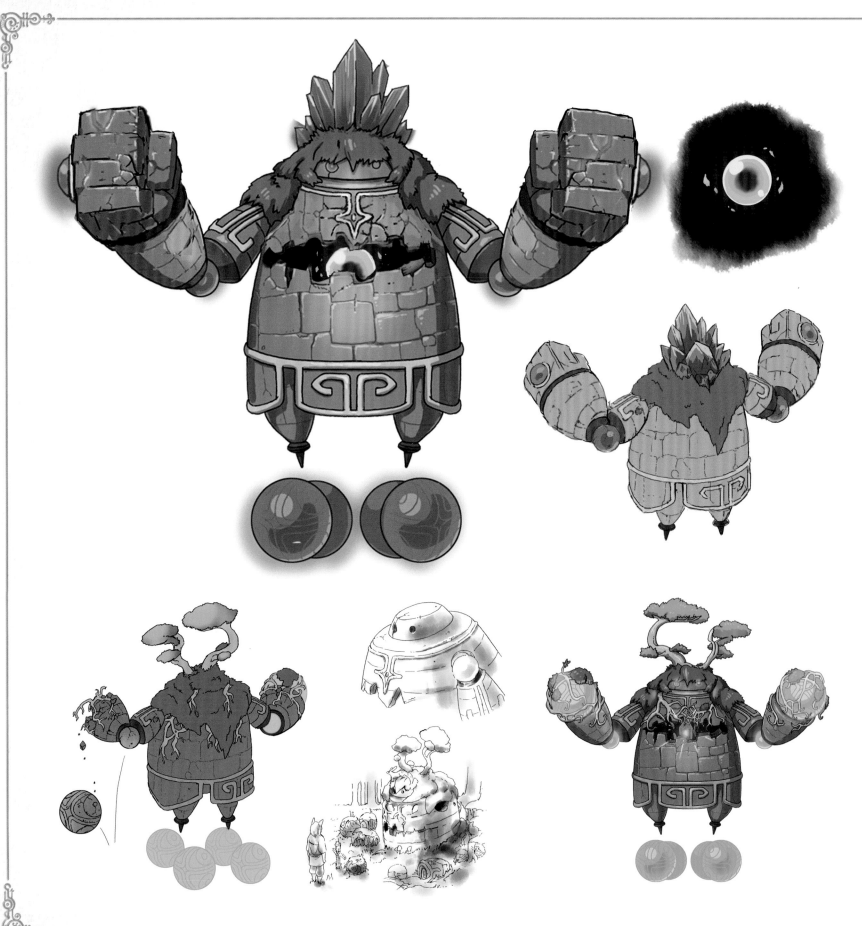

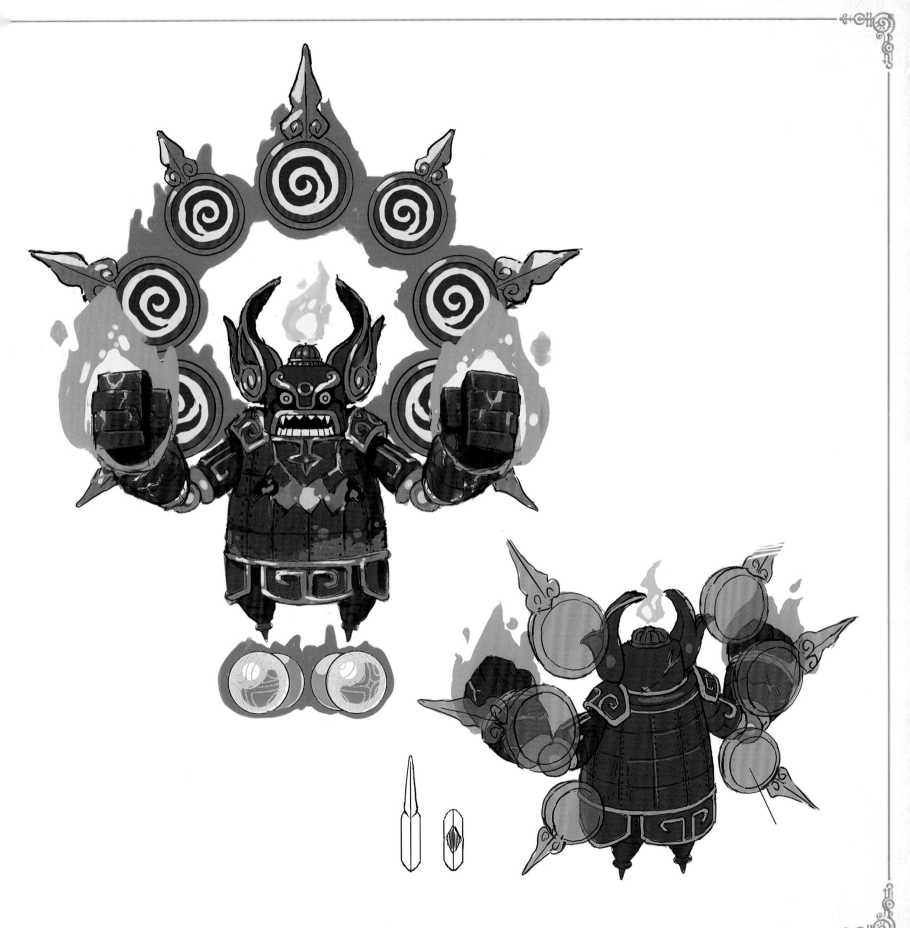

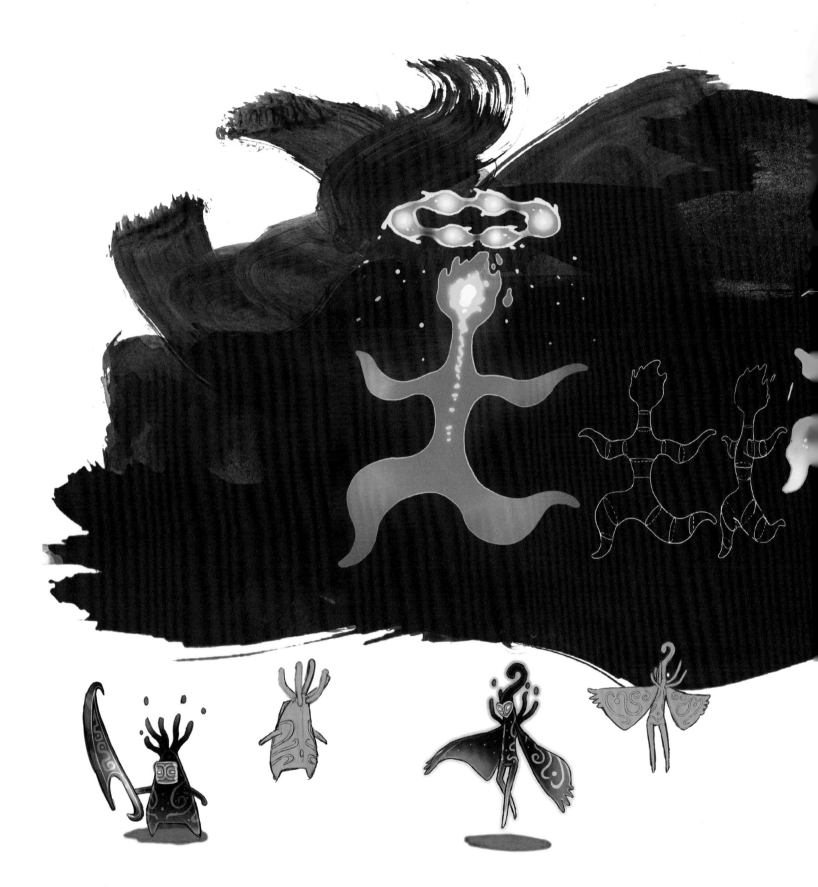

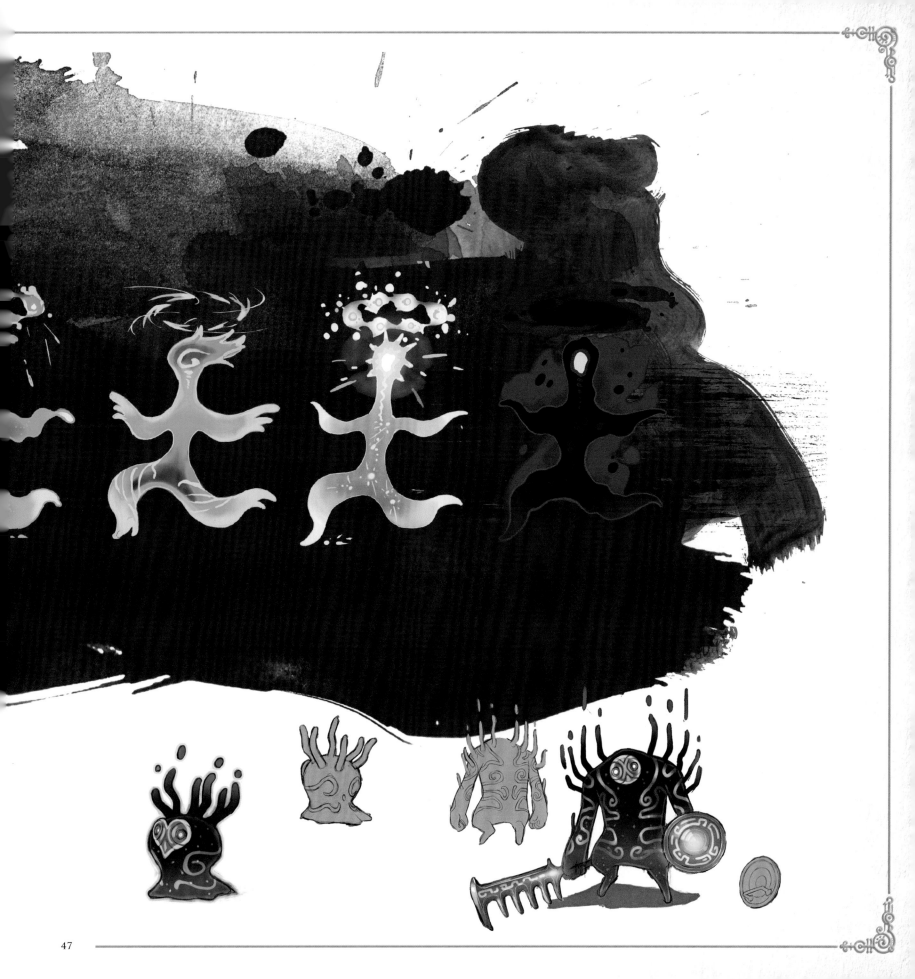

4 KINGMAKERS

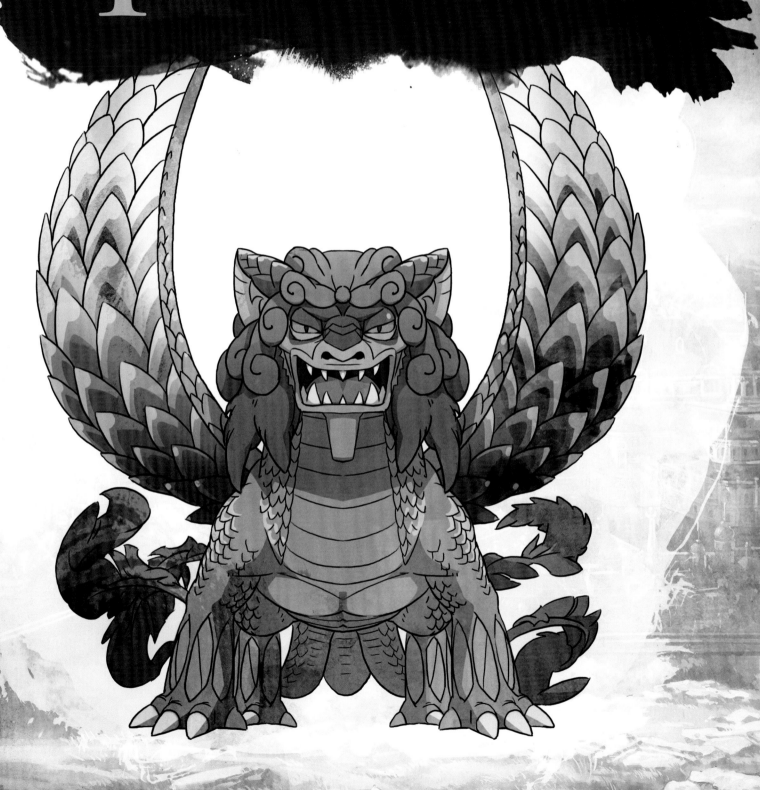

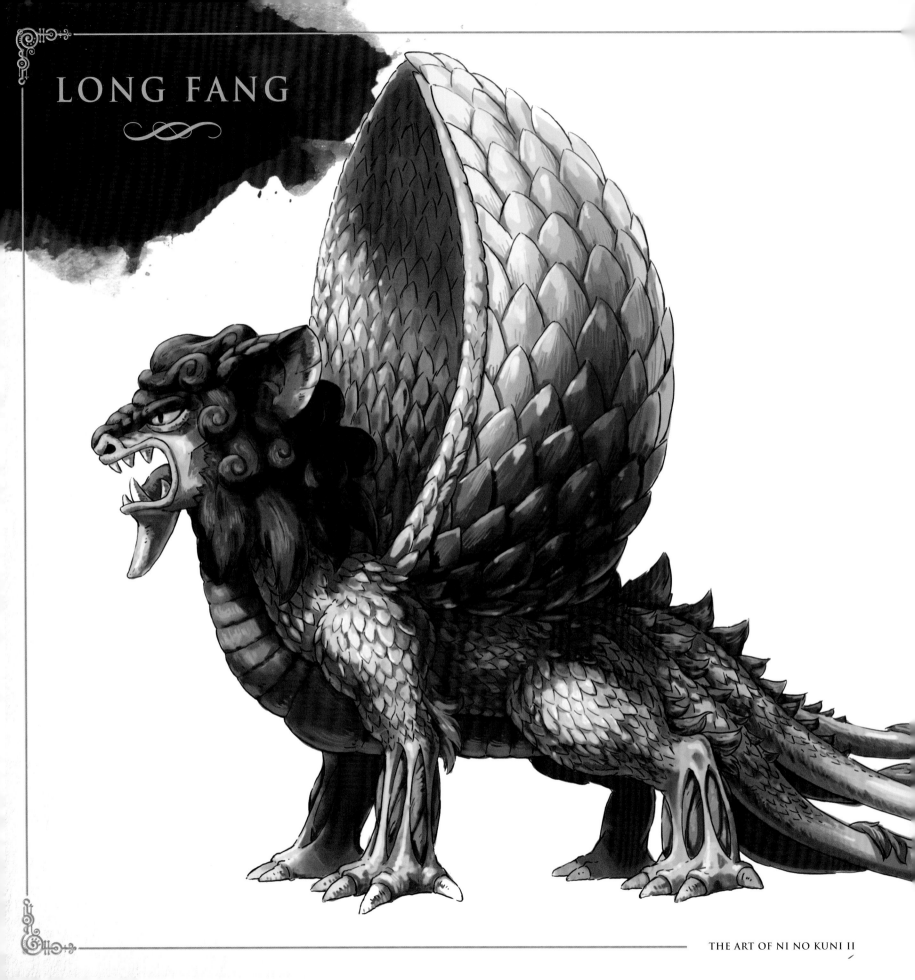

LONG FANG

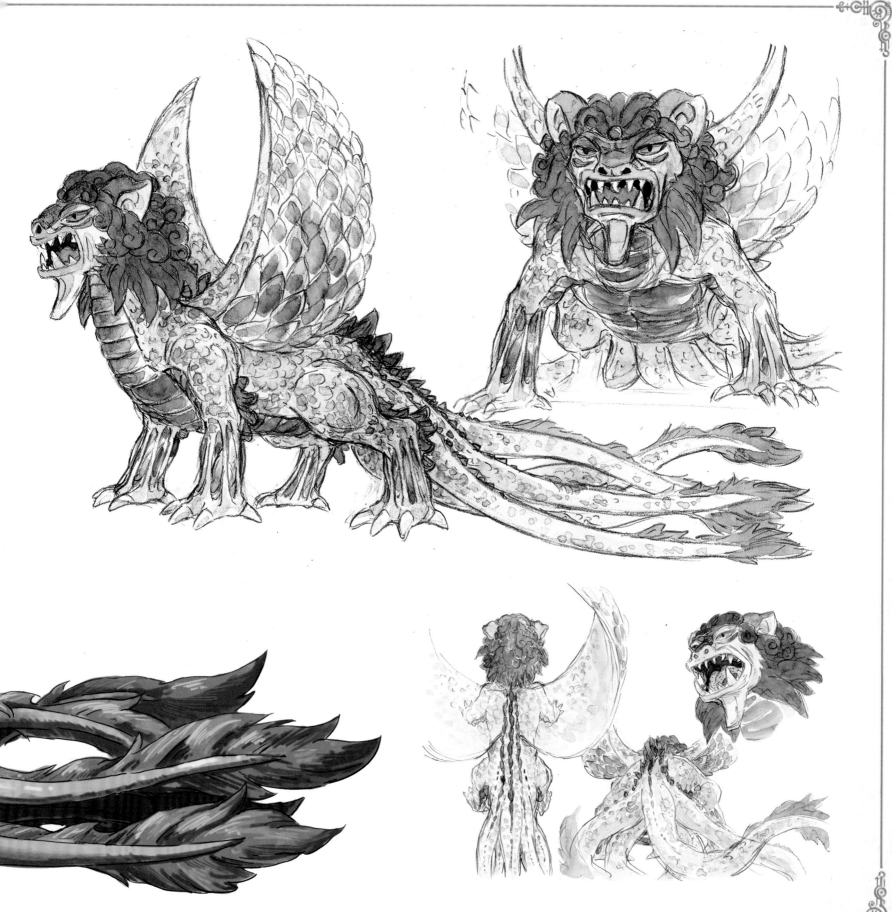

BRINESKIMMER

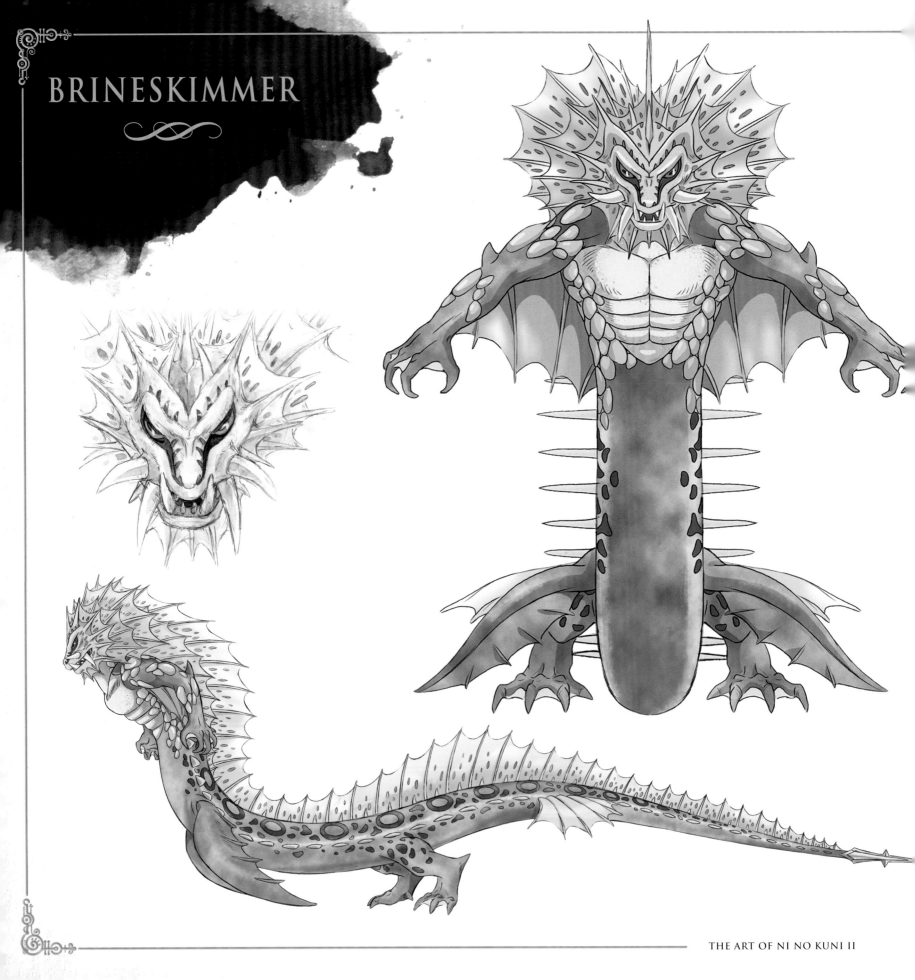

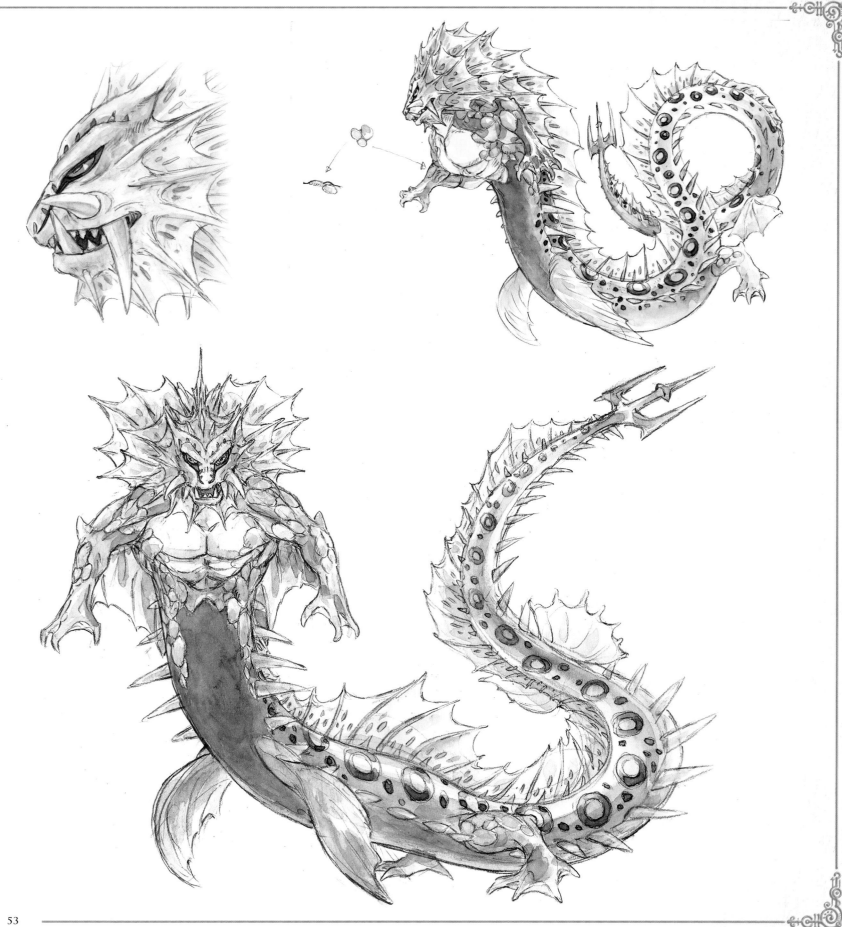

BASTION

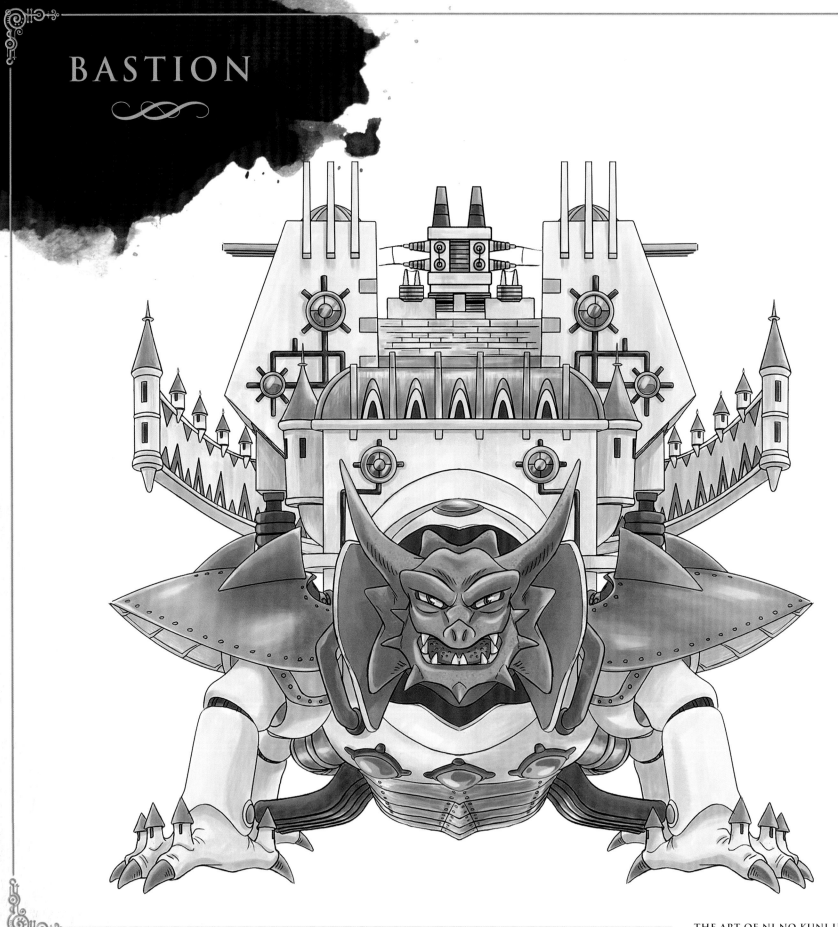

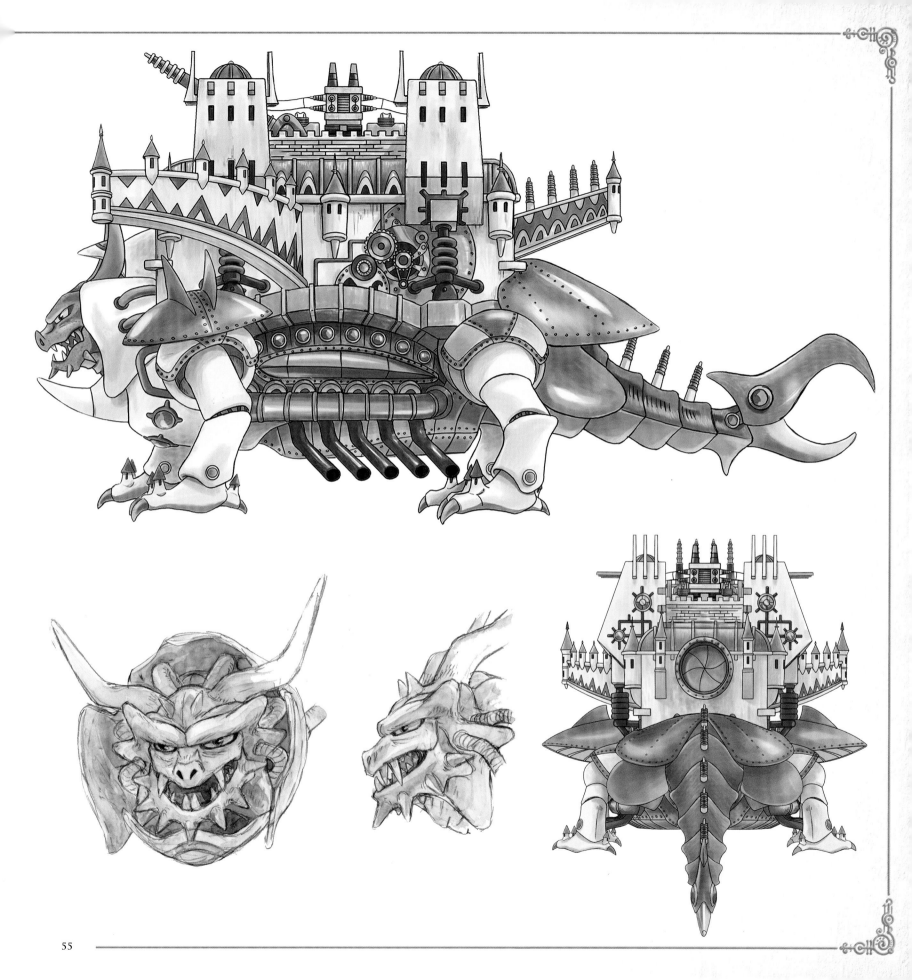

OAKENHEART

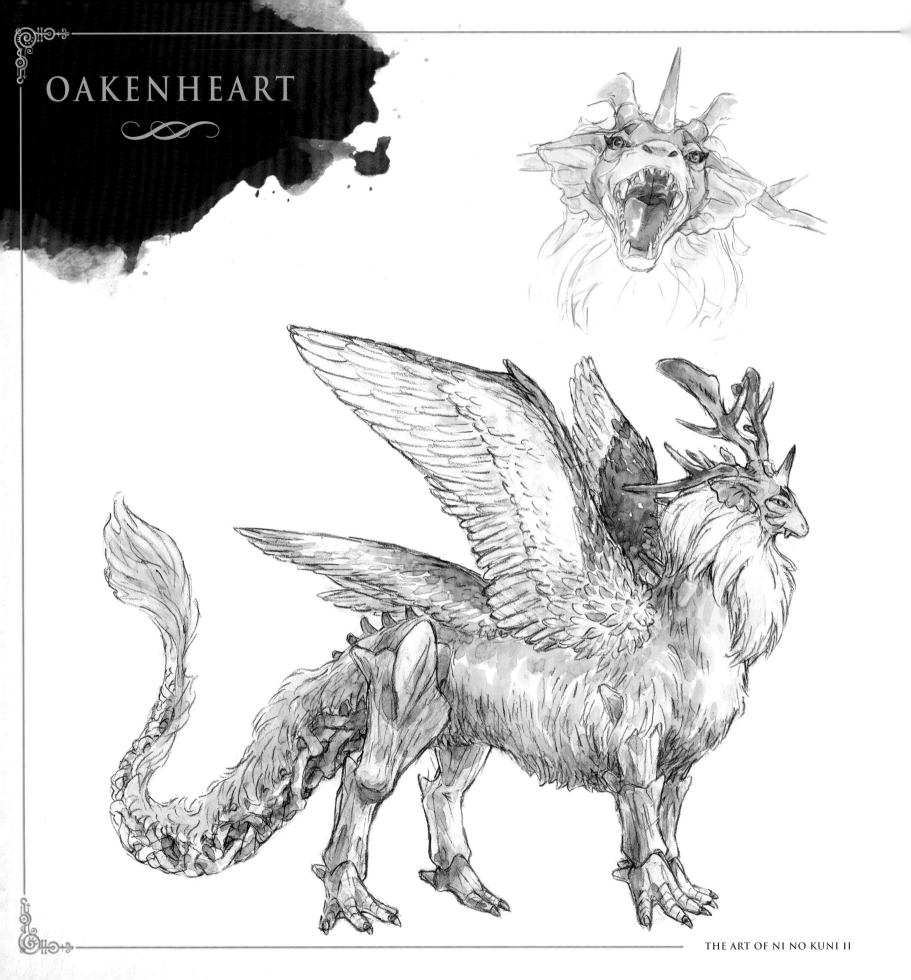

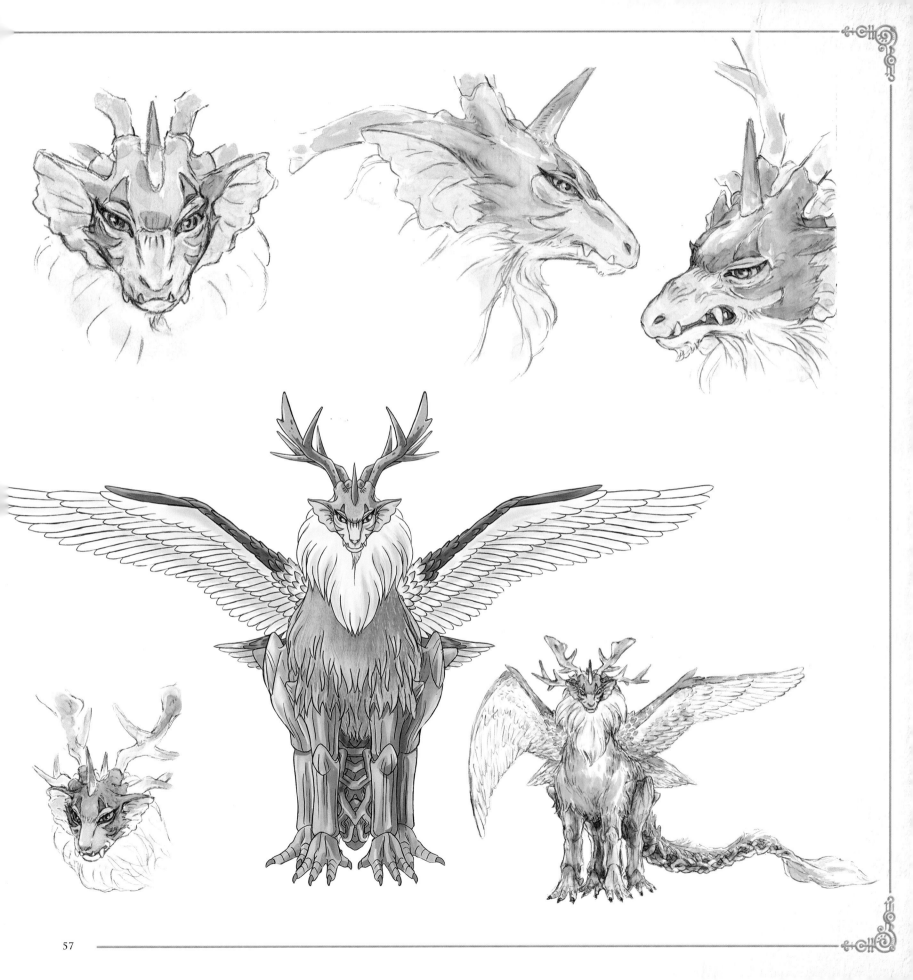

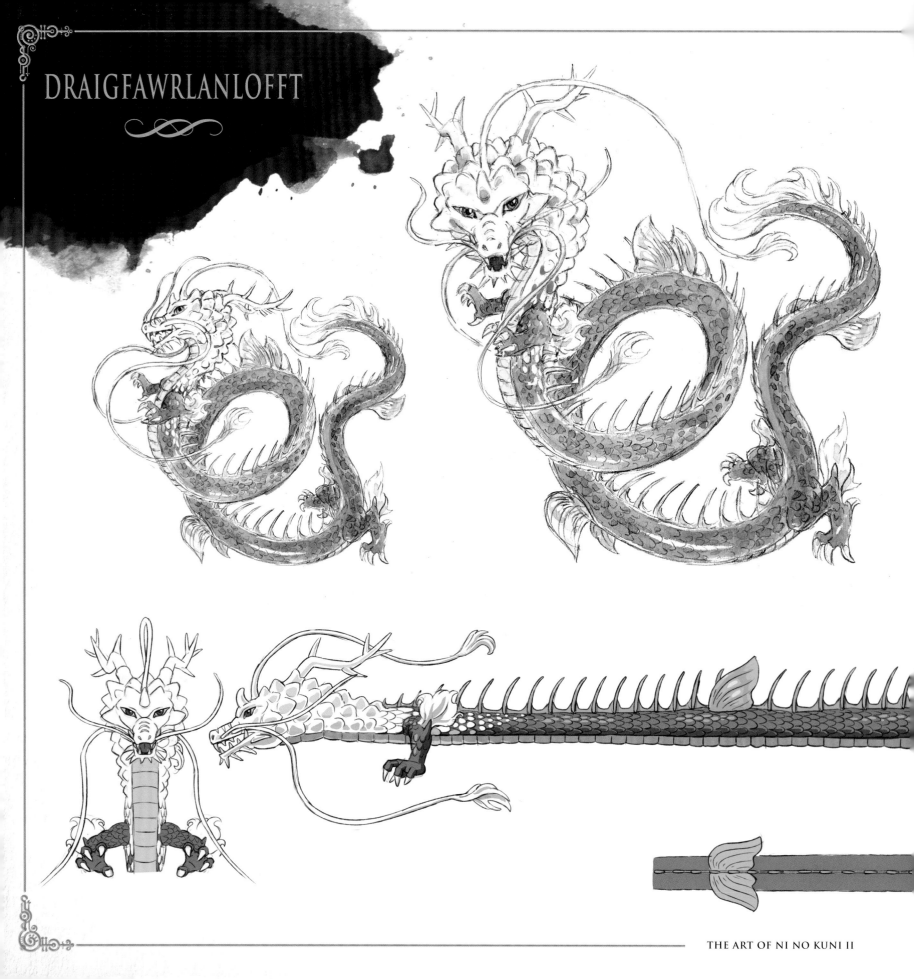

DRAIGFAWRLANLOFFT

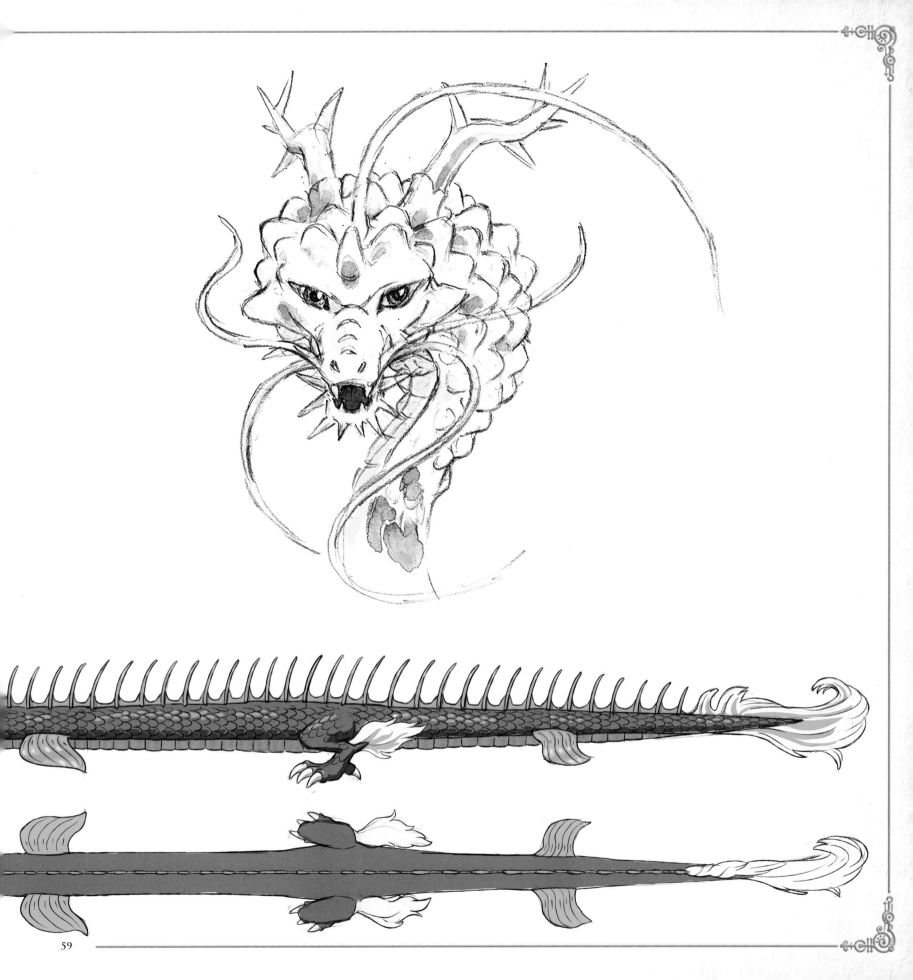

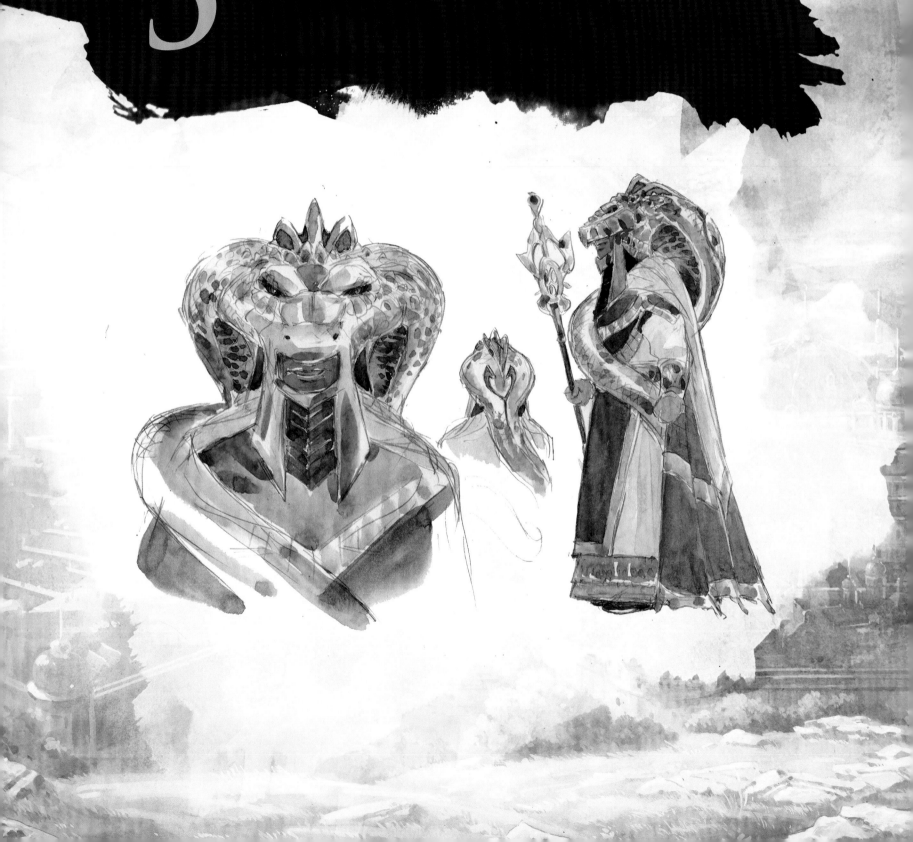

DOLORAN

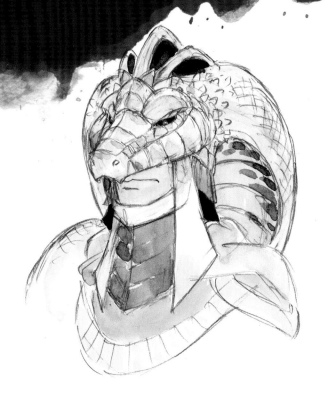

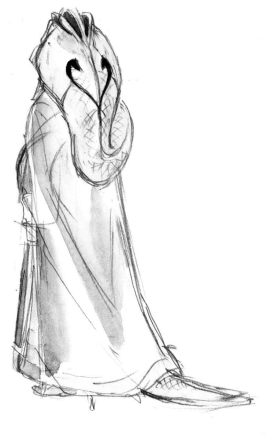

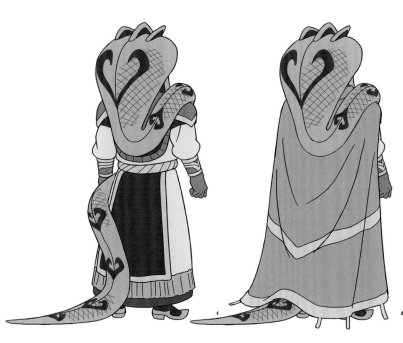

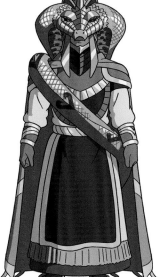

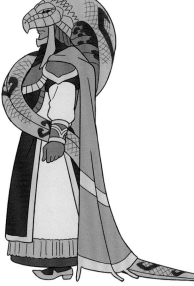

HORNED
ONE

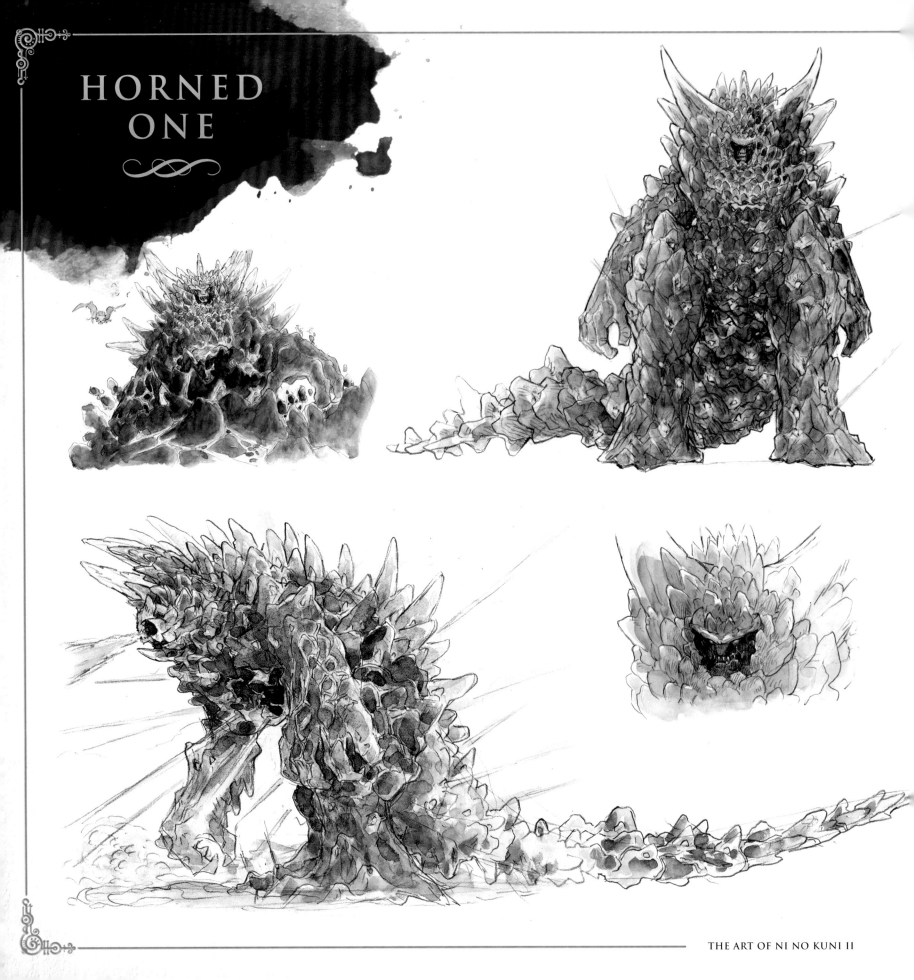

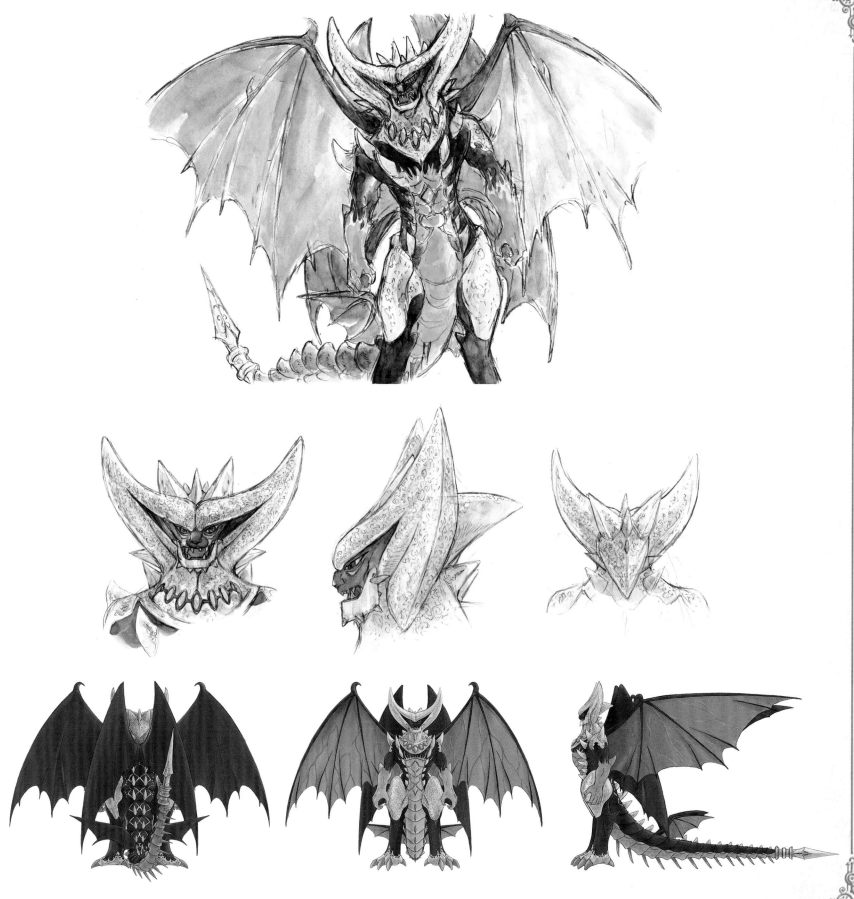

6 HIGGLEDIES

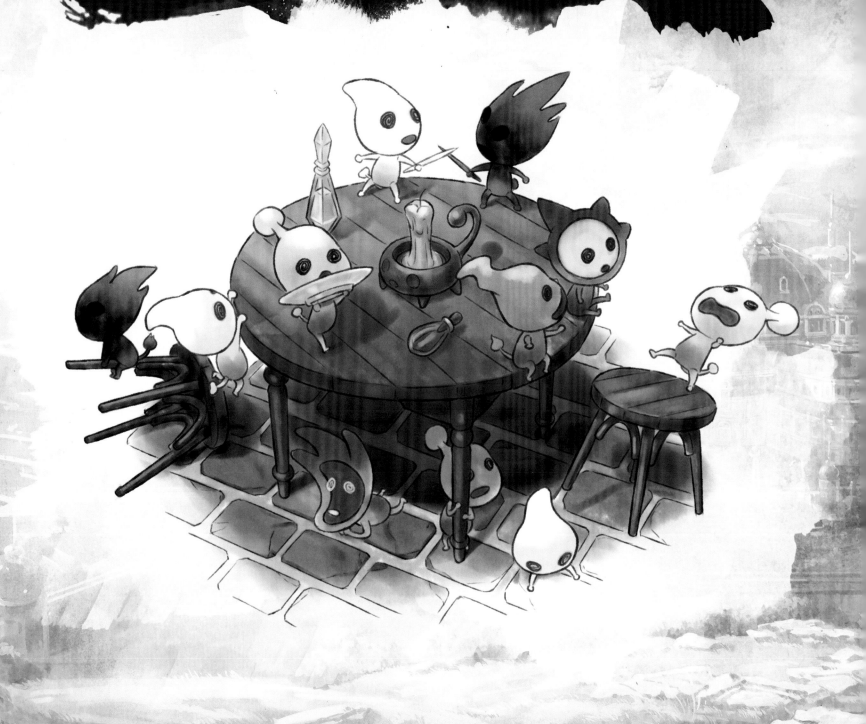

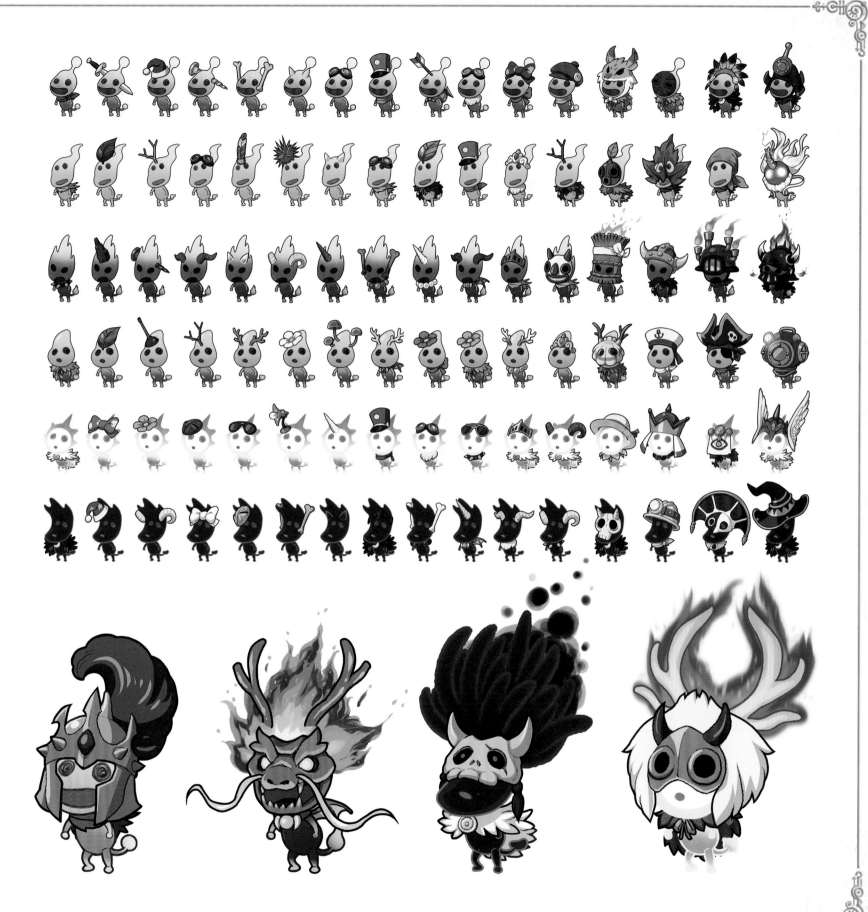

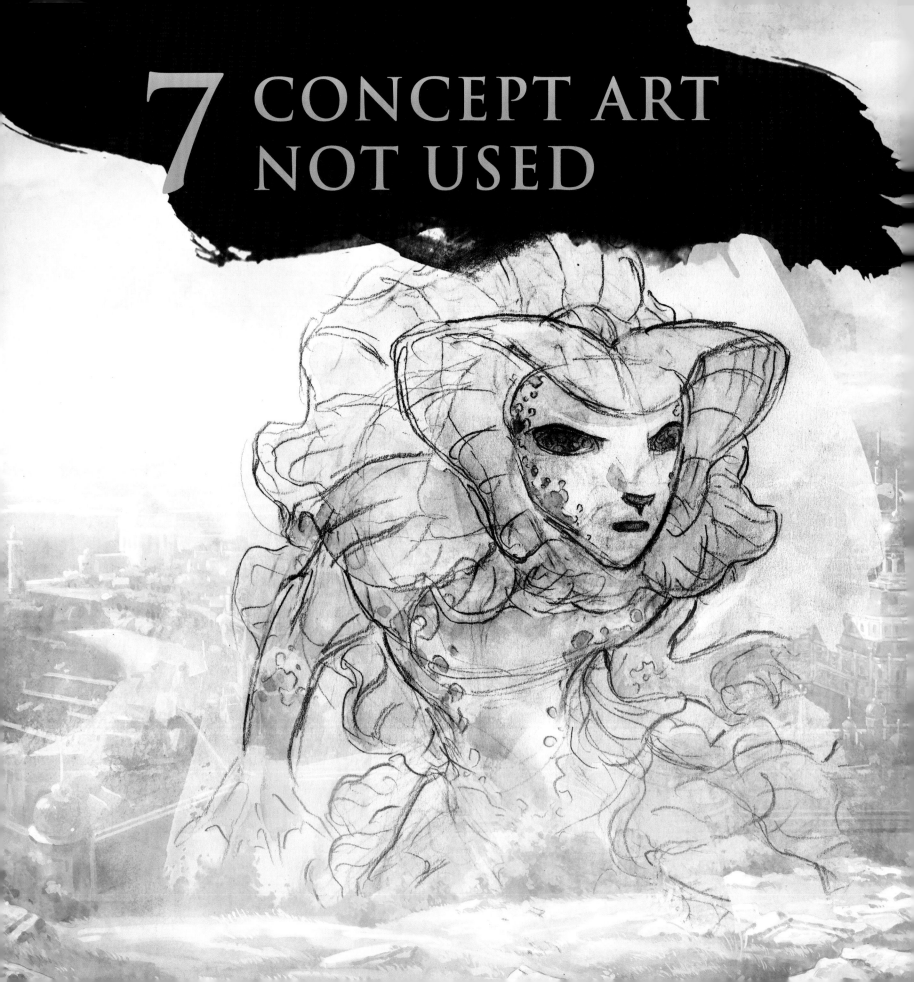

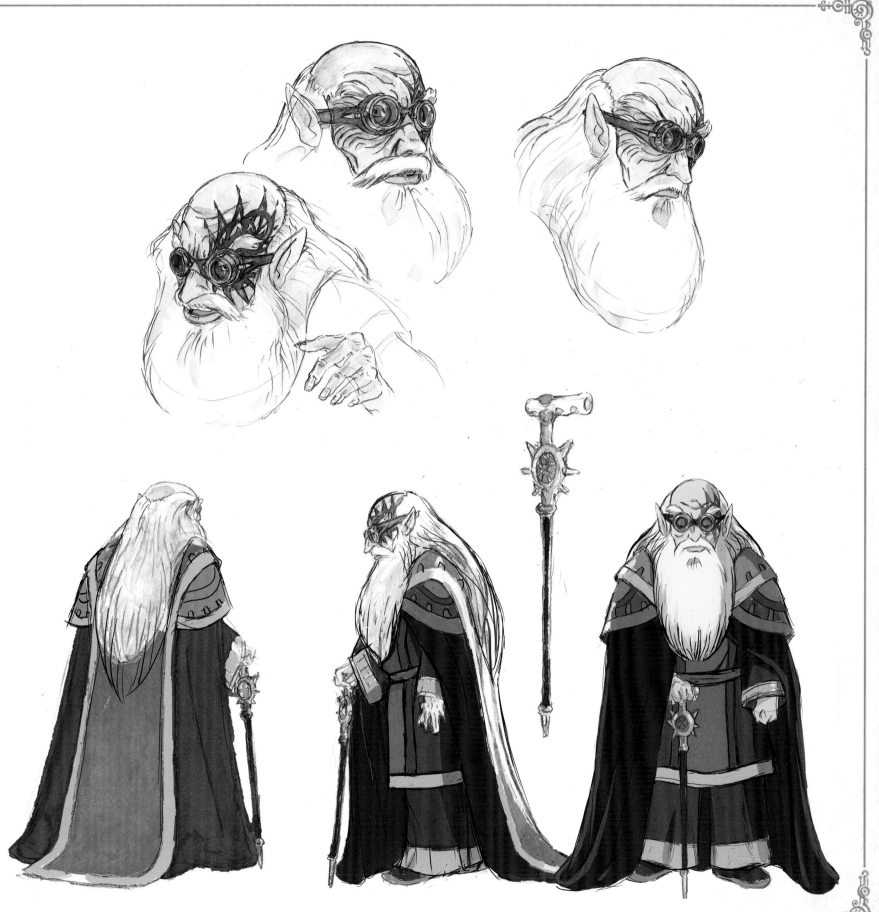

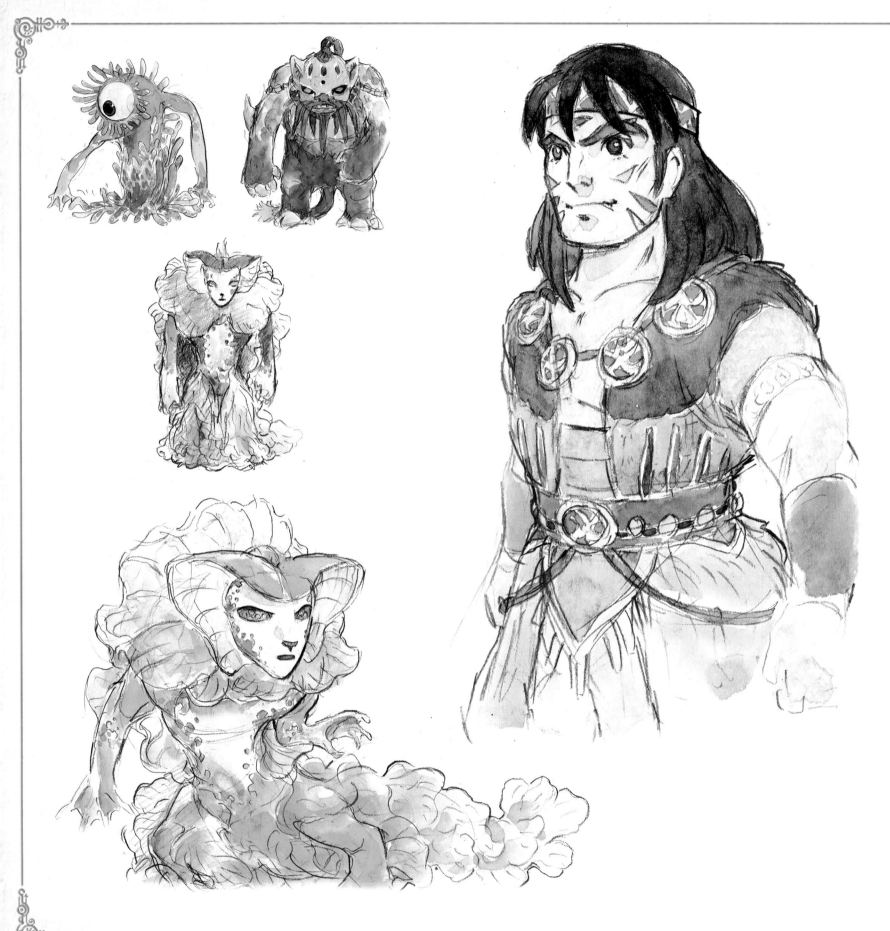

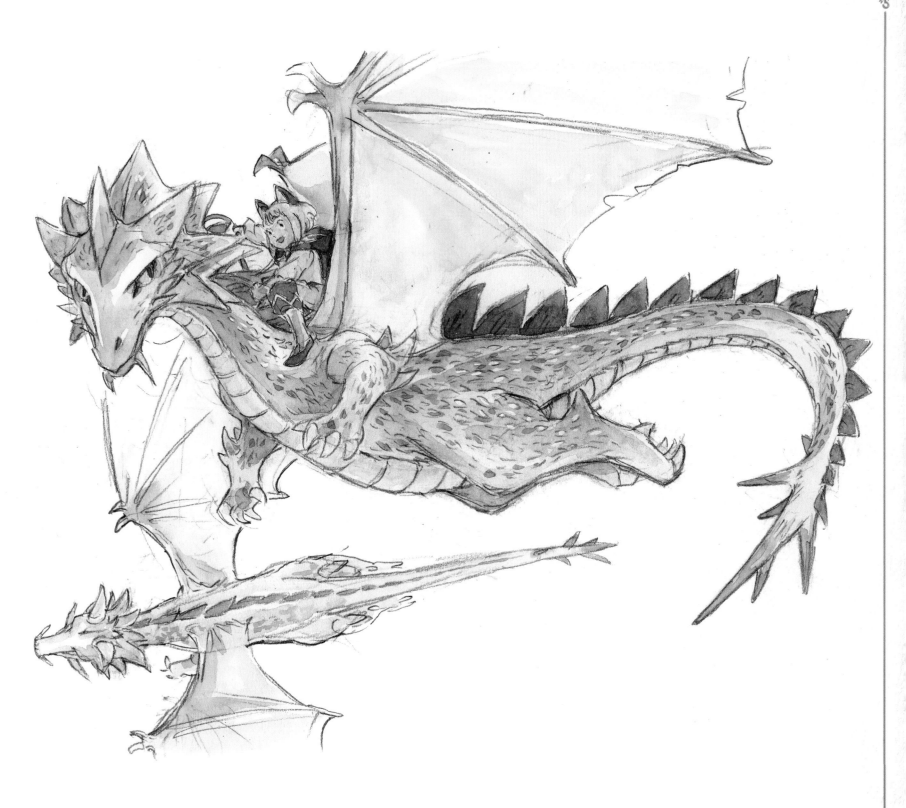

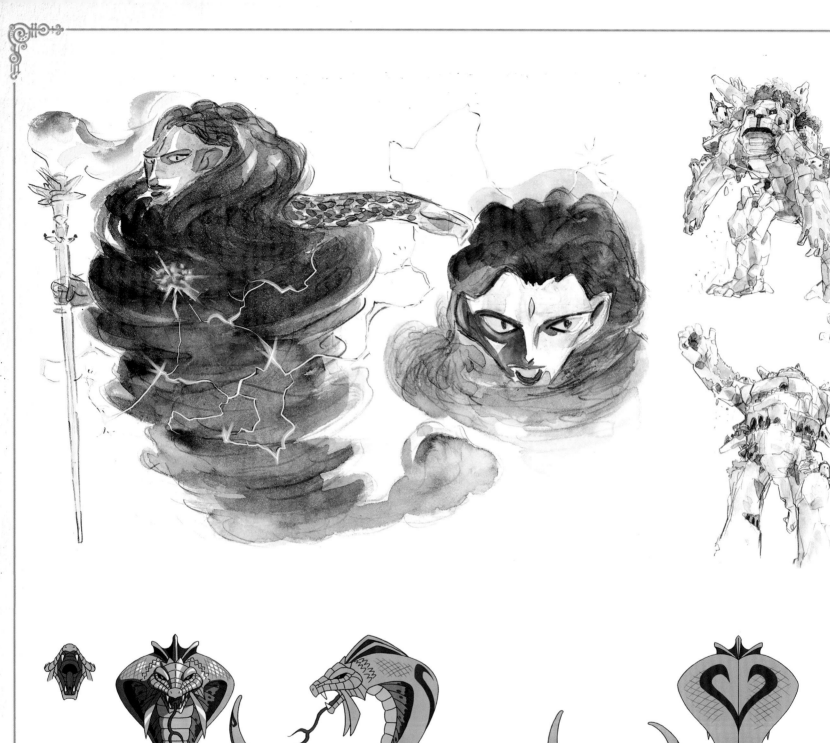
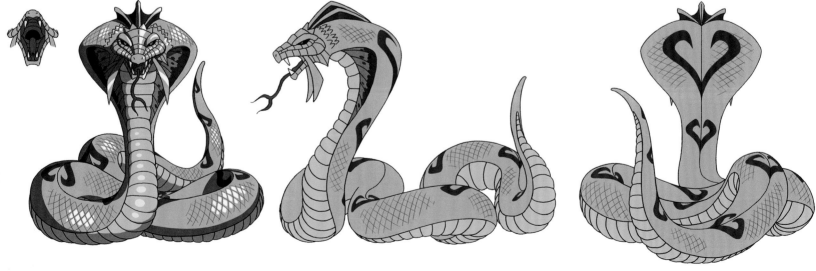

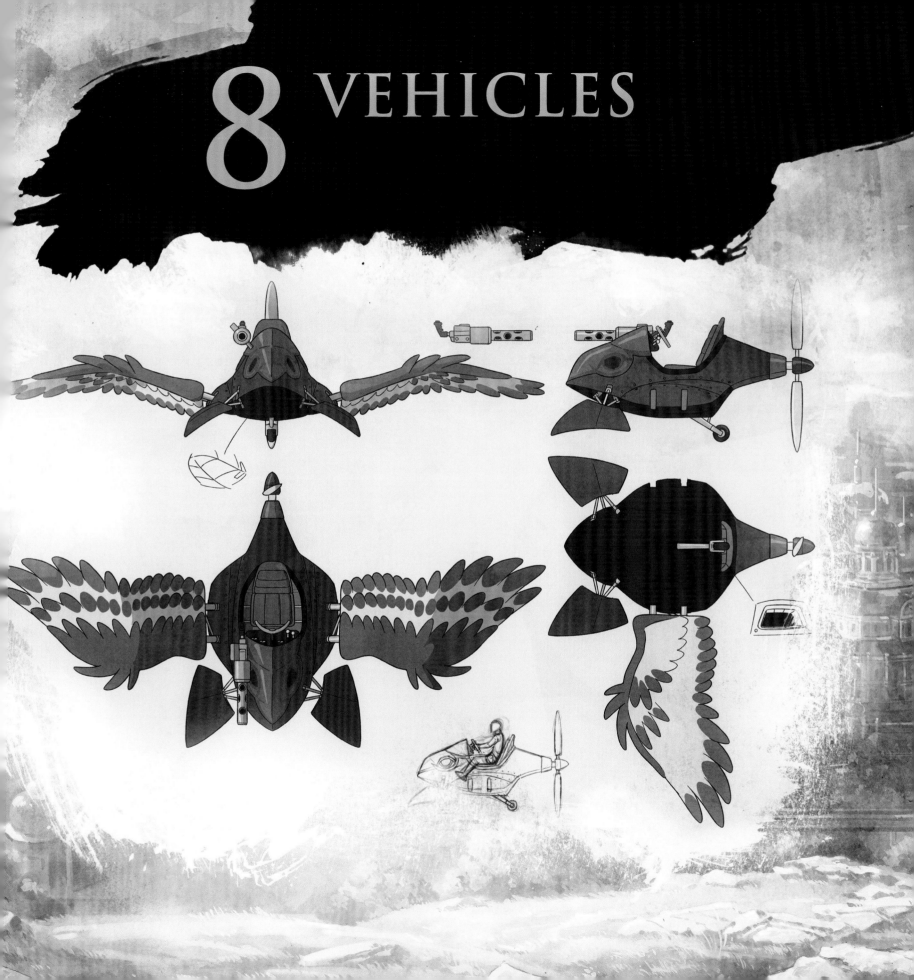

8 VEHICLES

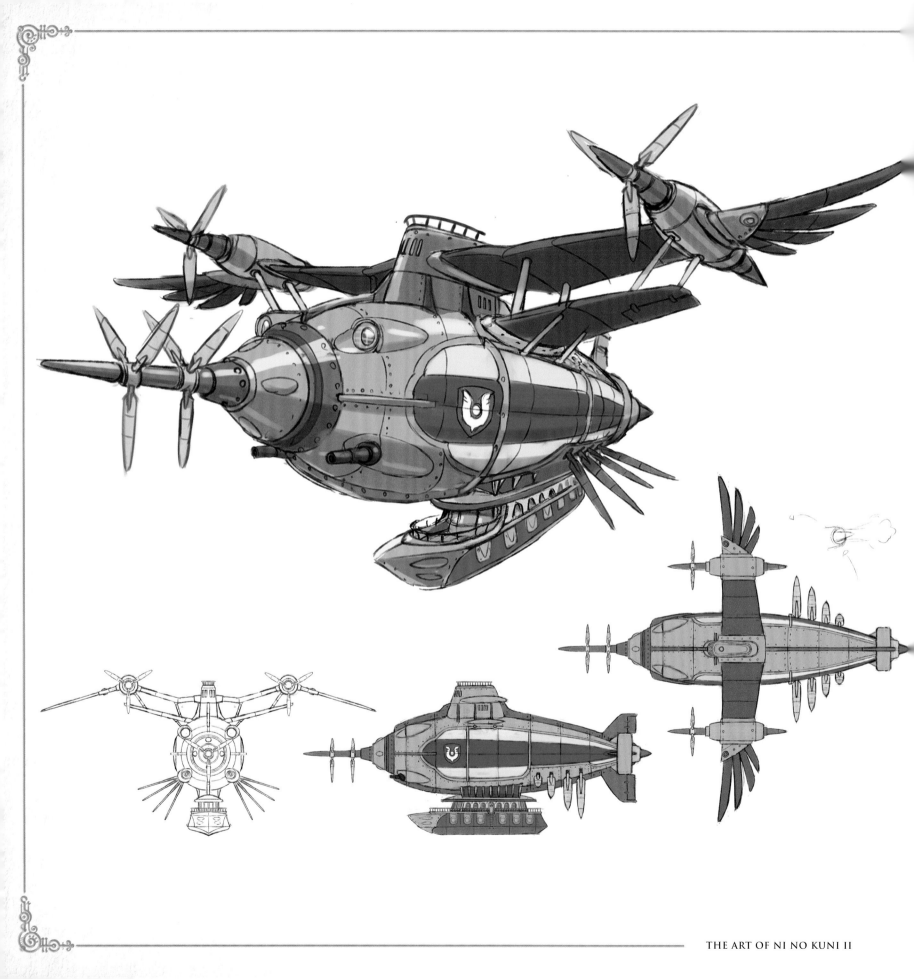

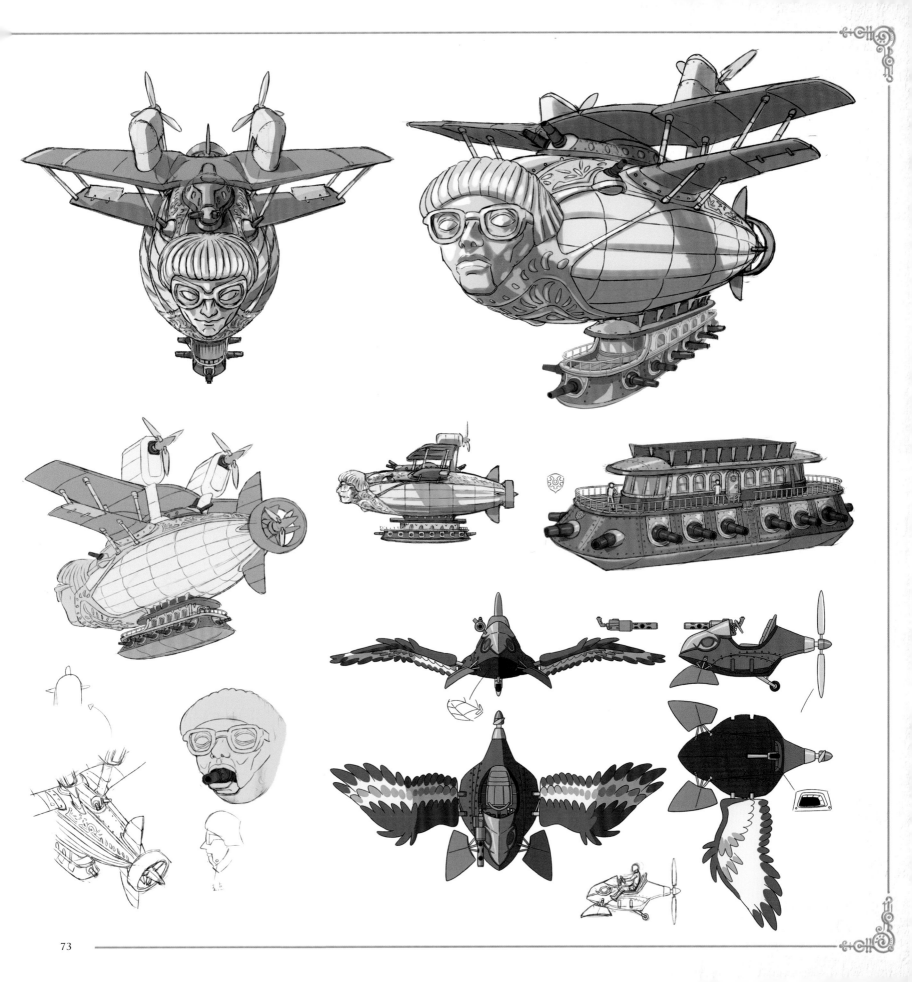

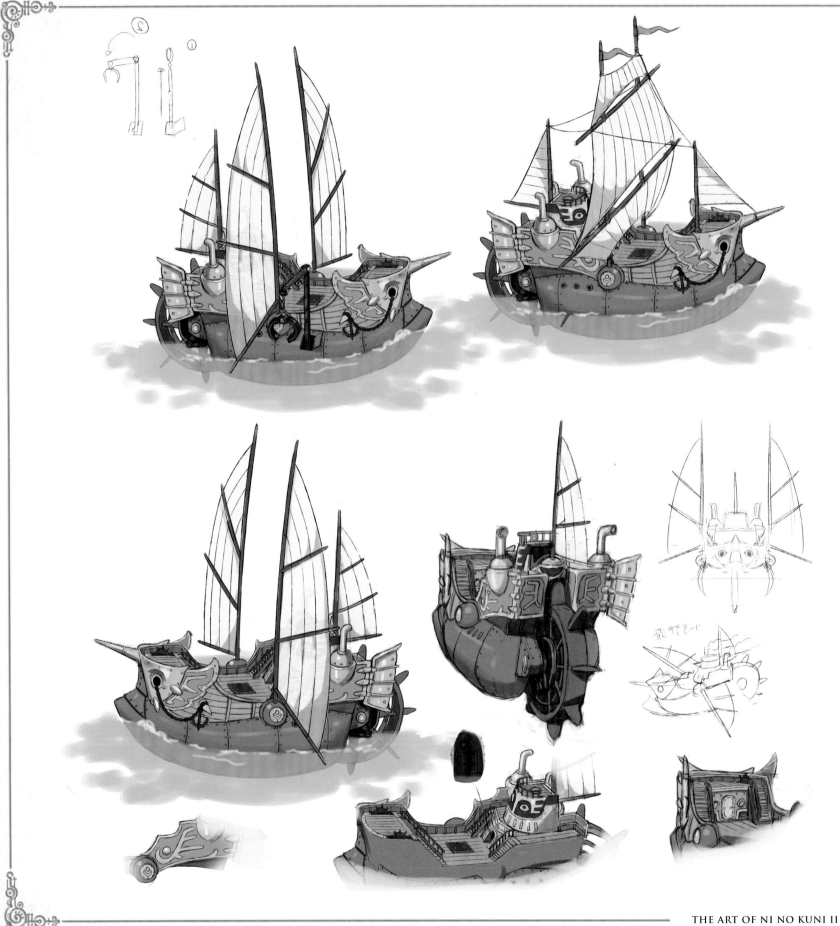

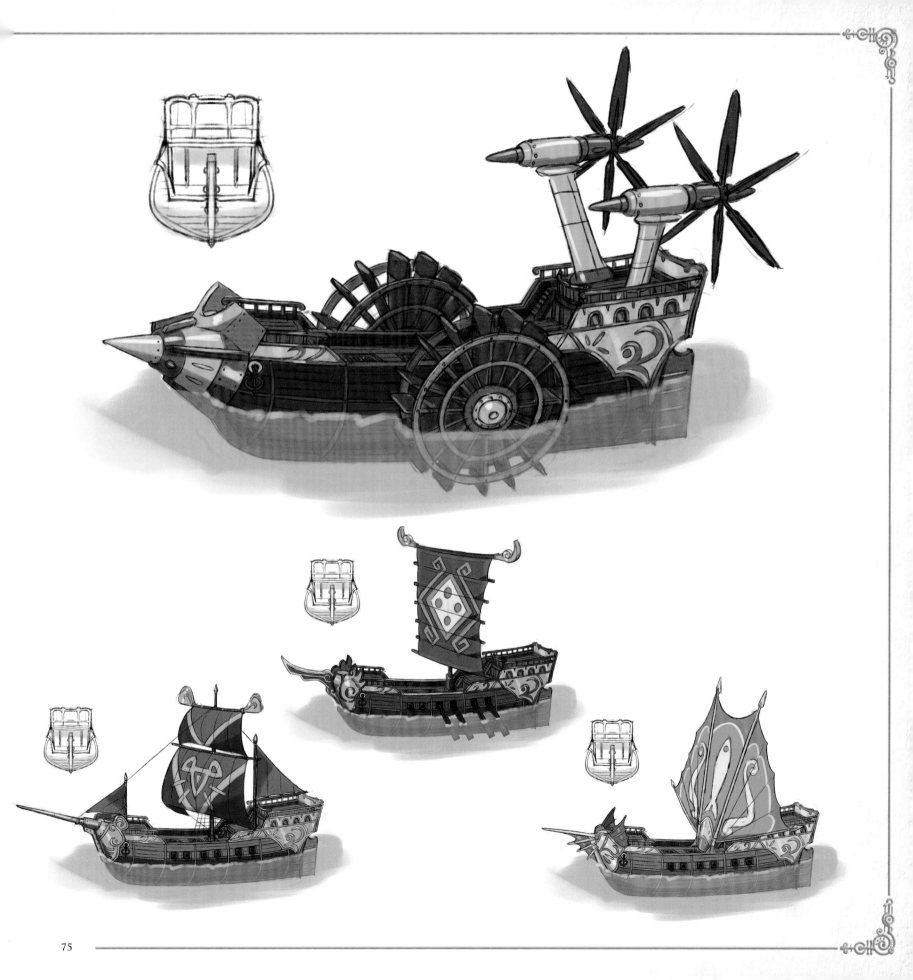

9 KINGDOMS

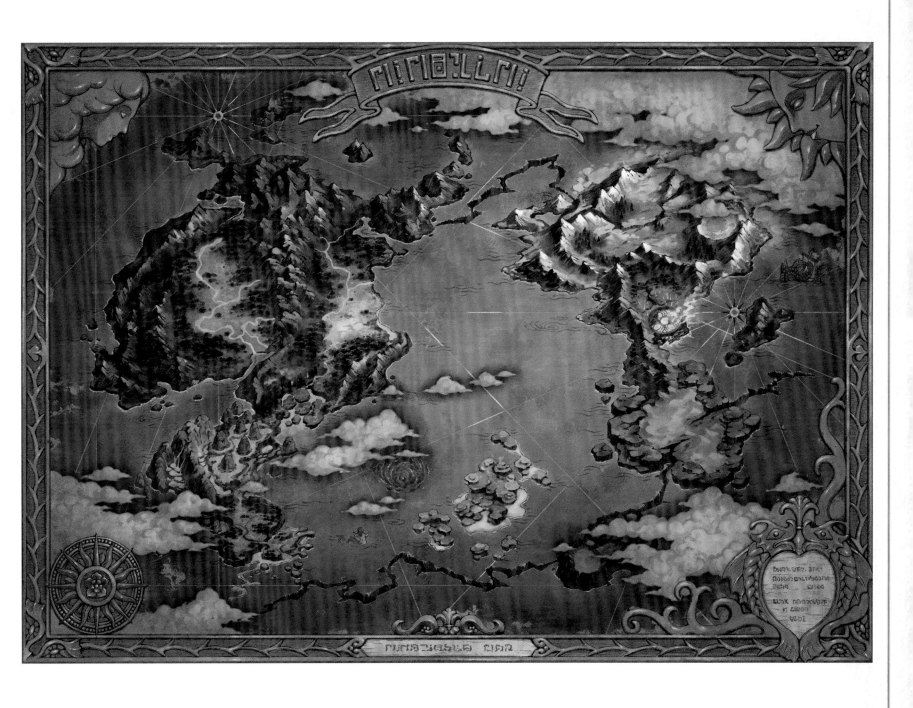

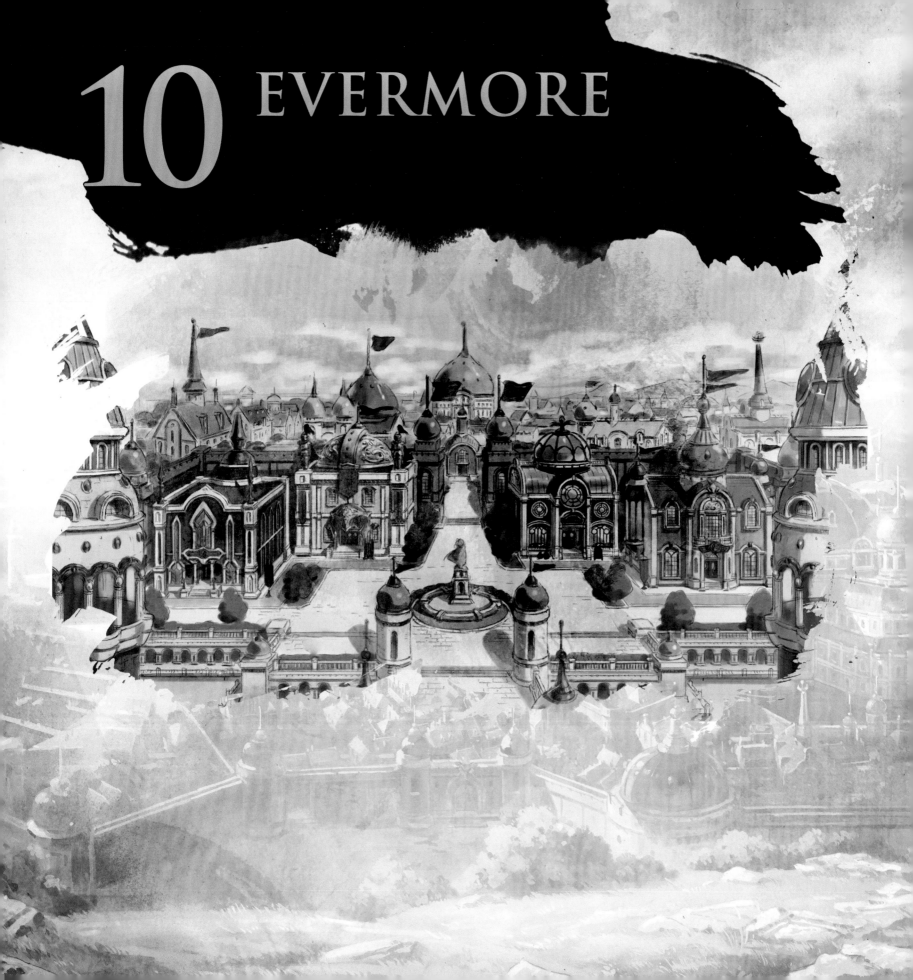

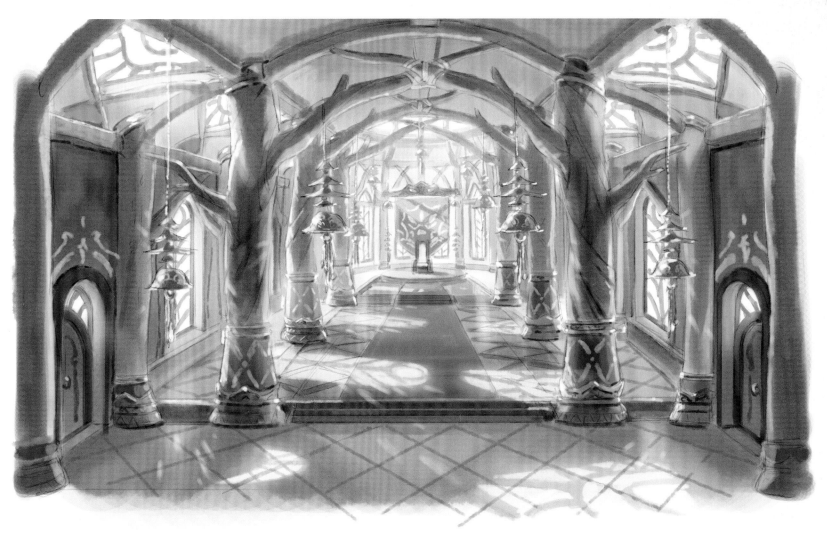

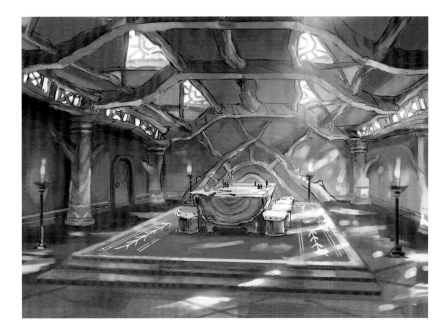

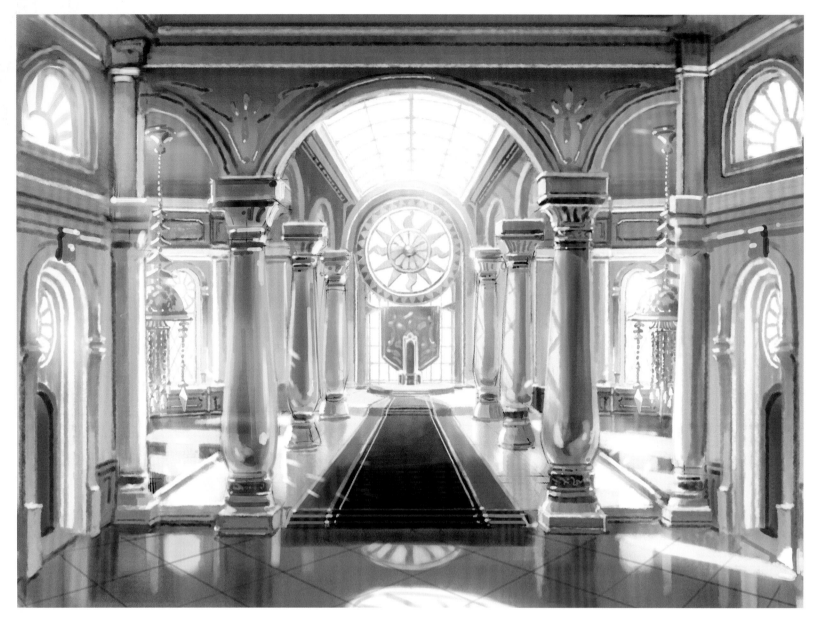

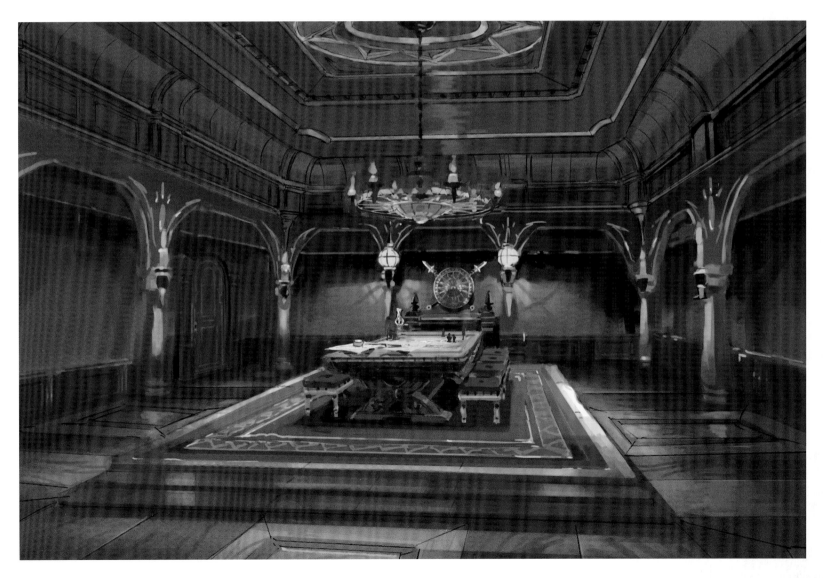

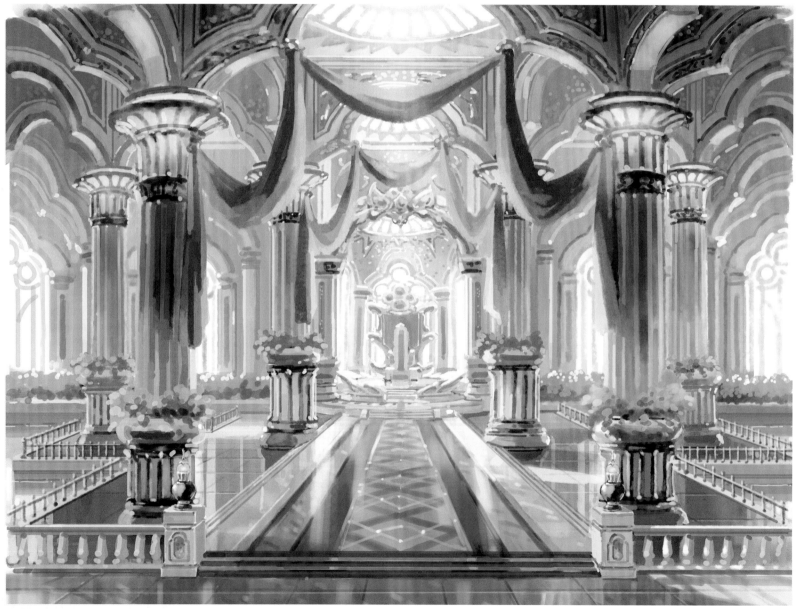

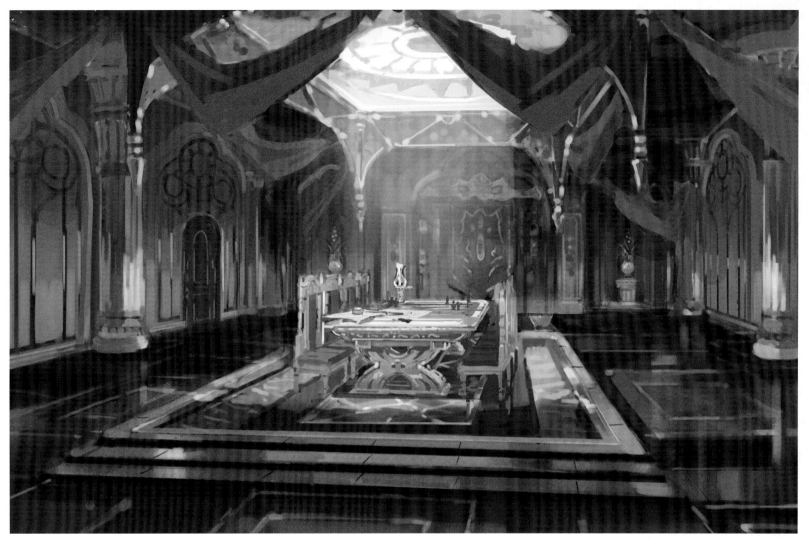

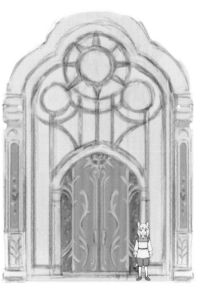

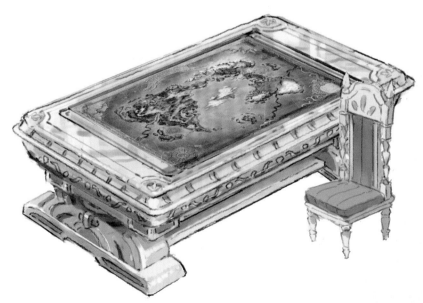

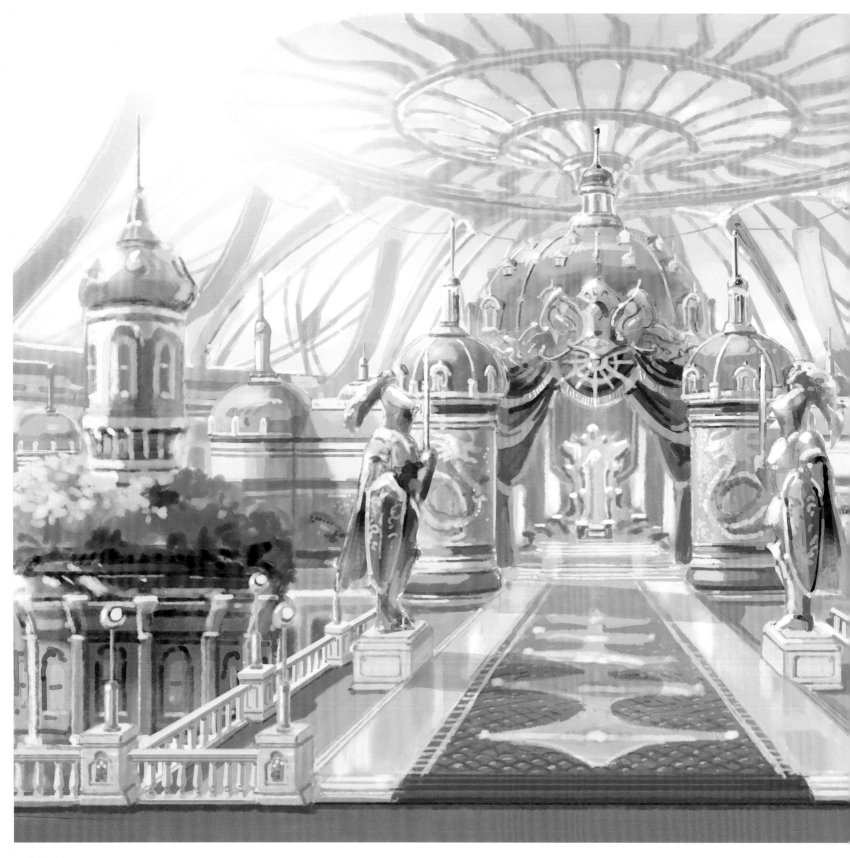

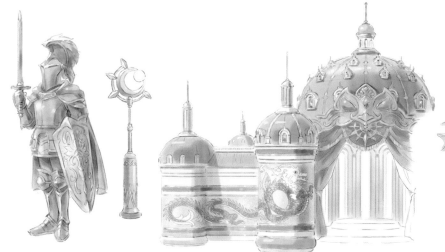

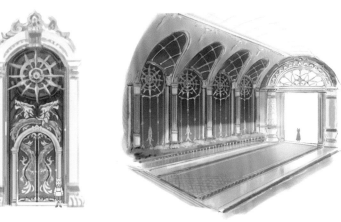

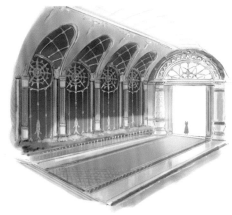

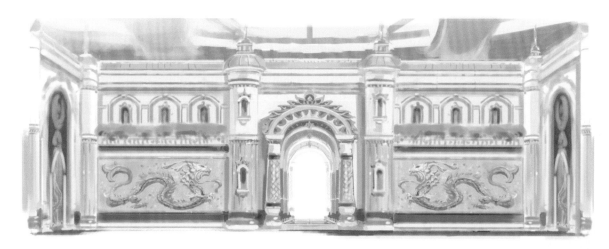

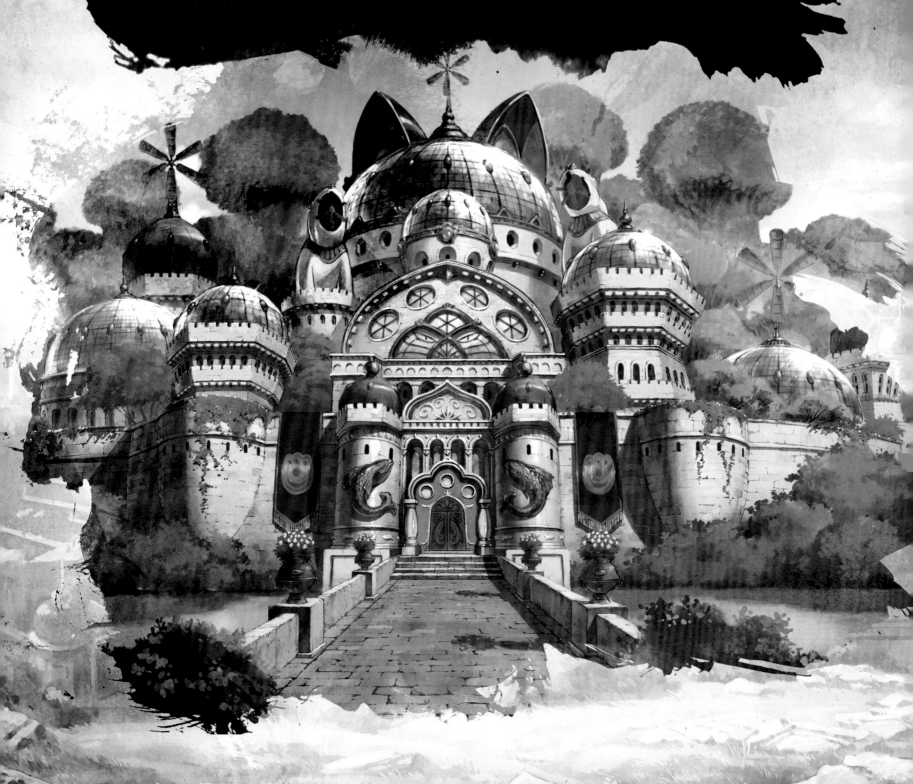

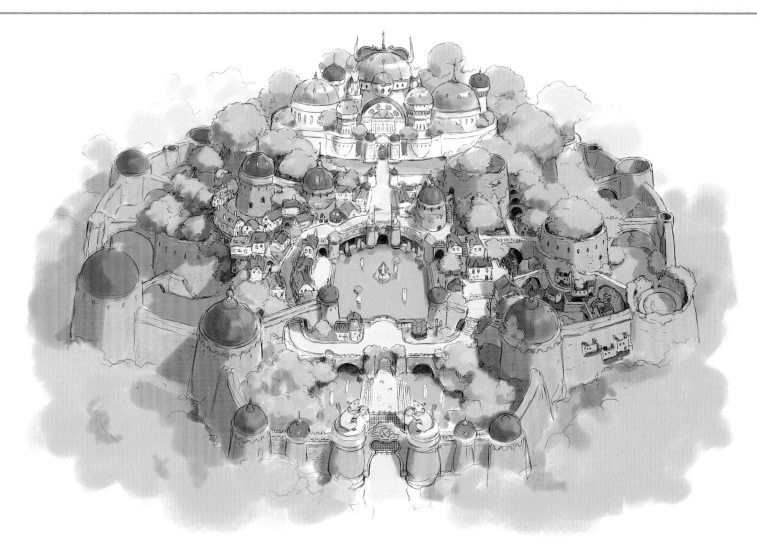

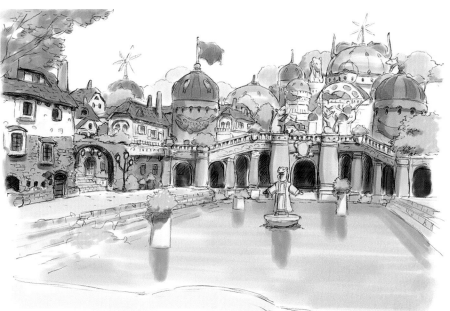

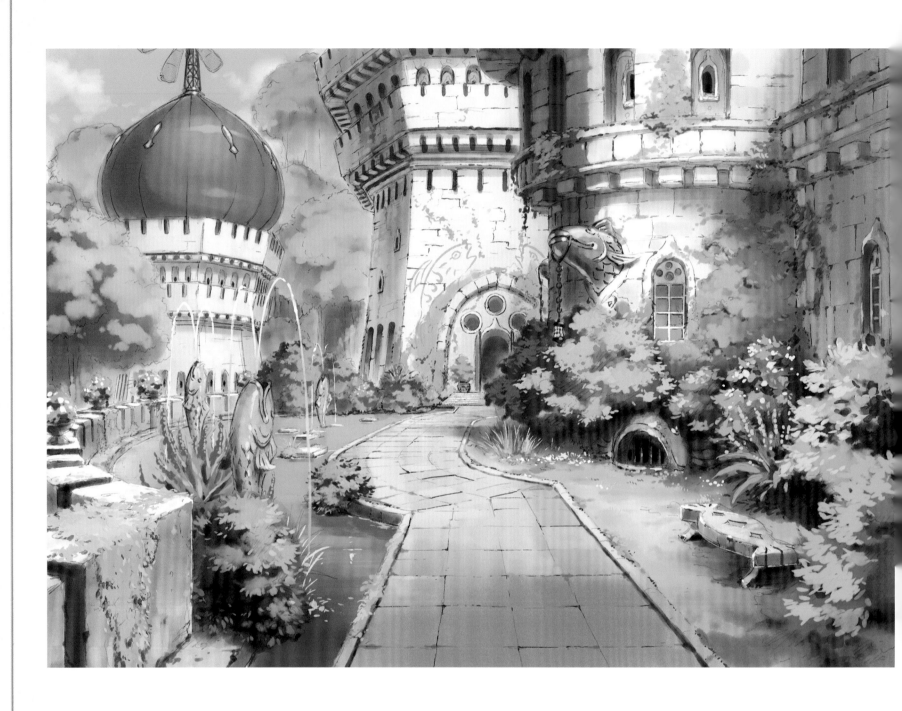

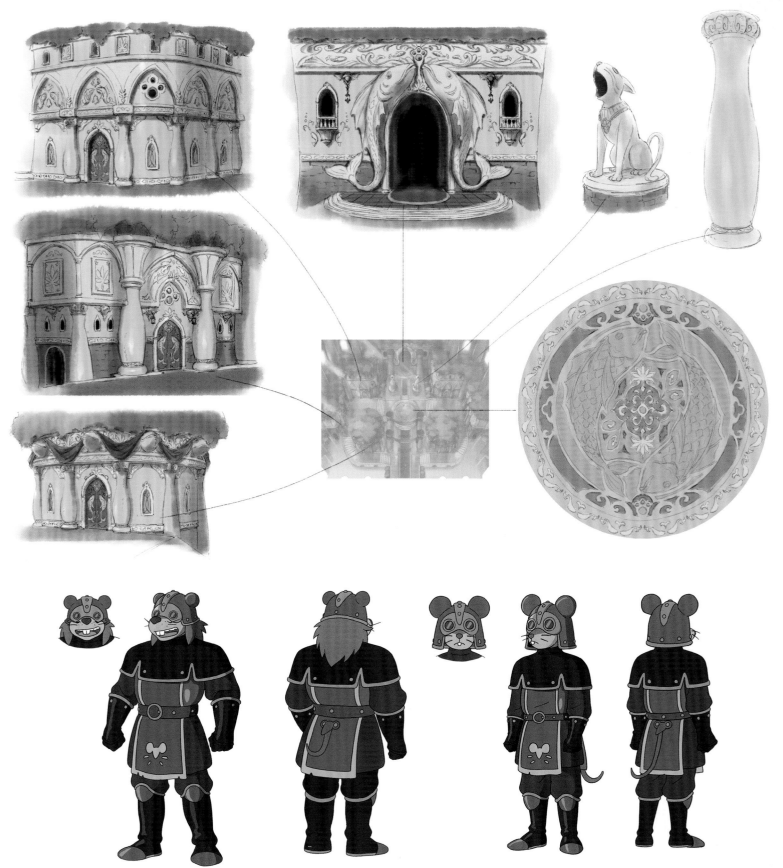

OTTO MASINGER

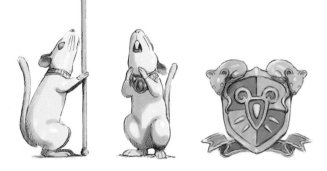

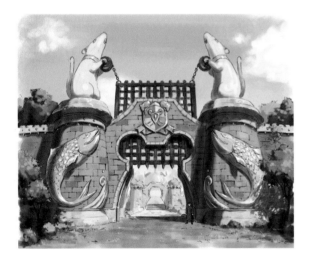

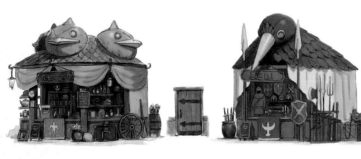

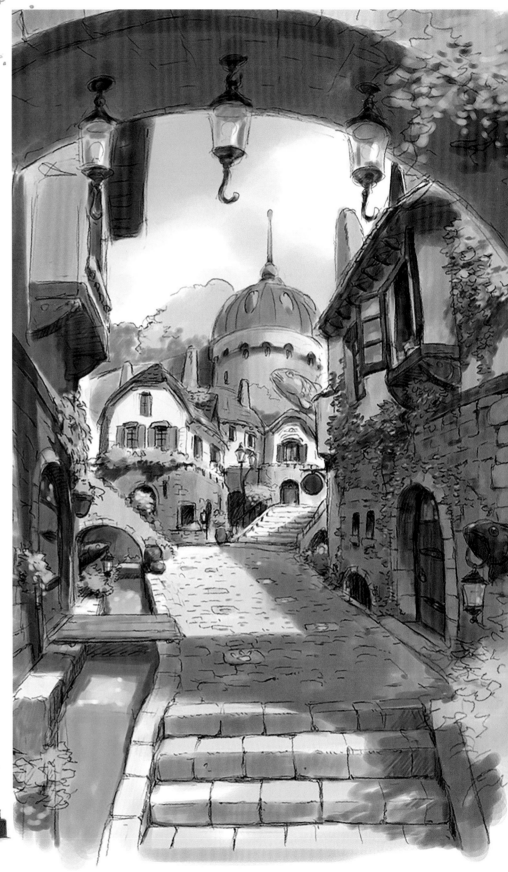

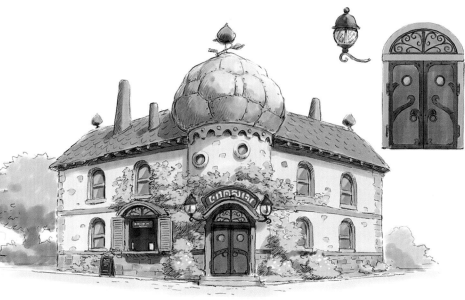

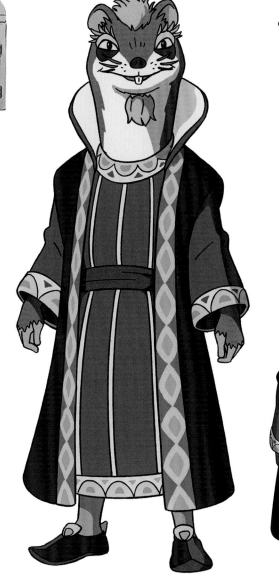

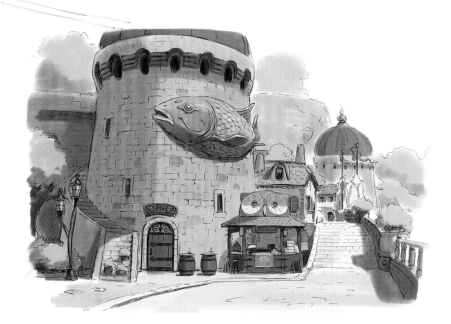

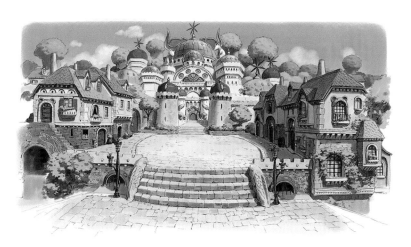

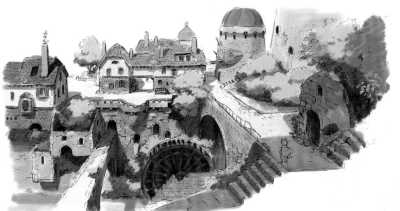

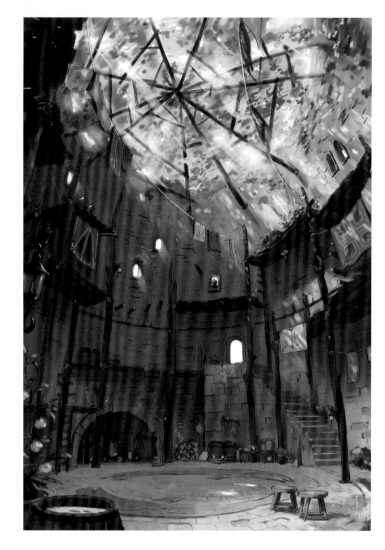

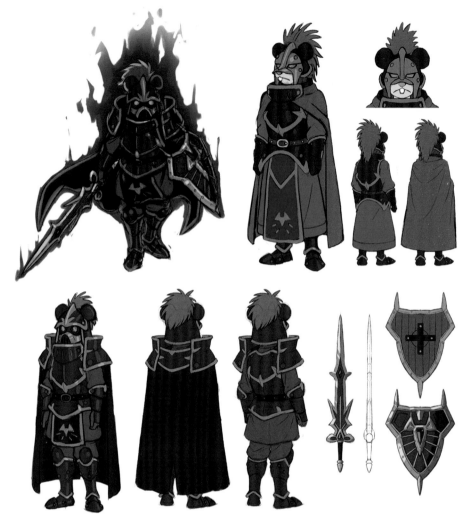

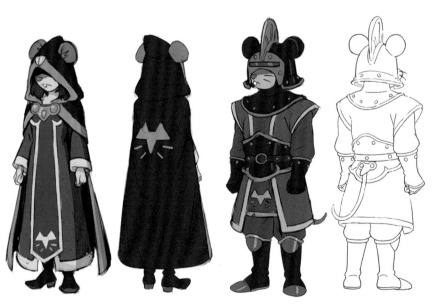

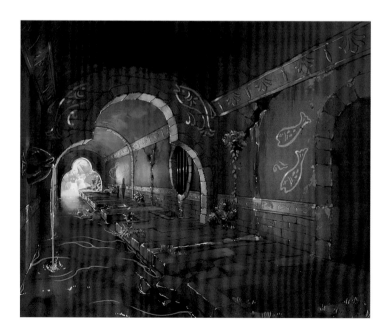

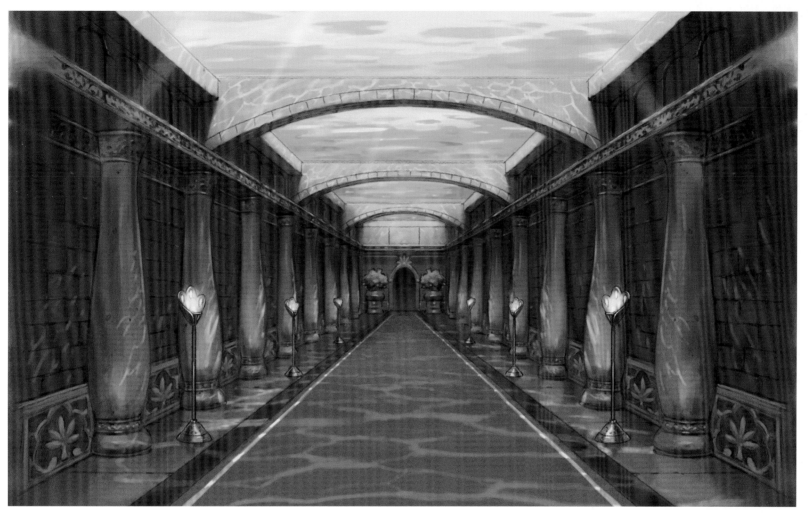

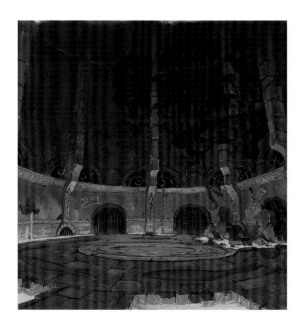

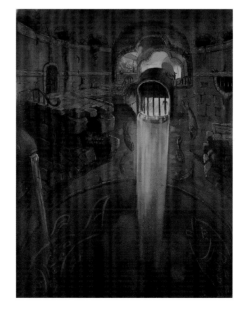

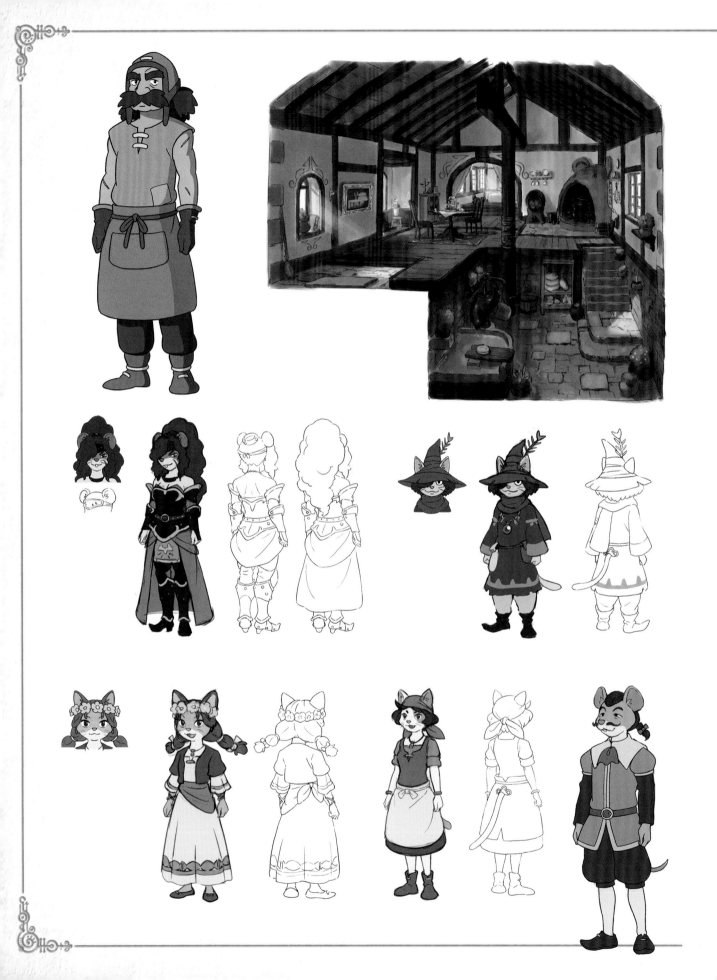

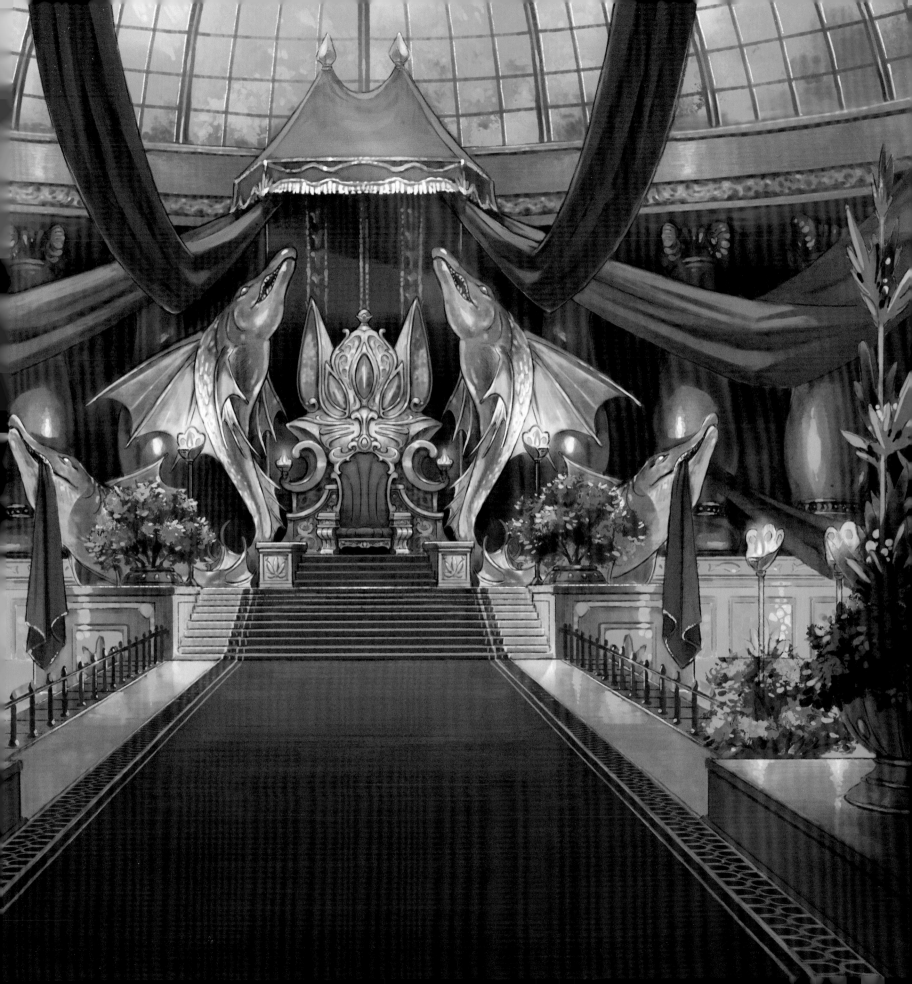

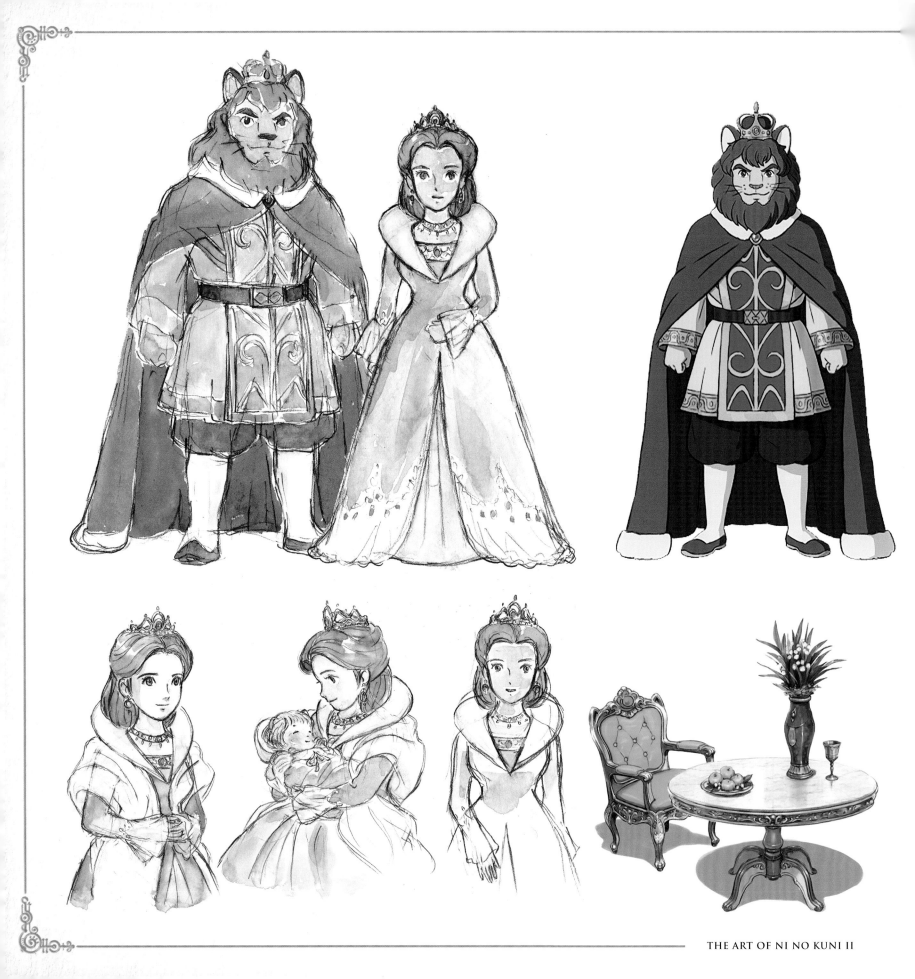

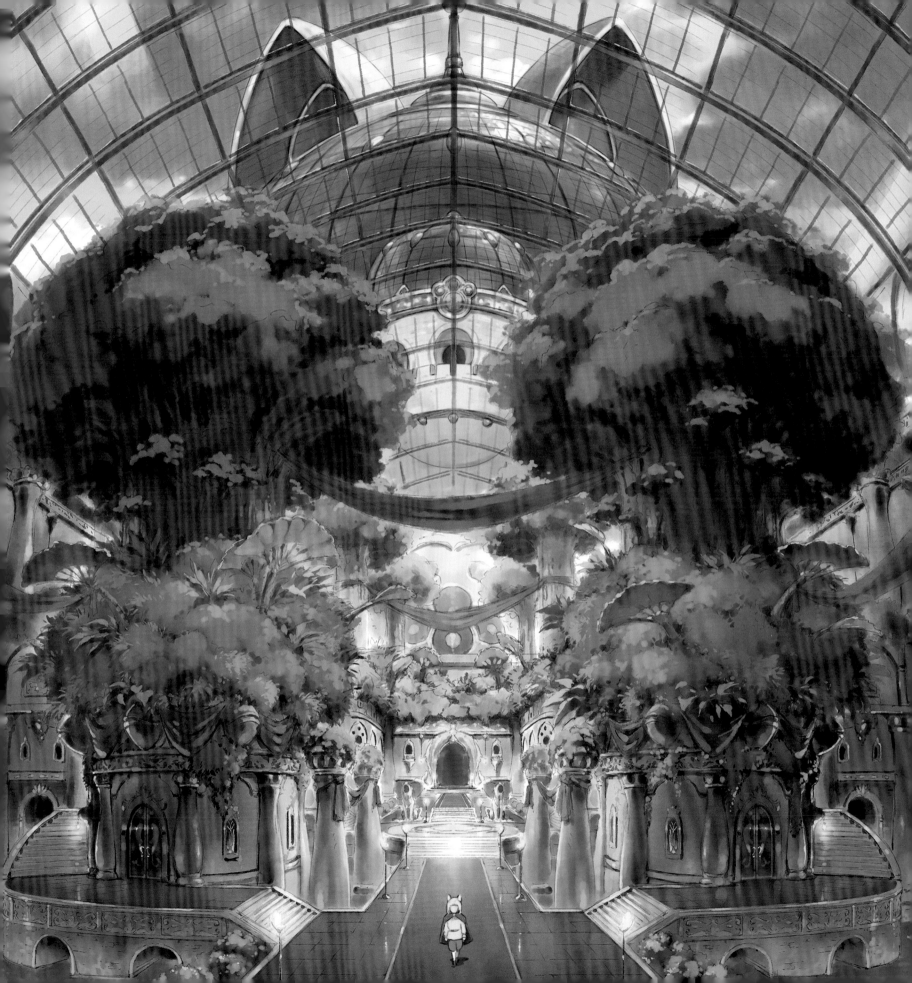

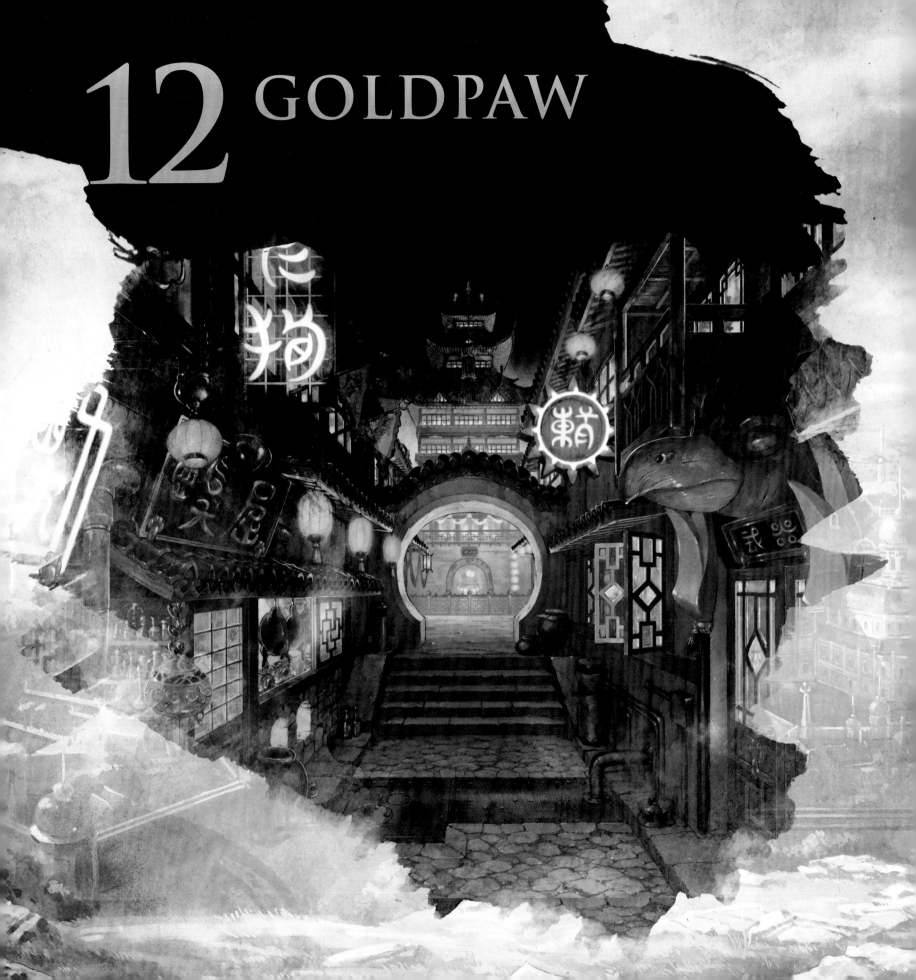

12 GOLDPAW

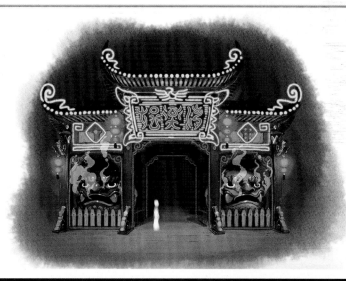

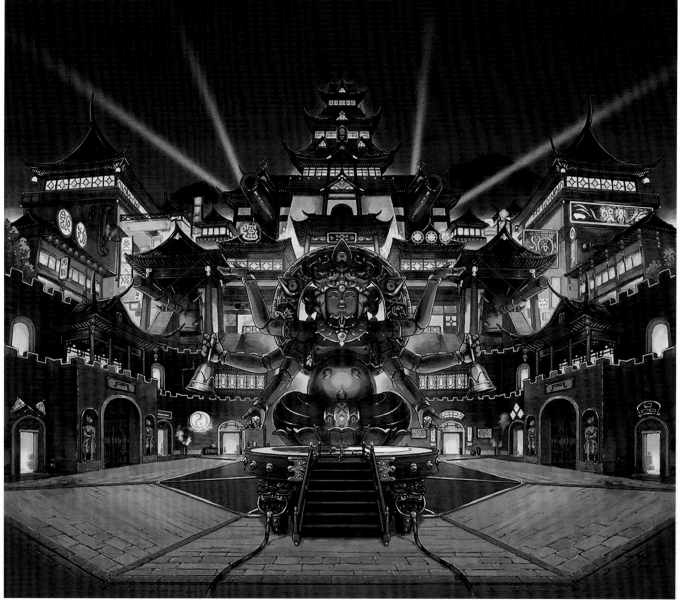

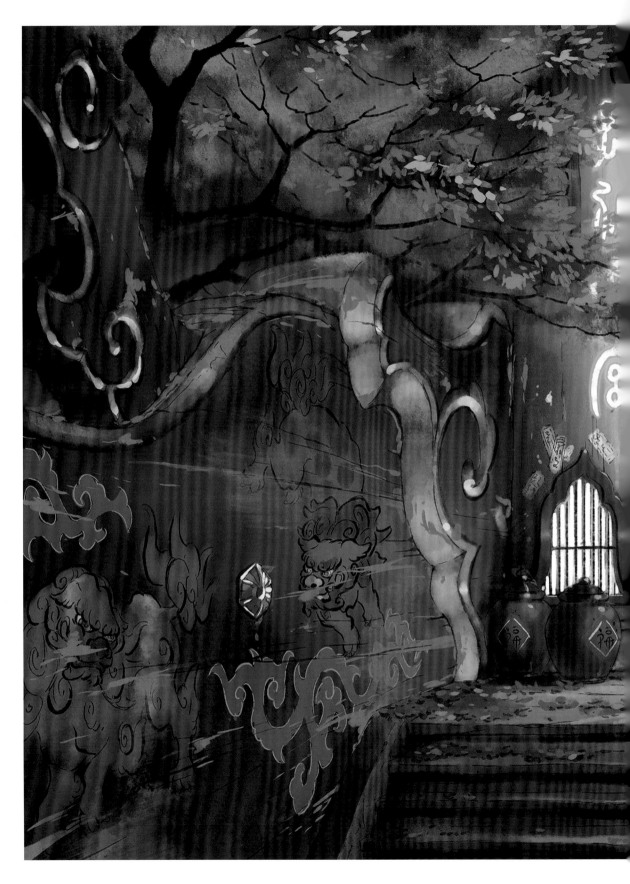

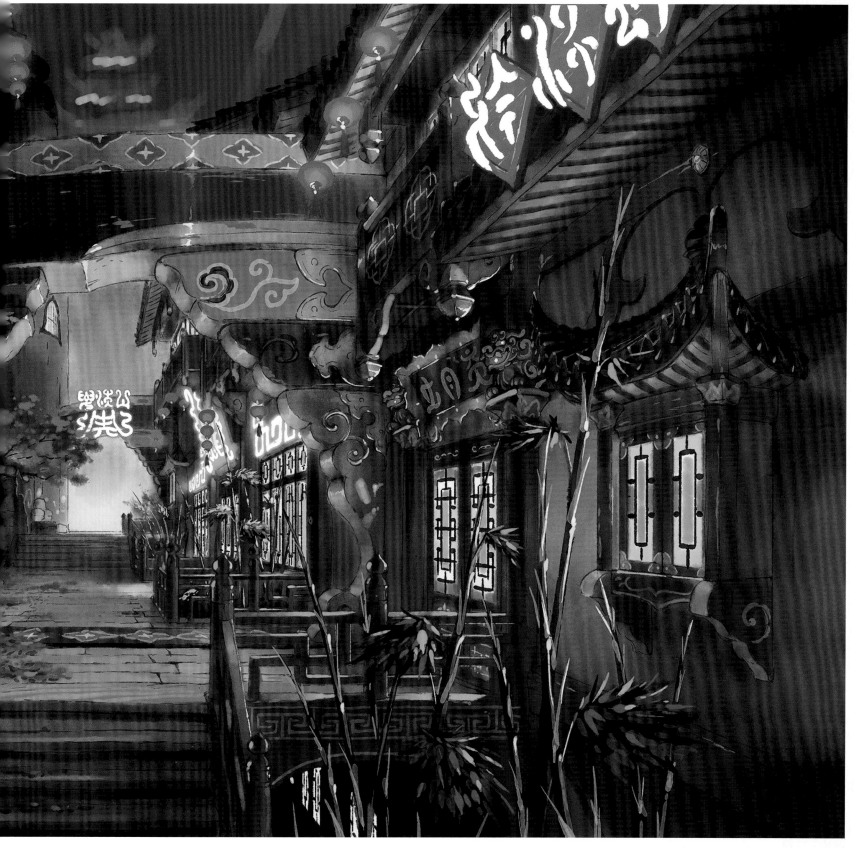

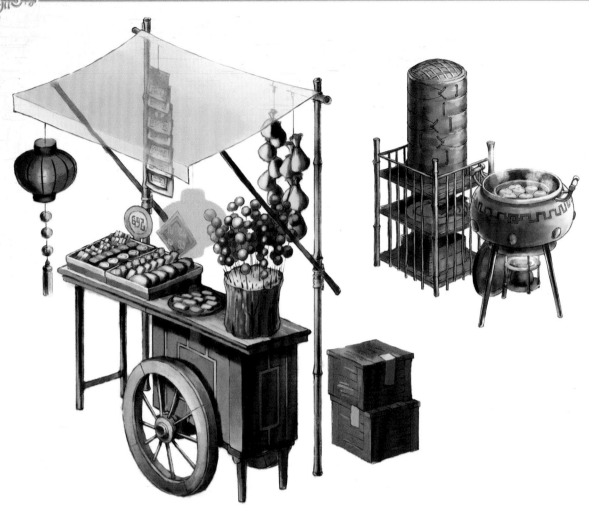

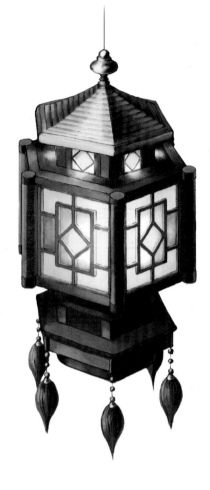

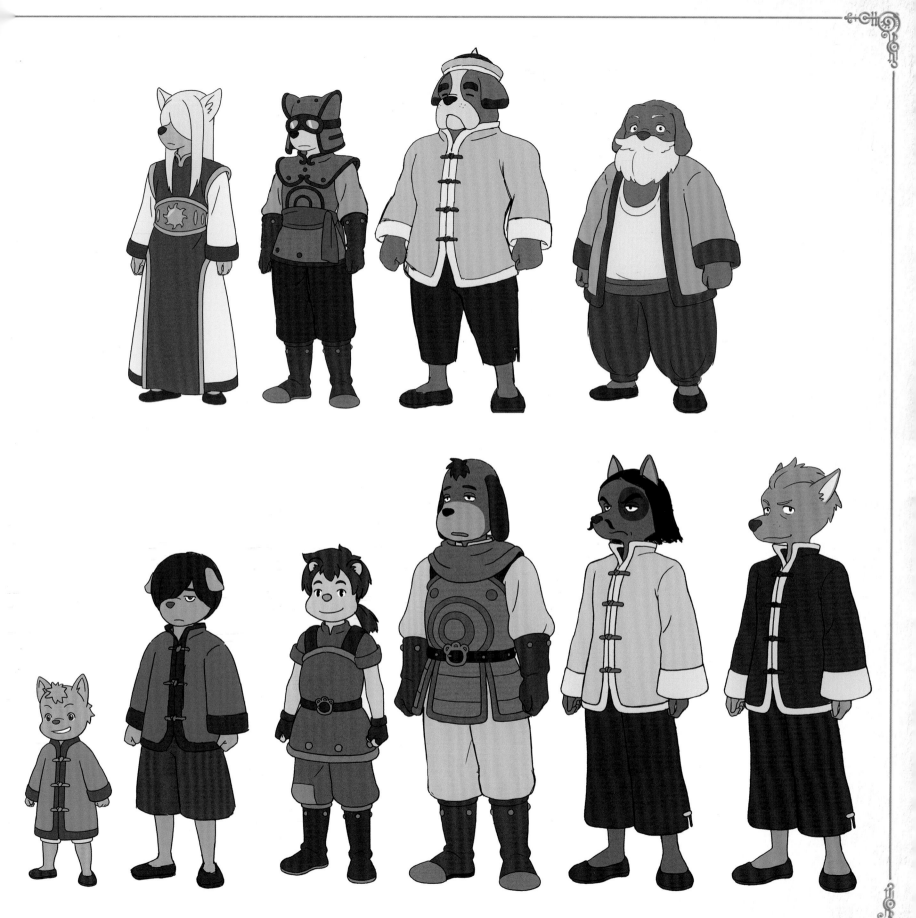

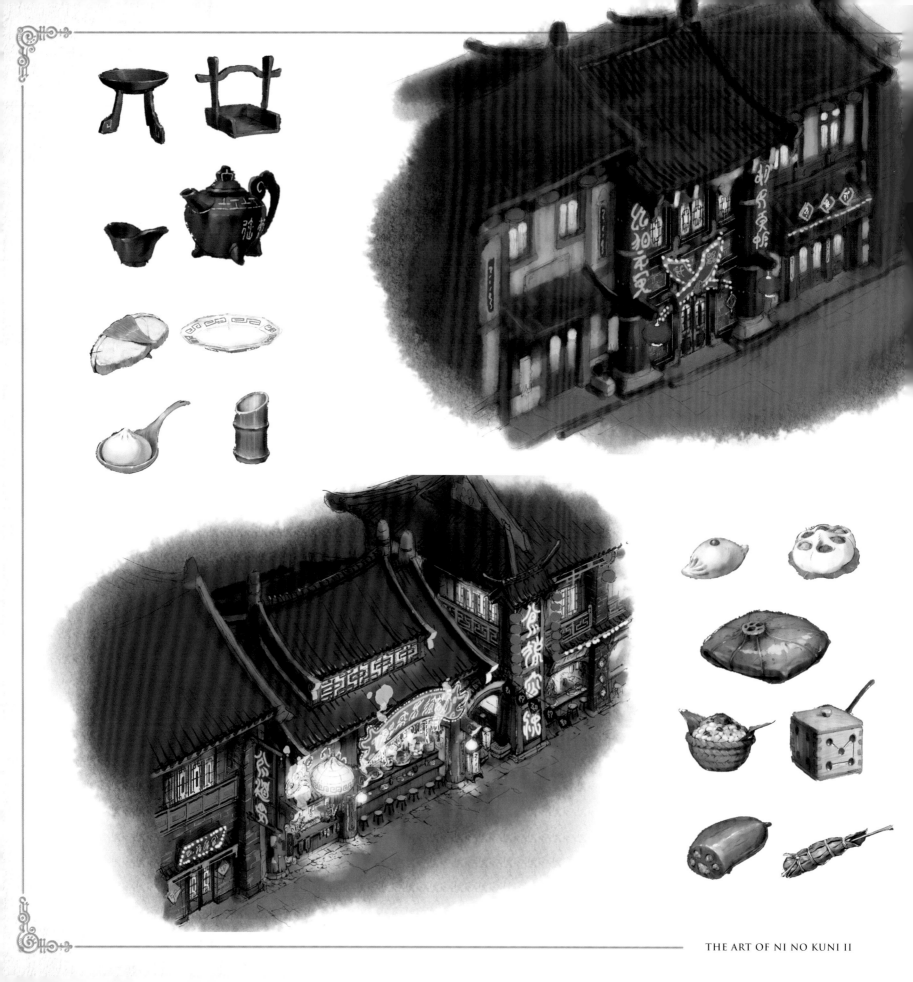

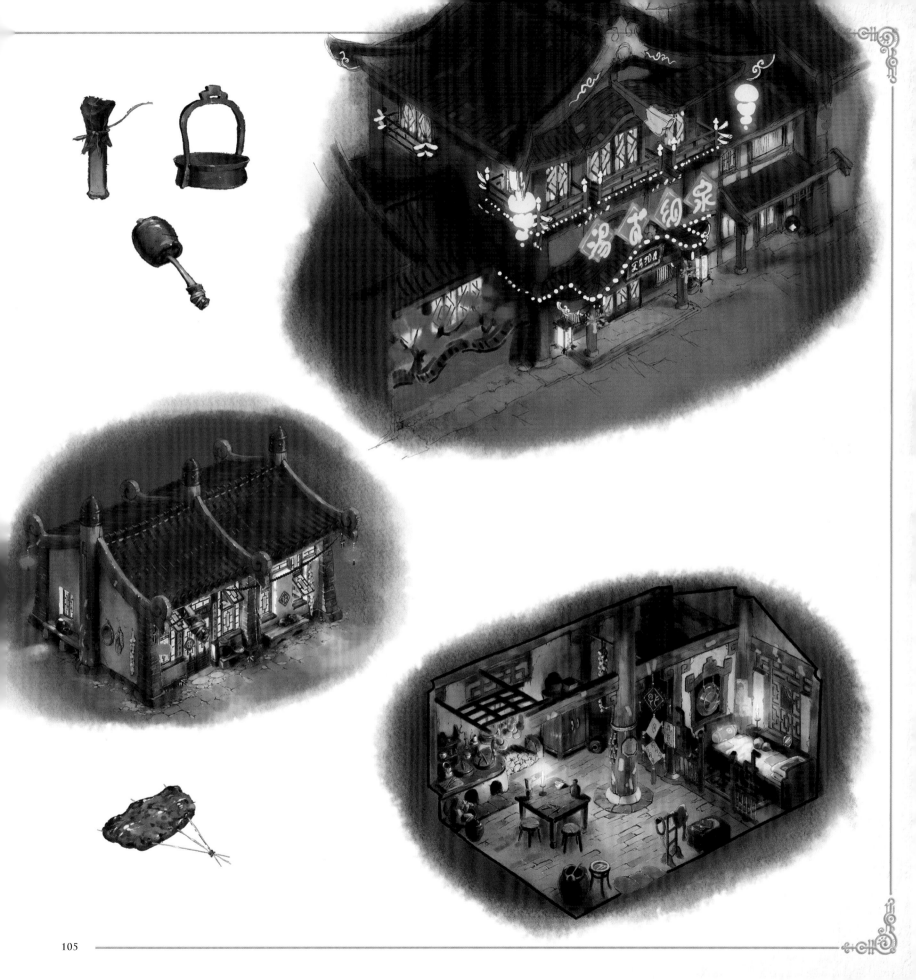

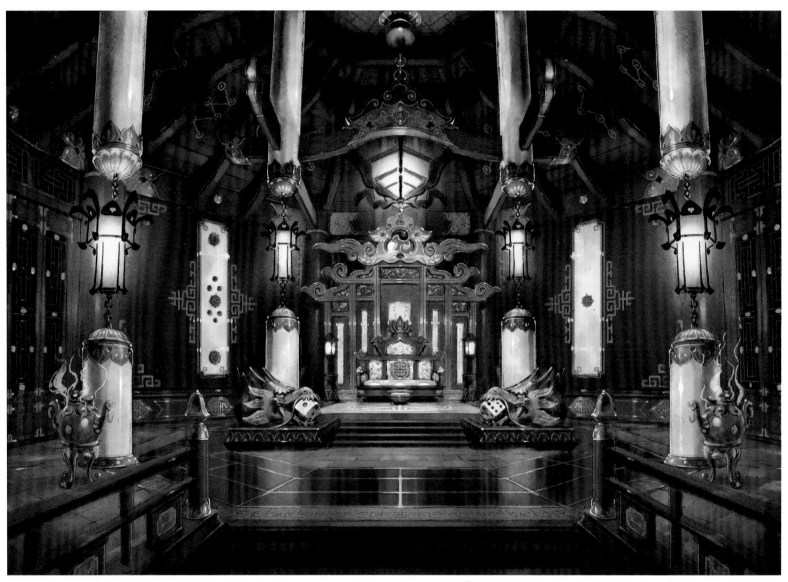

PUGNACIOUS

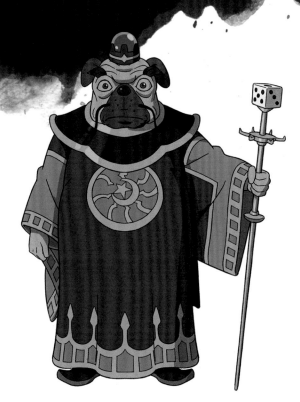

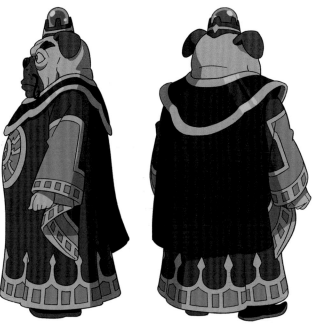

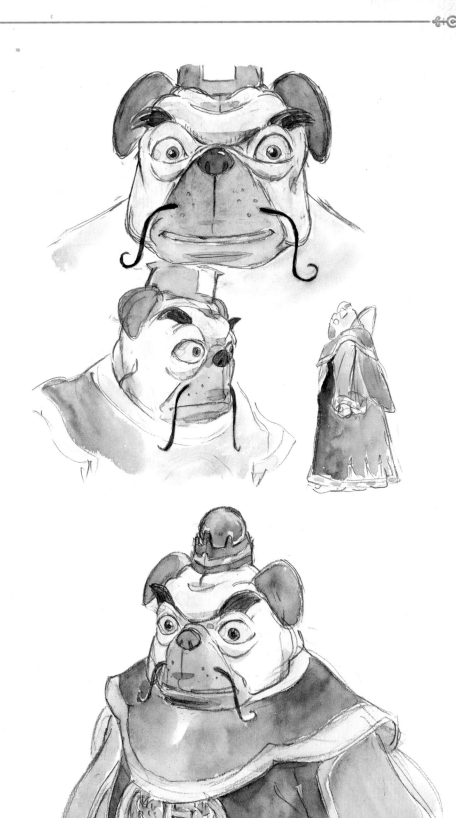

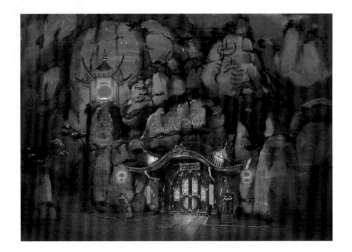

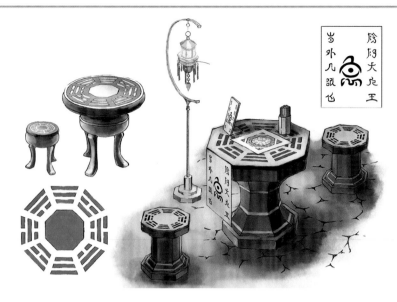

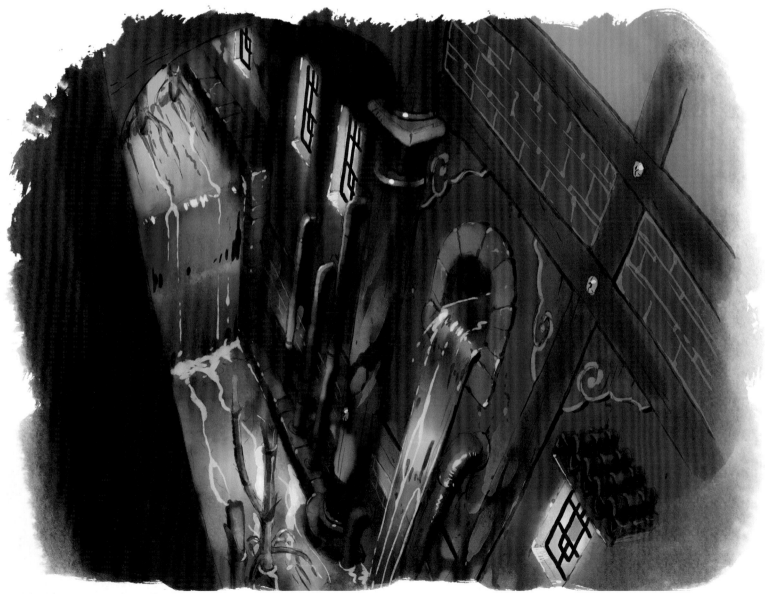

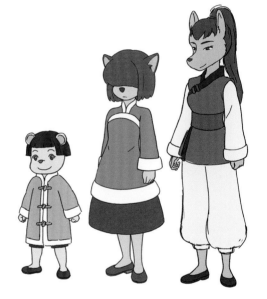
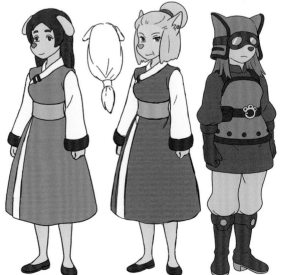
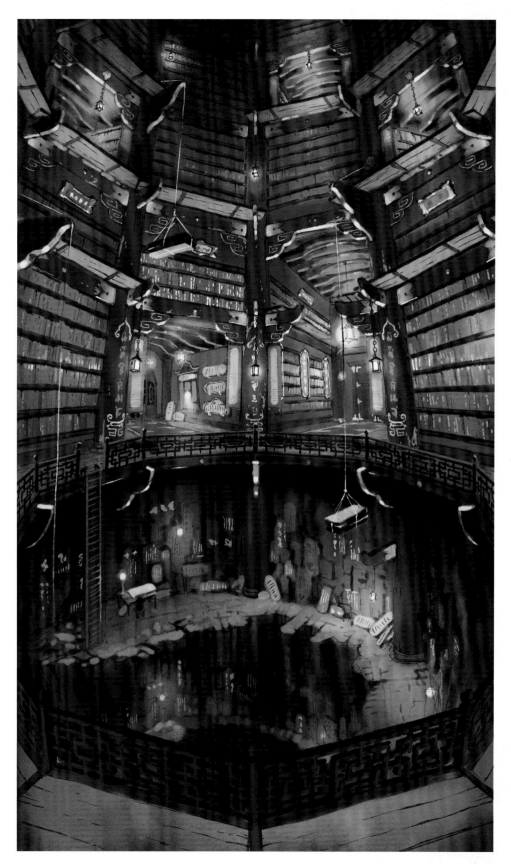

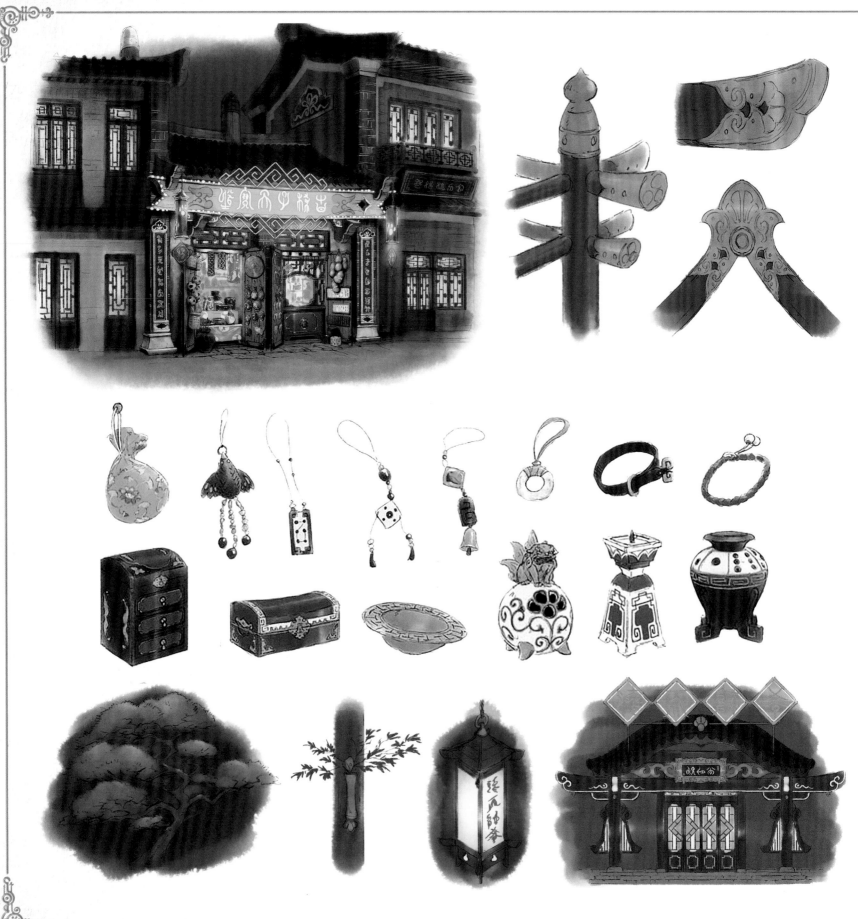

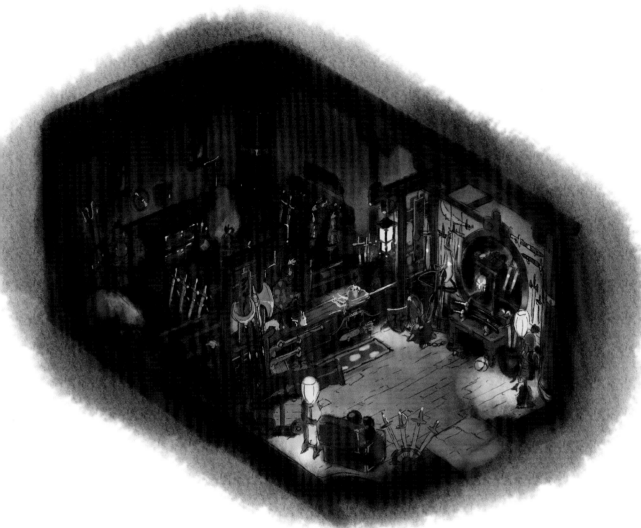

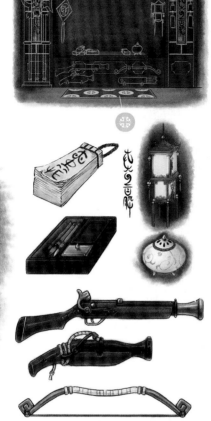

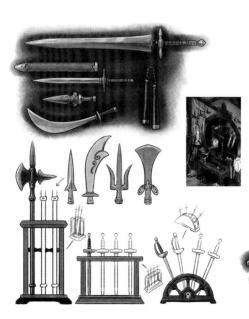

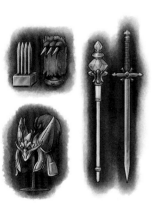

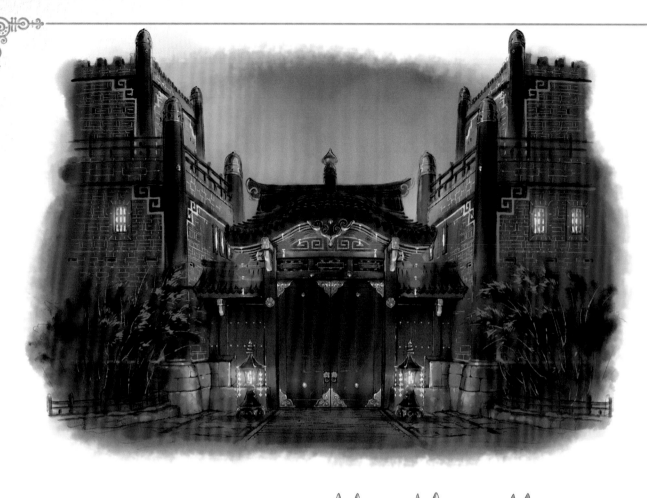

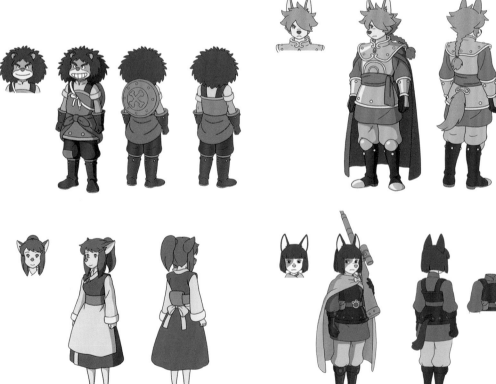

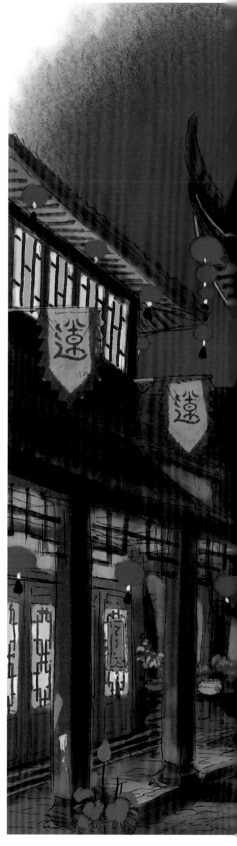

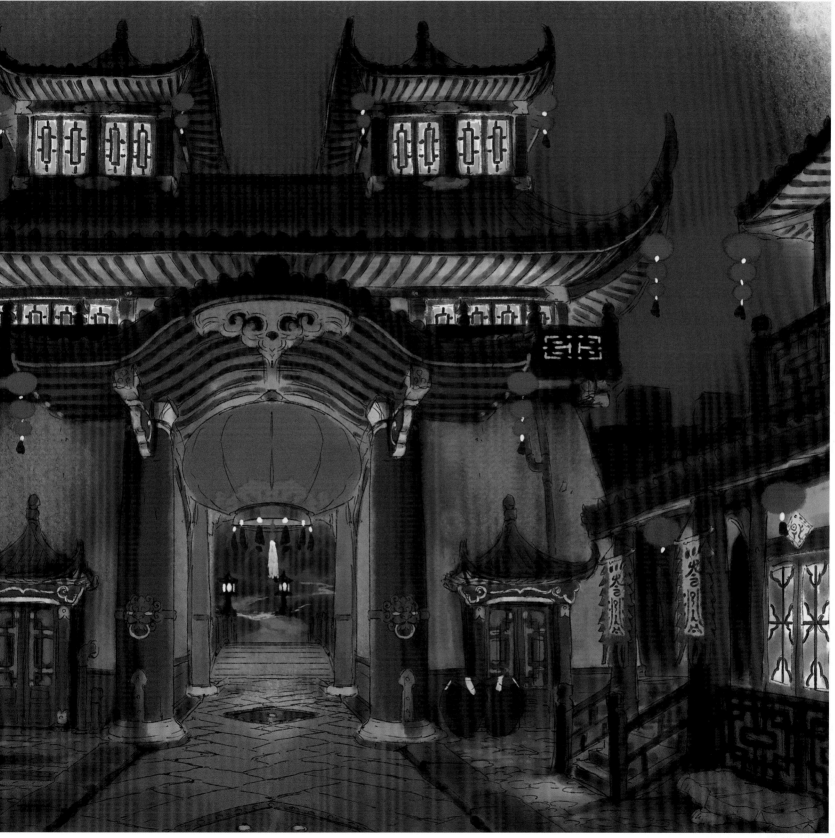

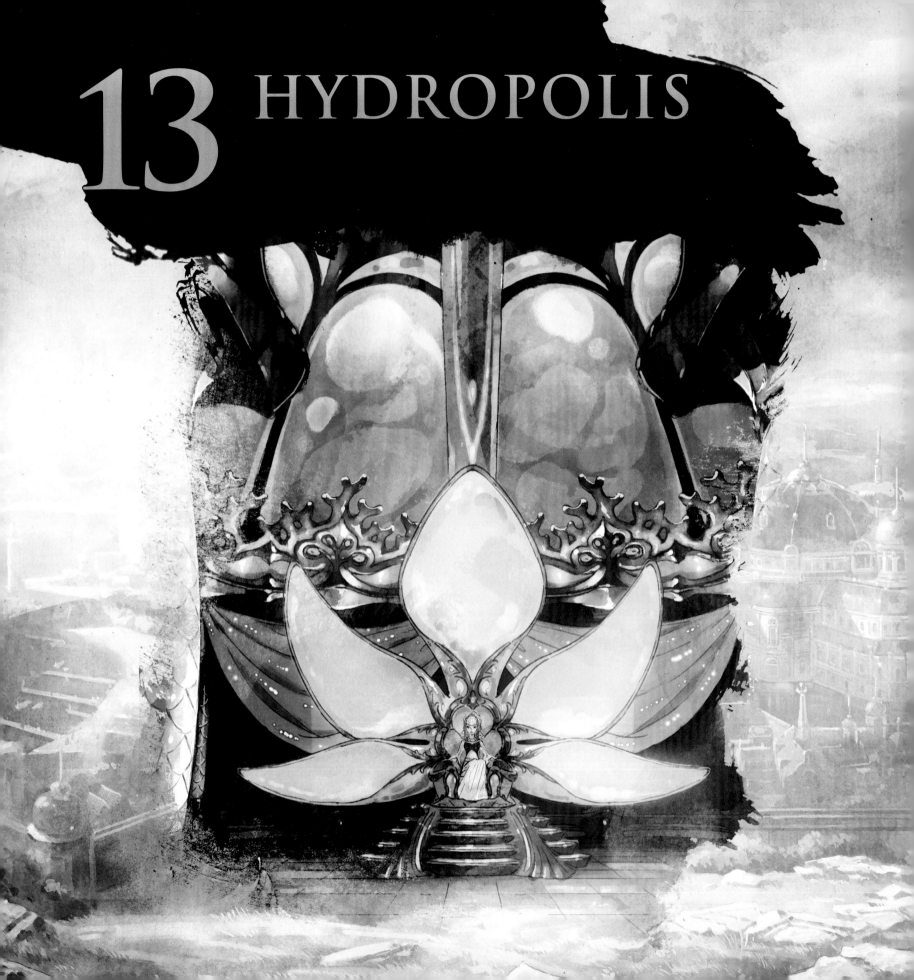

13 HYDROPOLIS

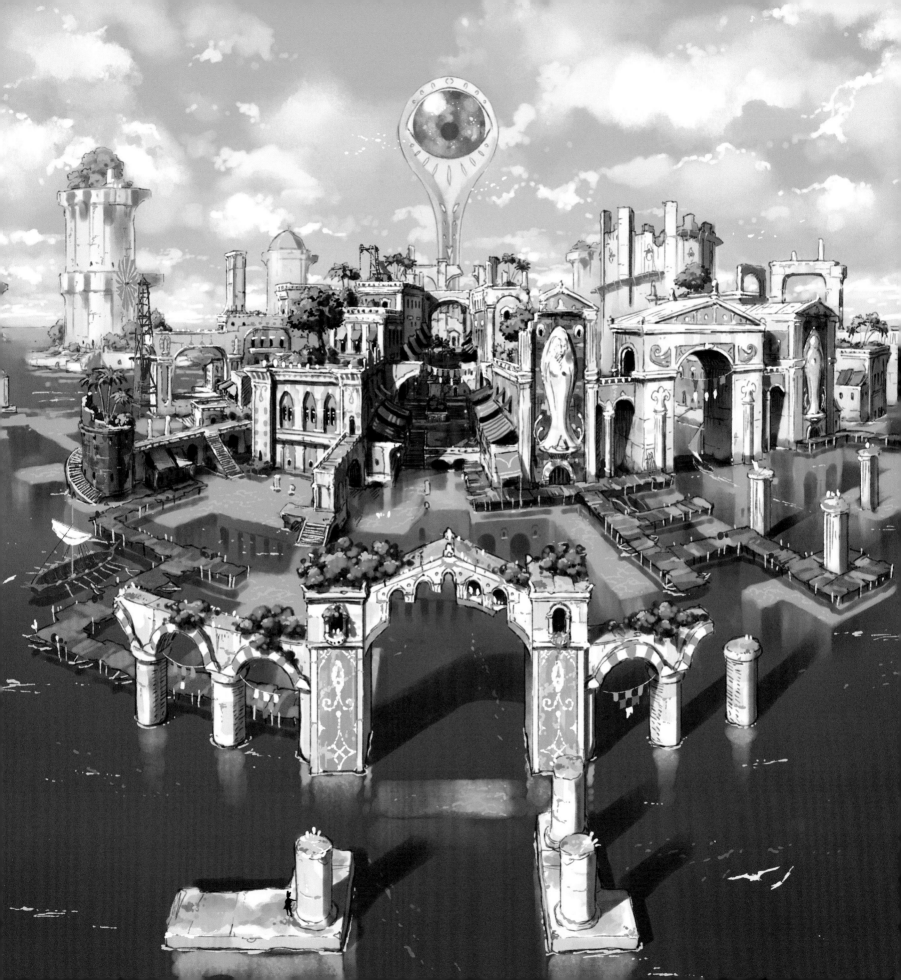

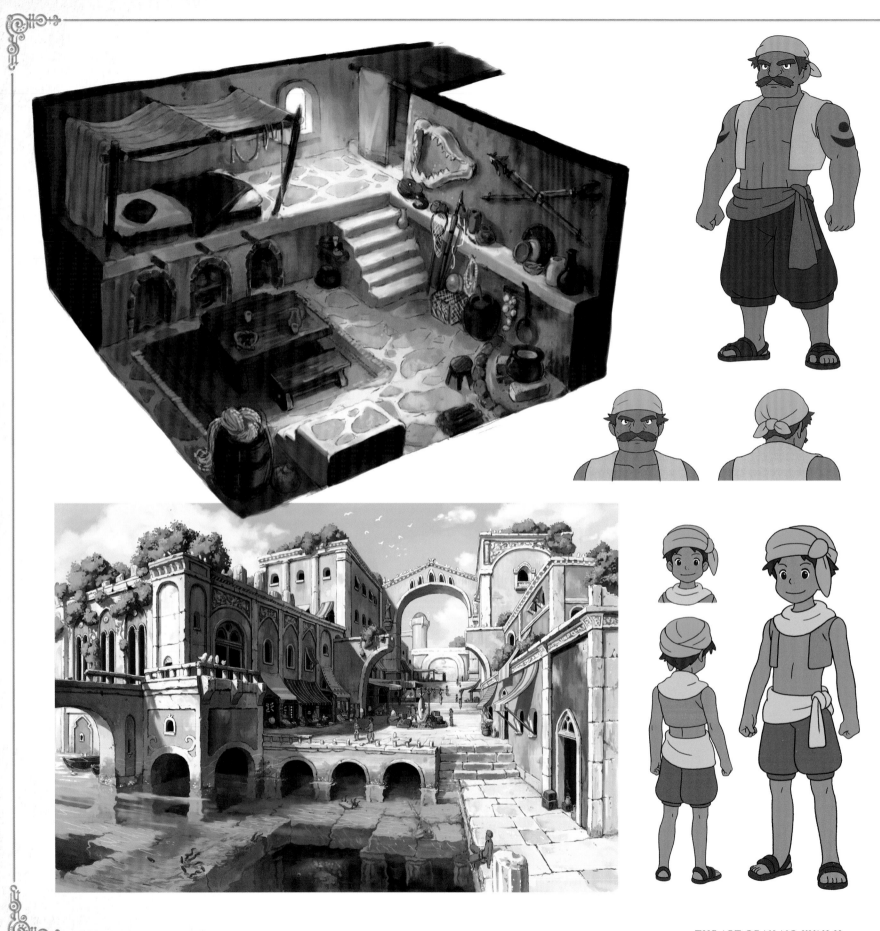

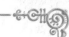

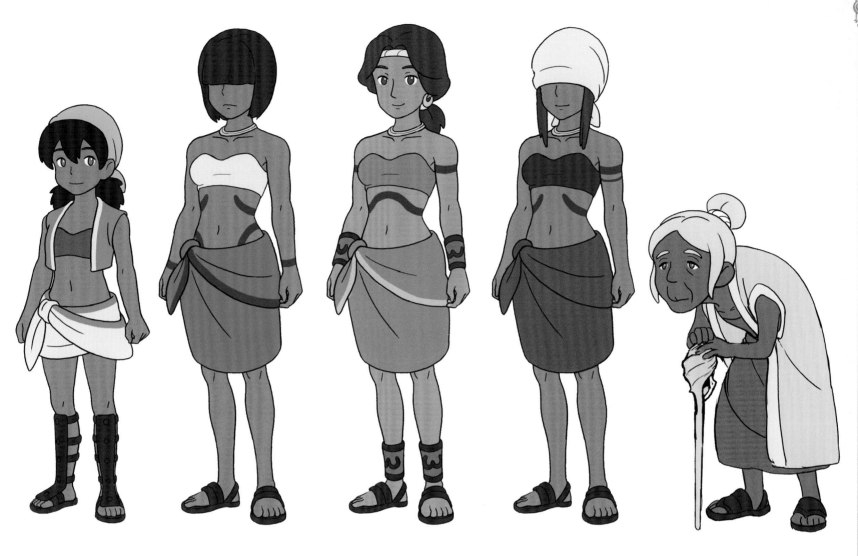

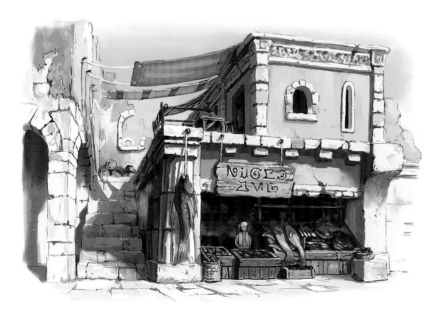

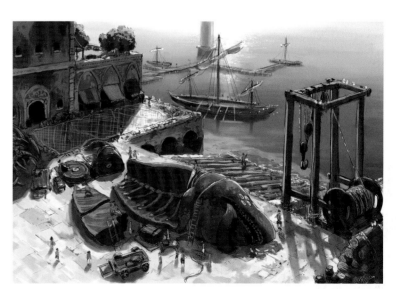

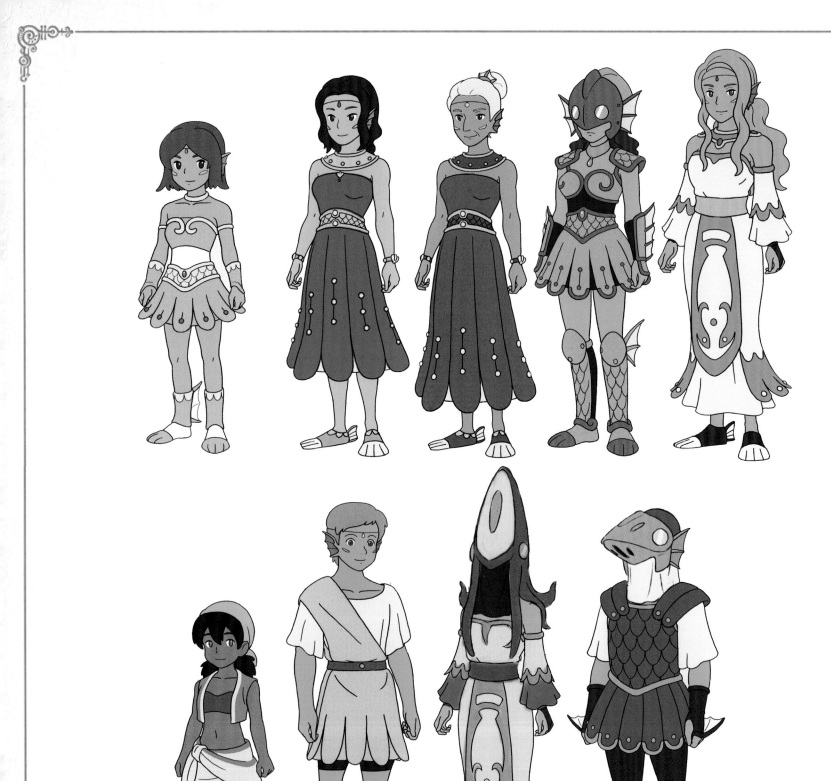

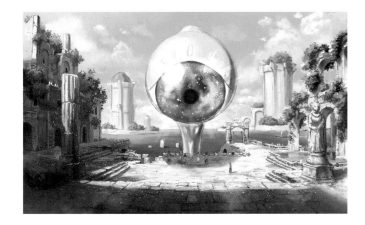

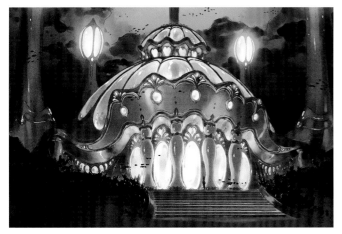

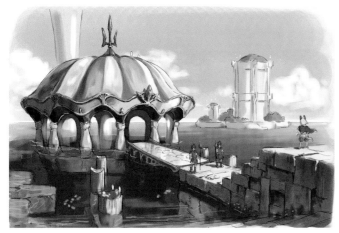

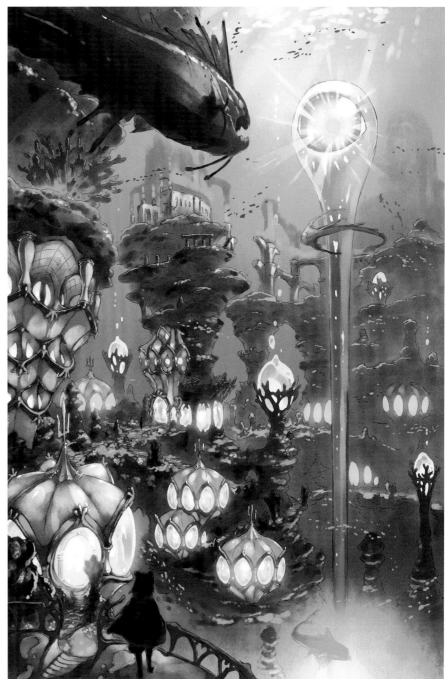

NERA

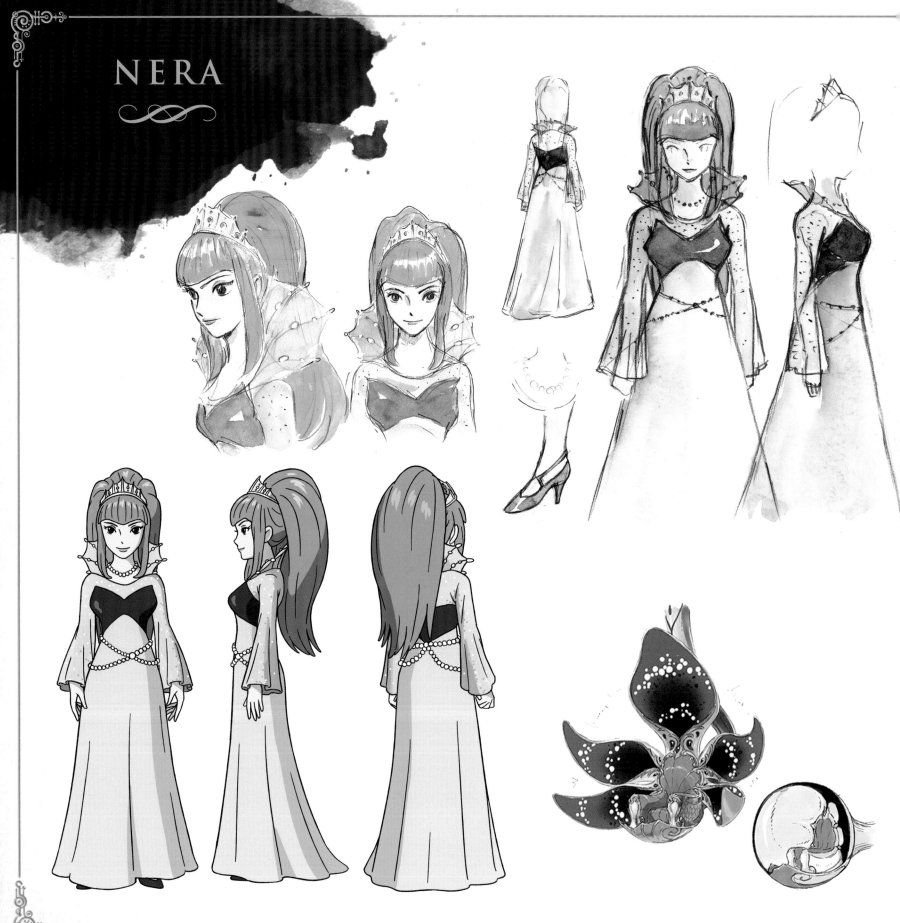

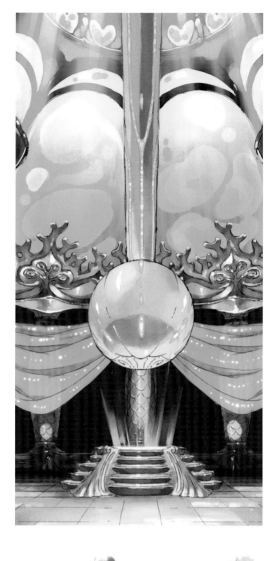

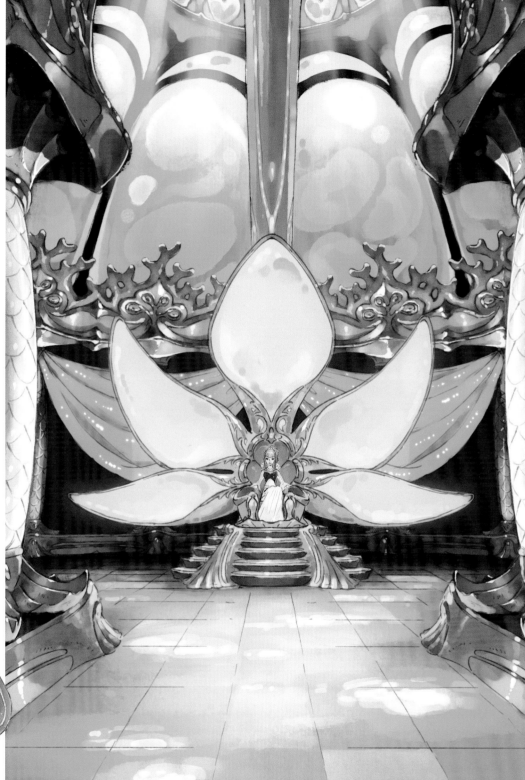

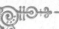

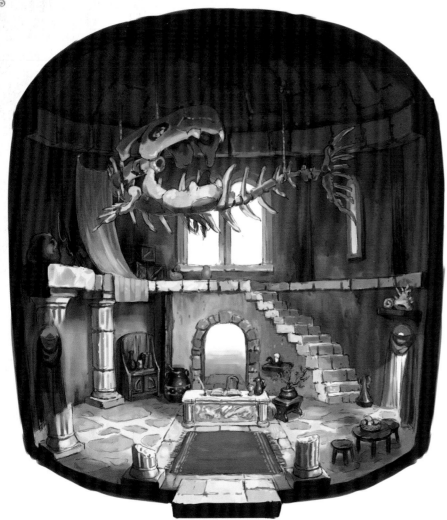

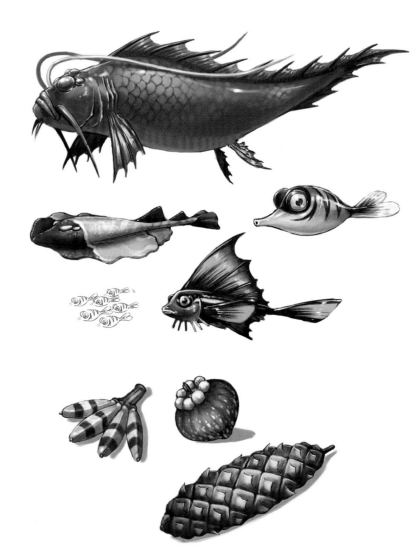

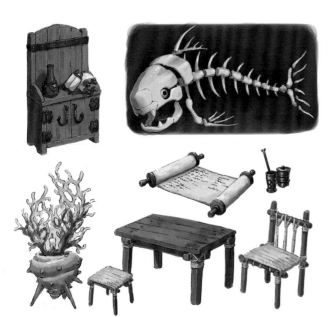

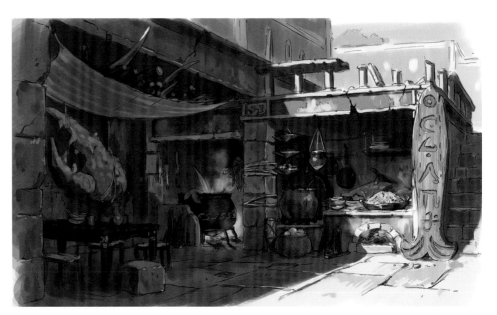

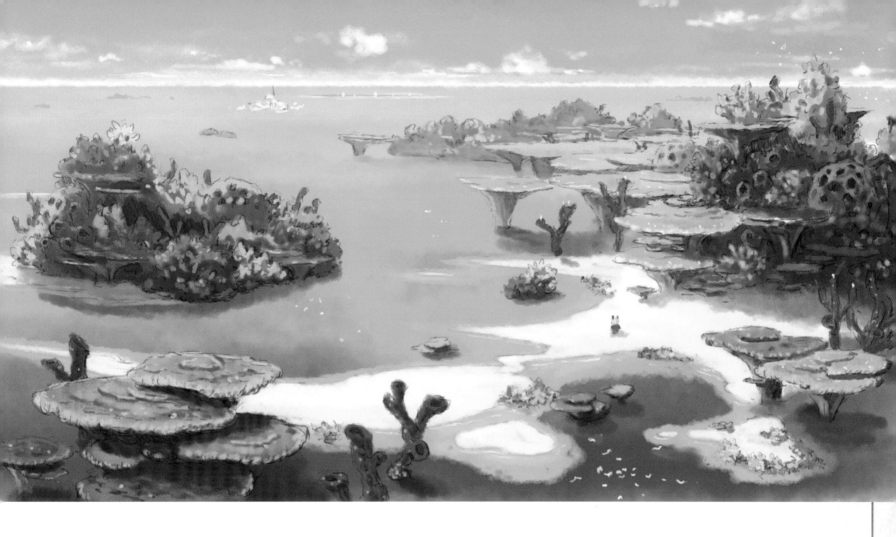

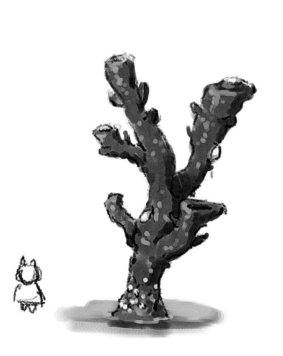

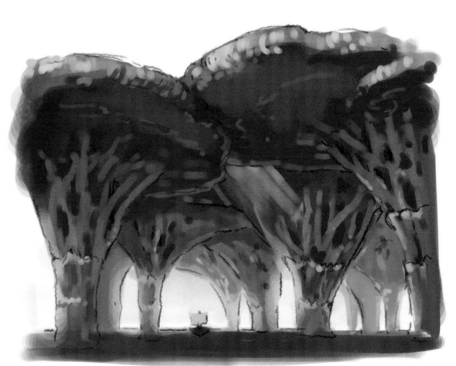

14 BROADLEAF

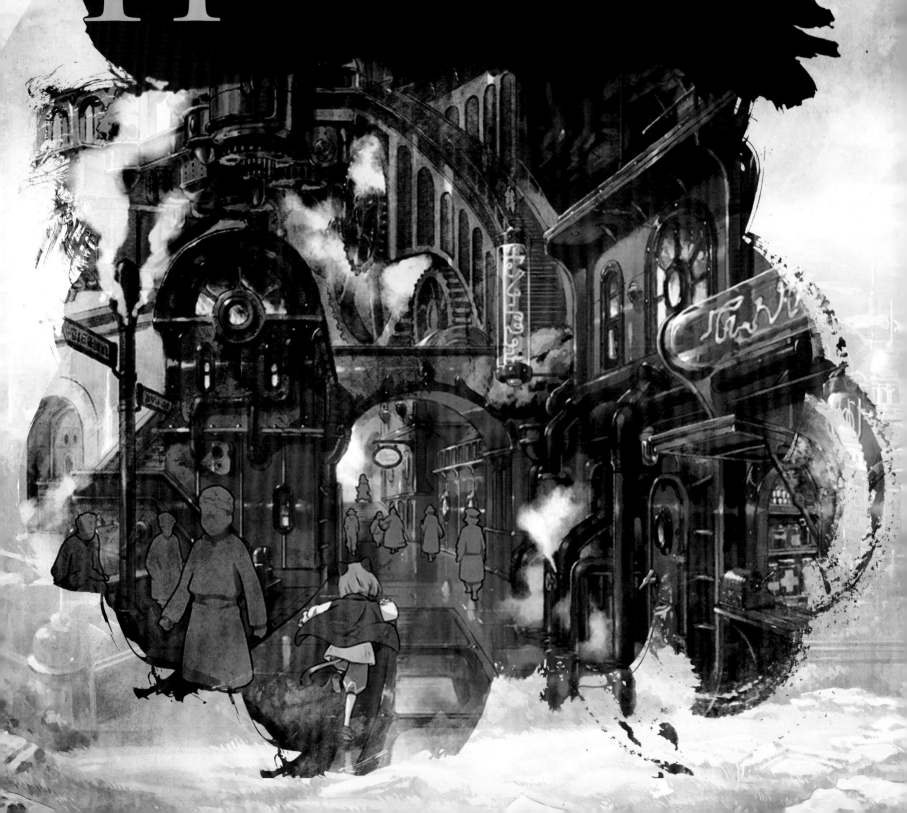

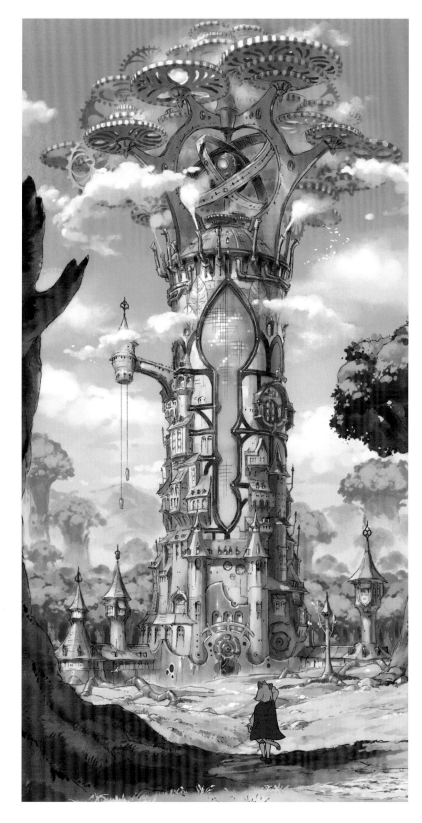

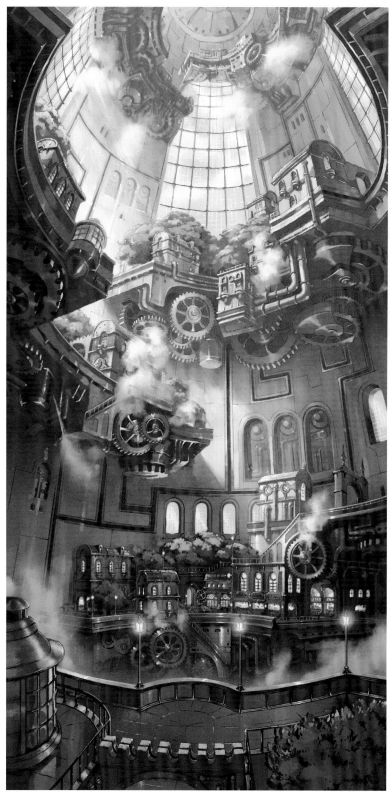

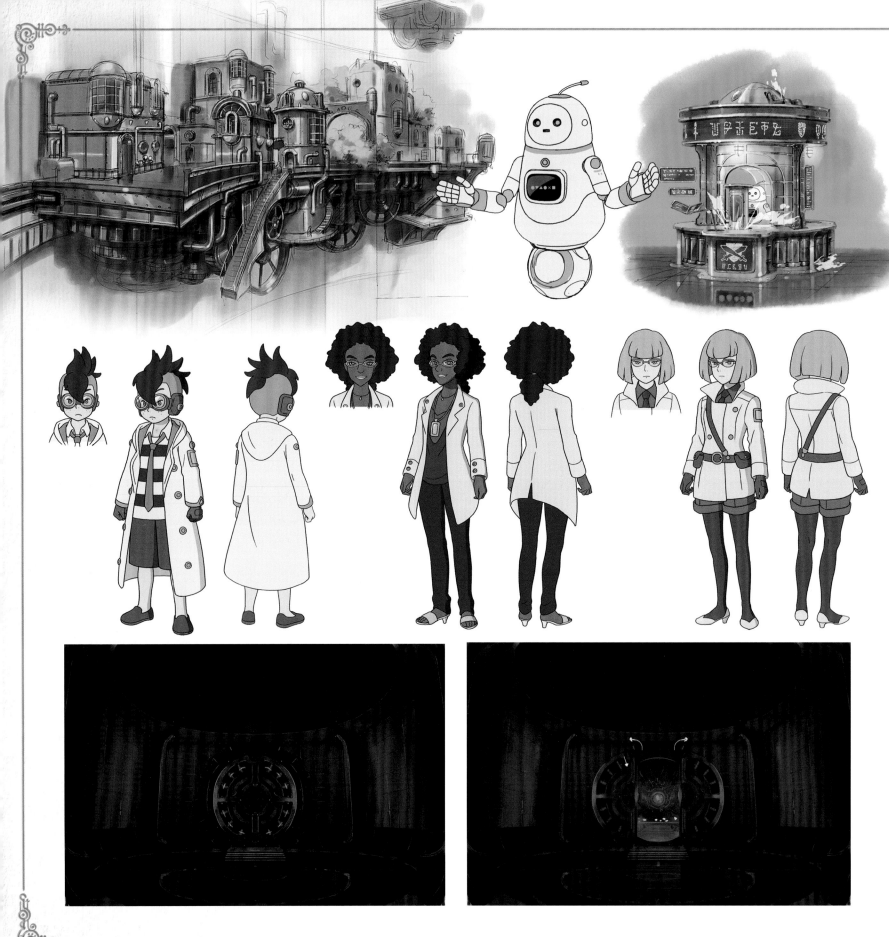

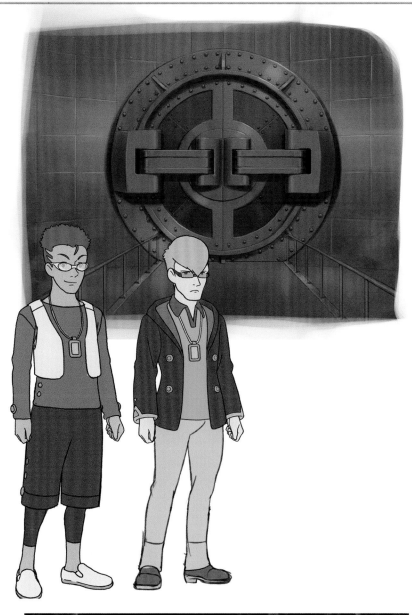

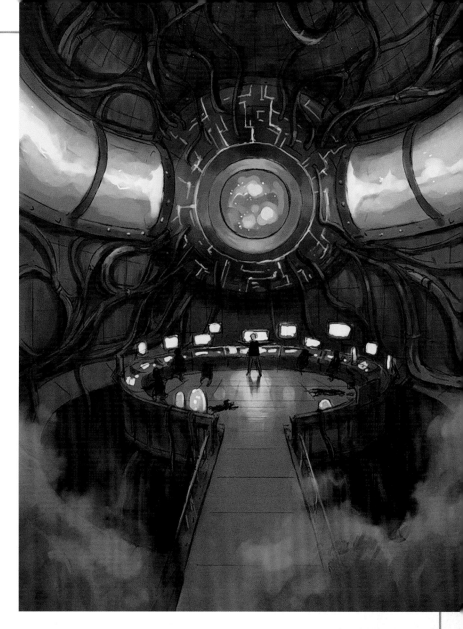

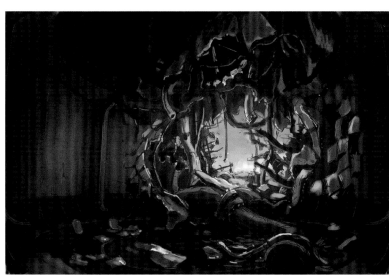

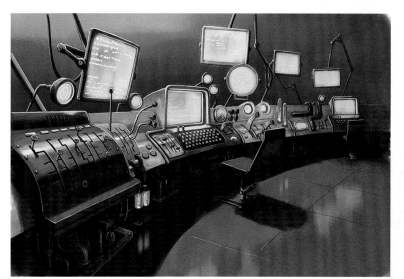

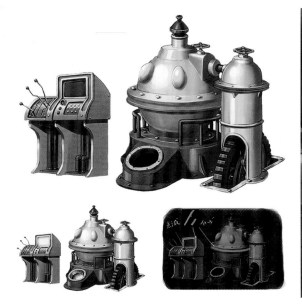

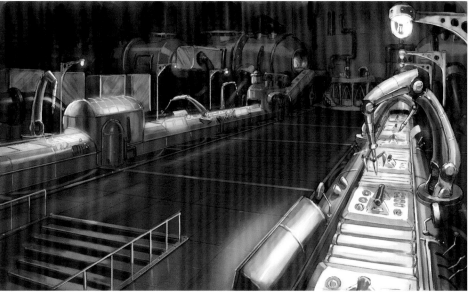

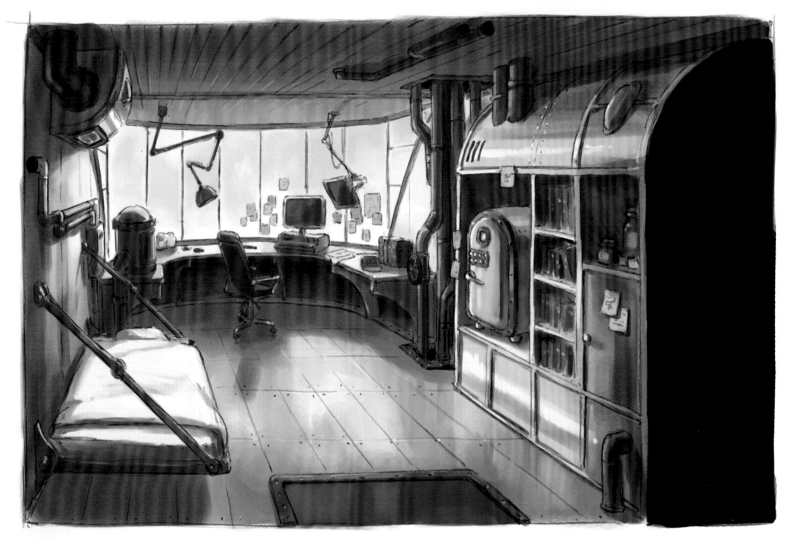

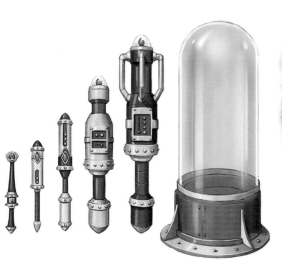

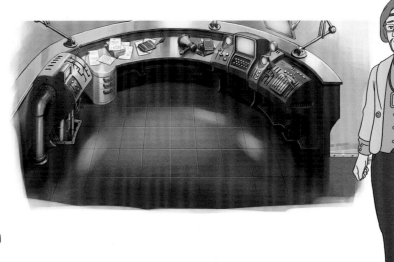

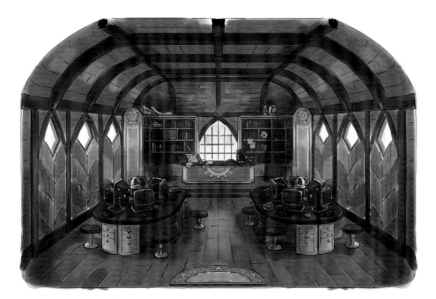

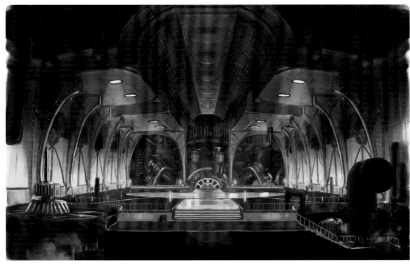

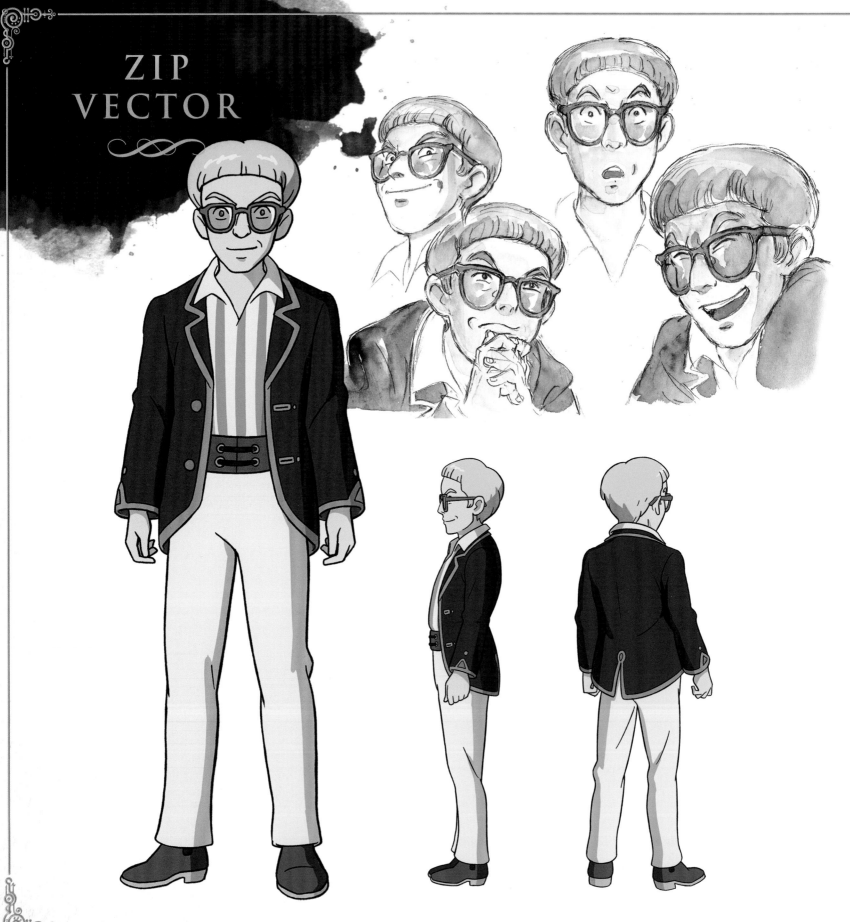

ZIP
VECTOR

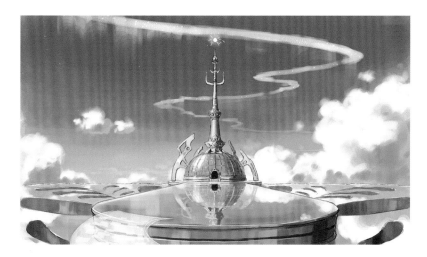

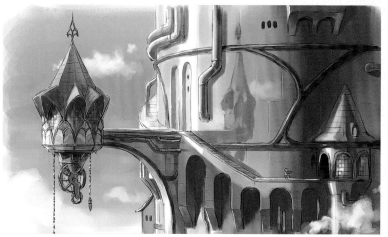

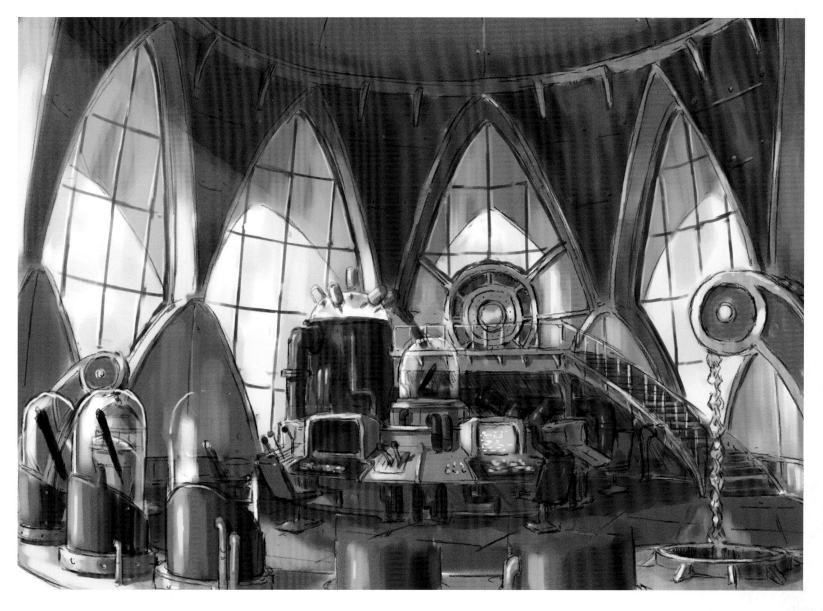

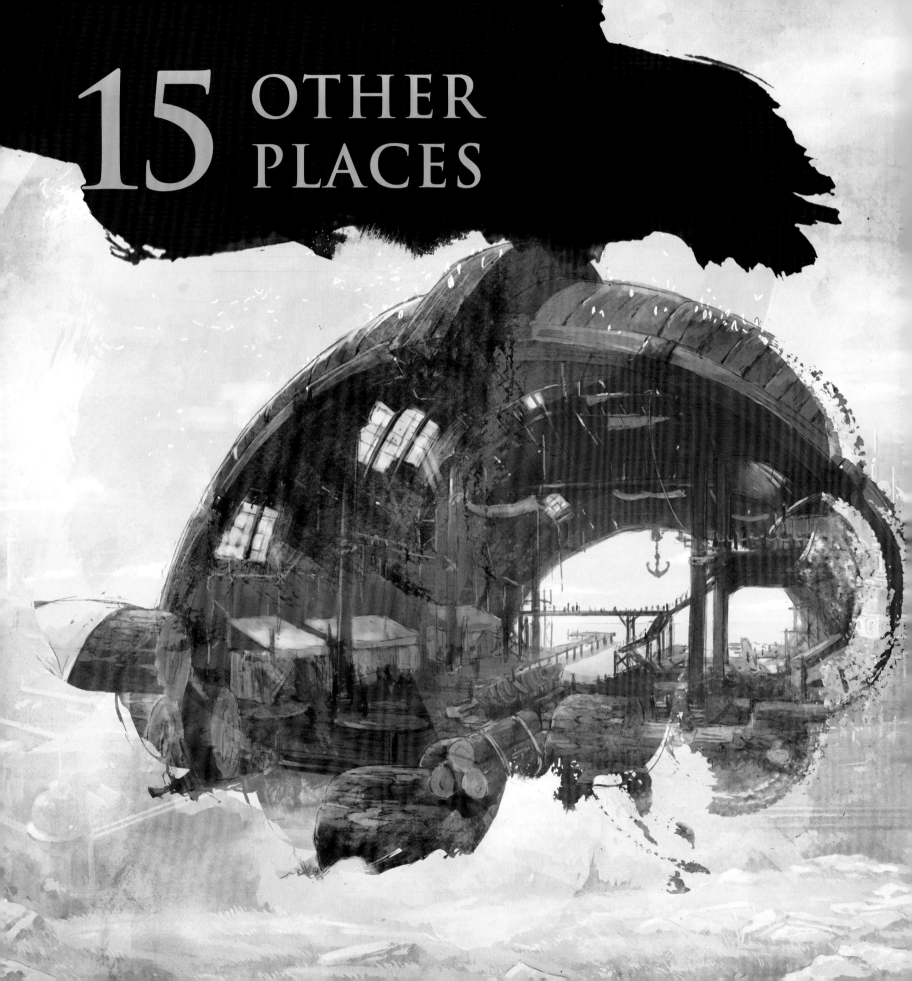

15 OTHER PLACES

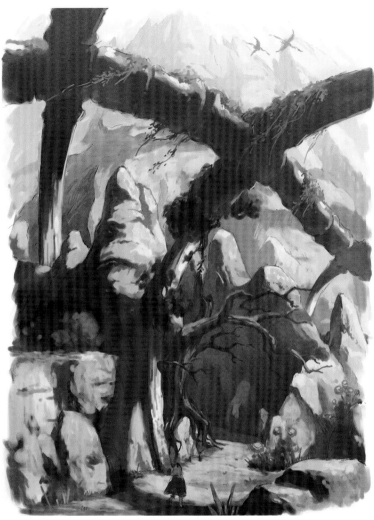

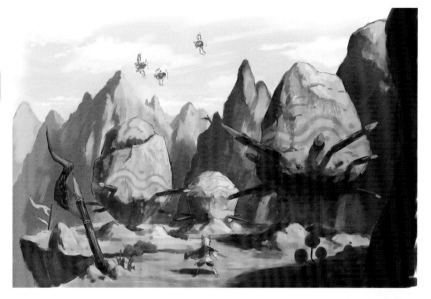

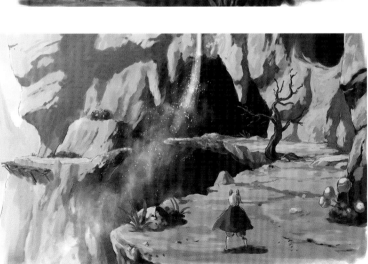

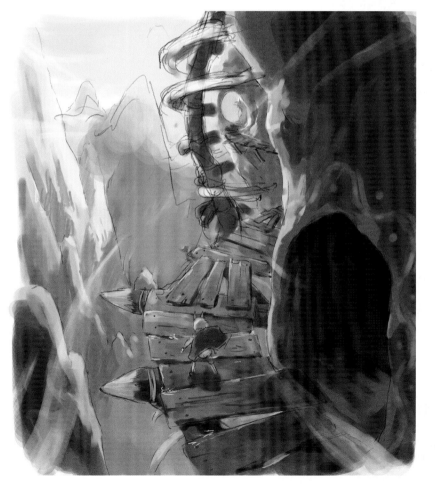

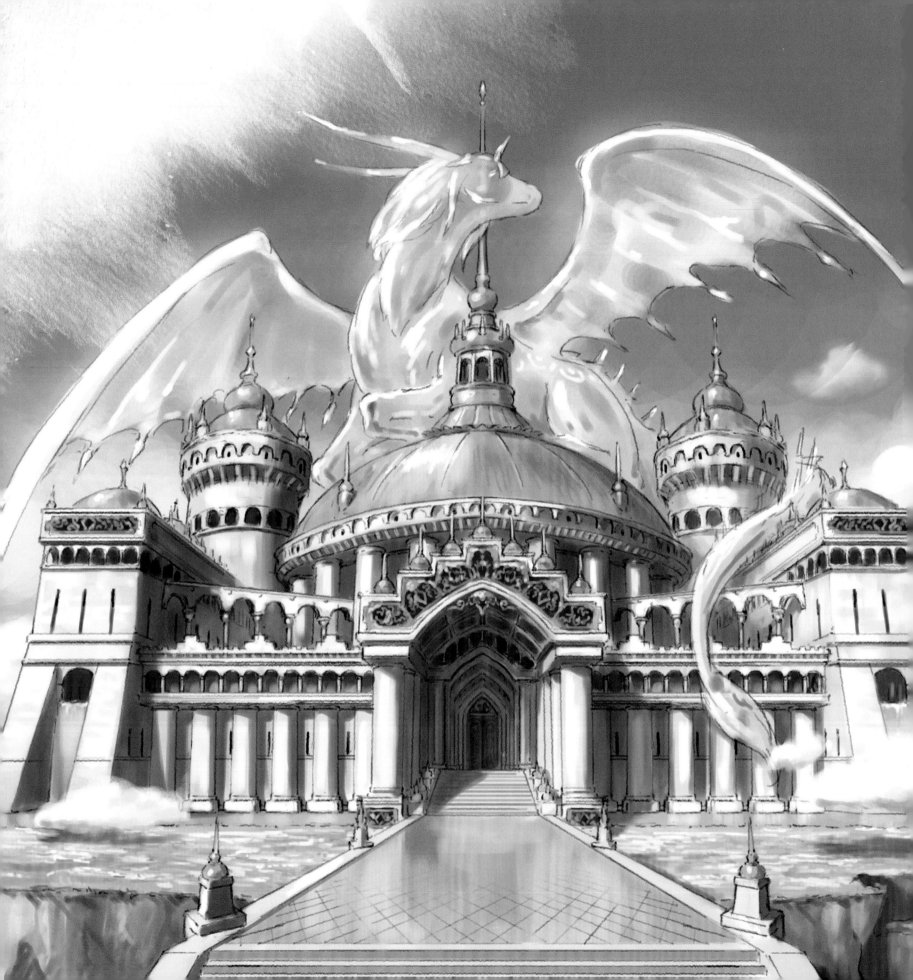

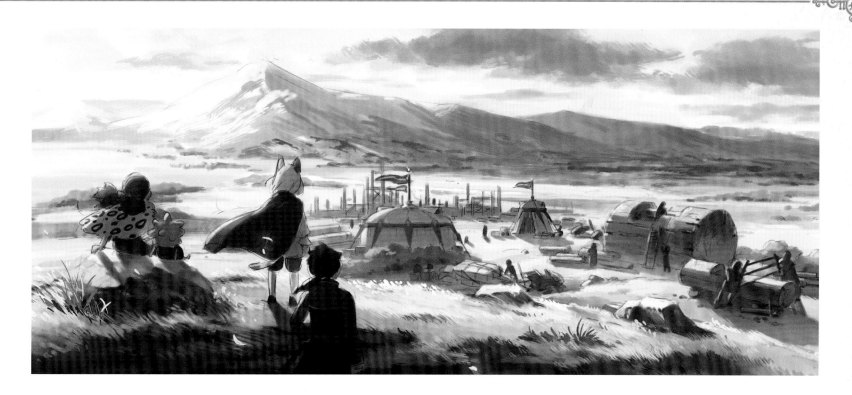

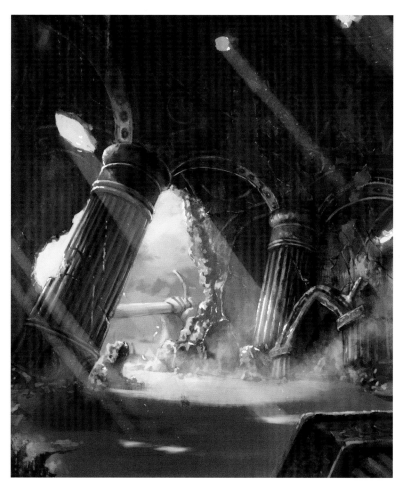

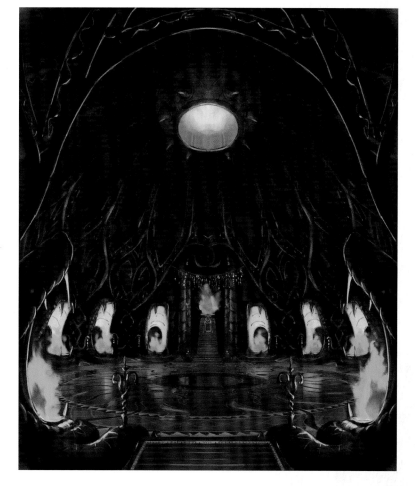

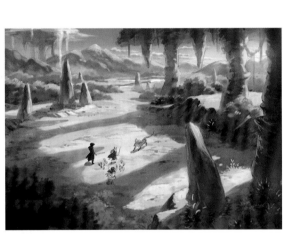

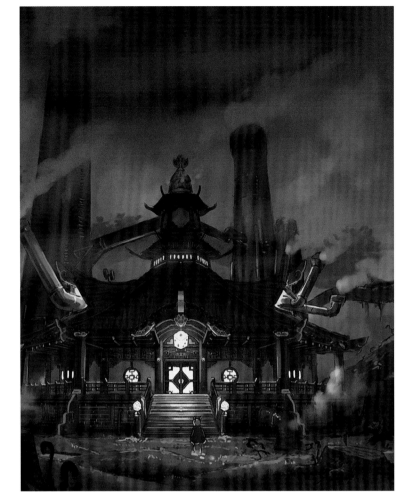

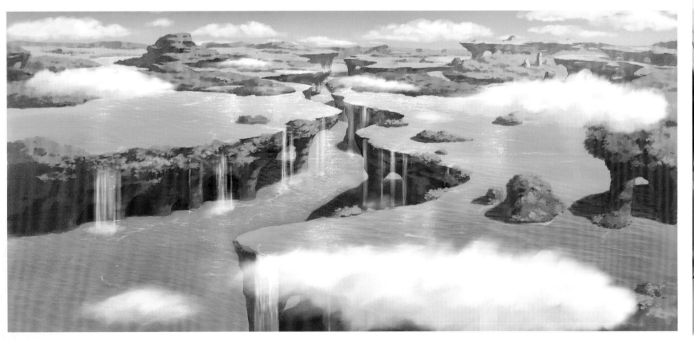

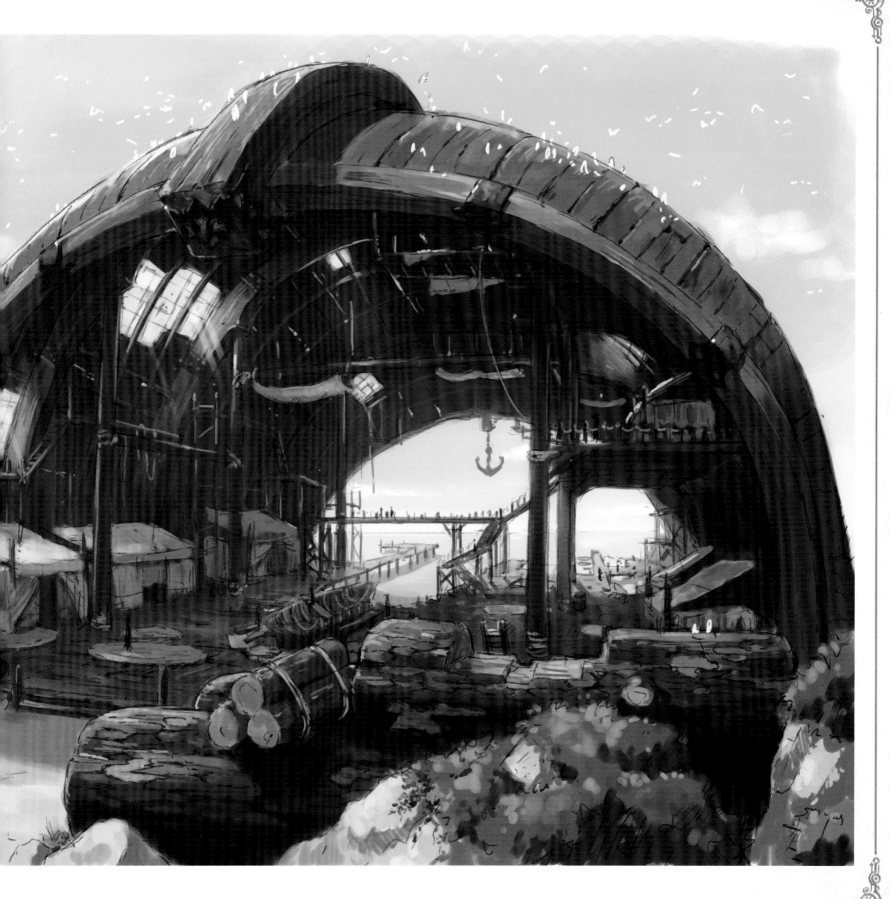

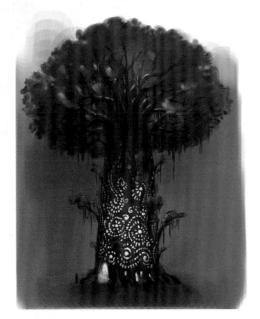

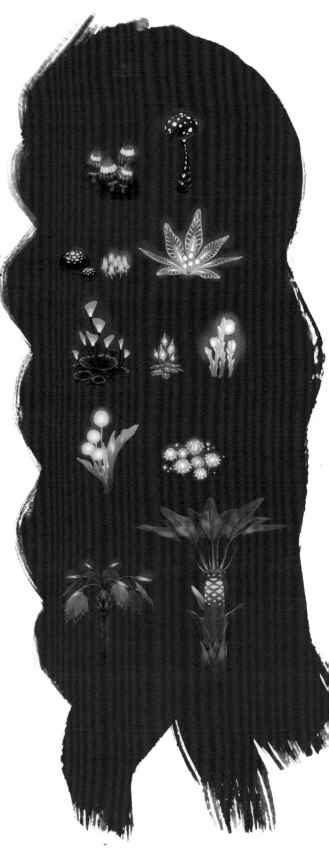
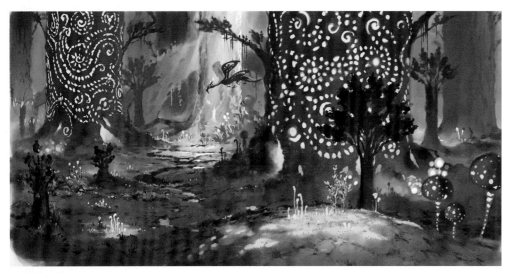
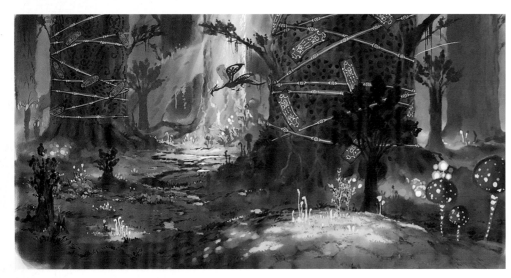

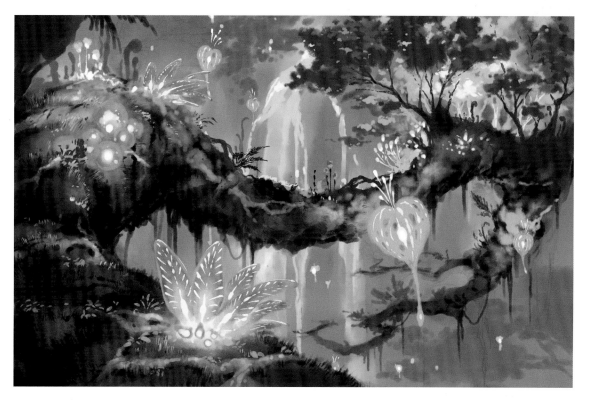

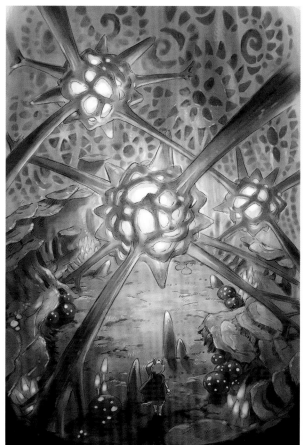

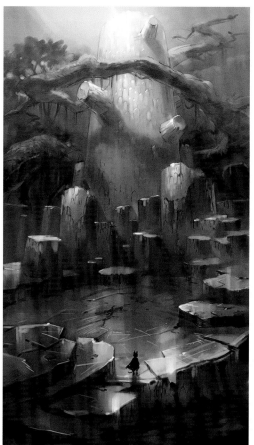

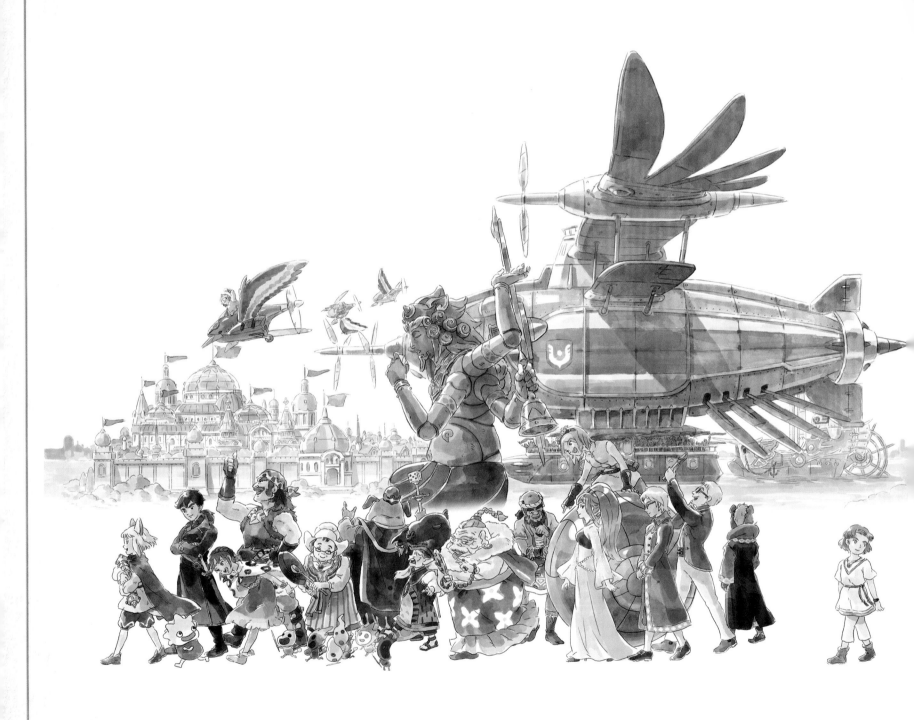
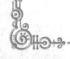

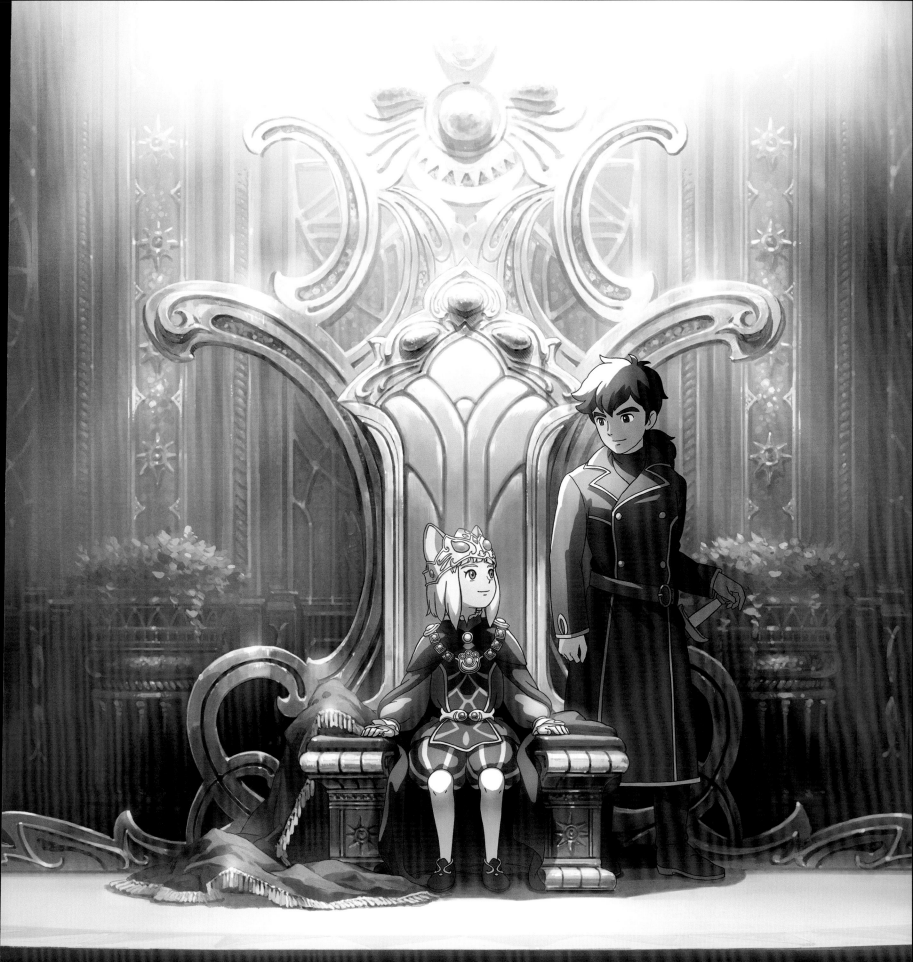

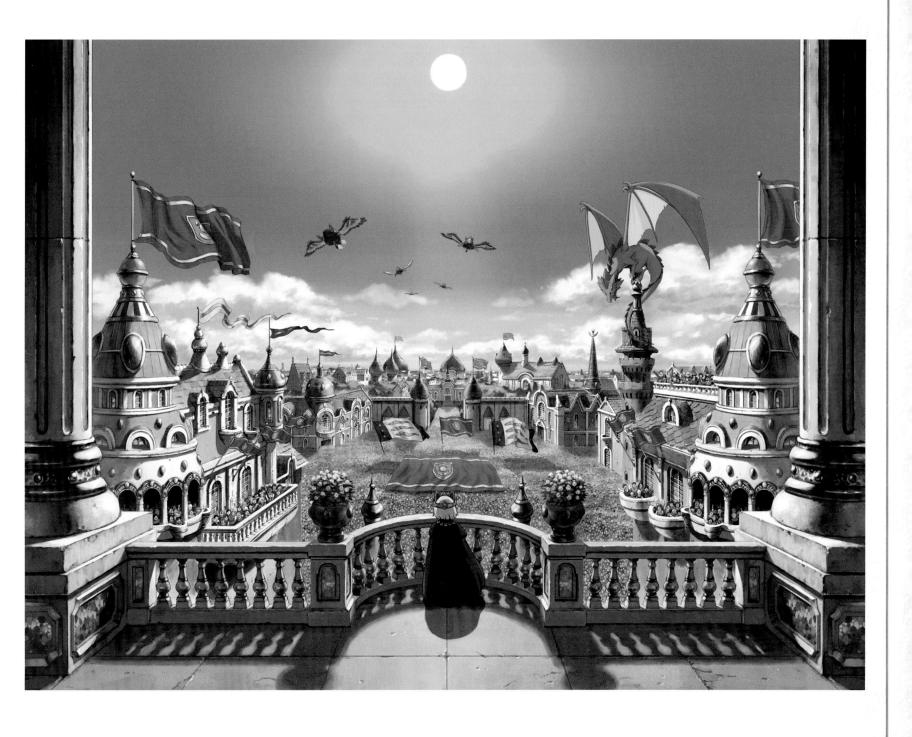

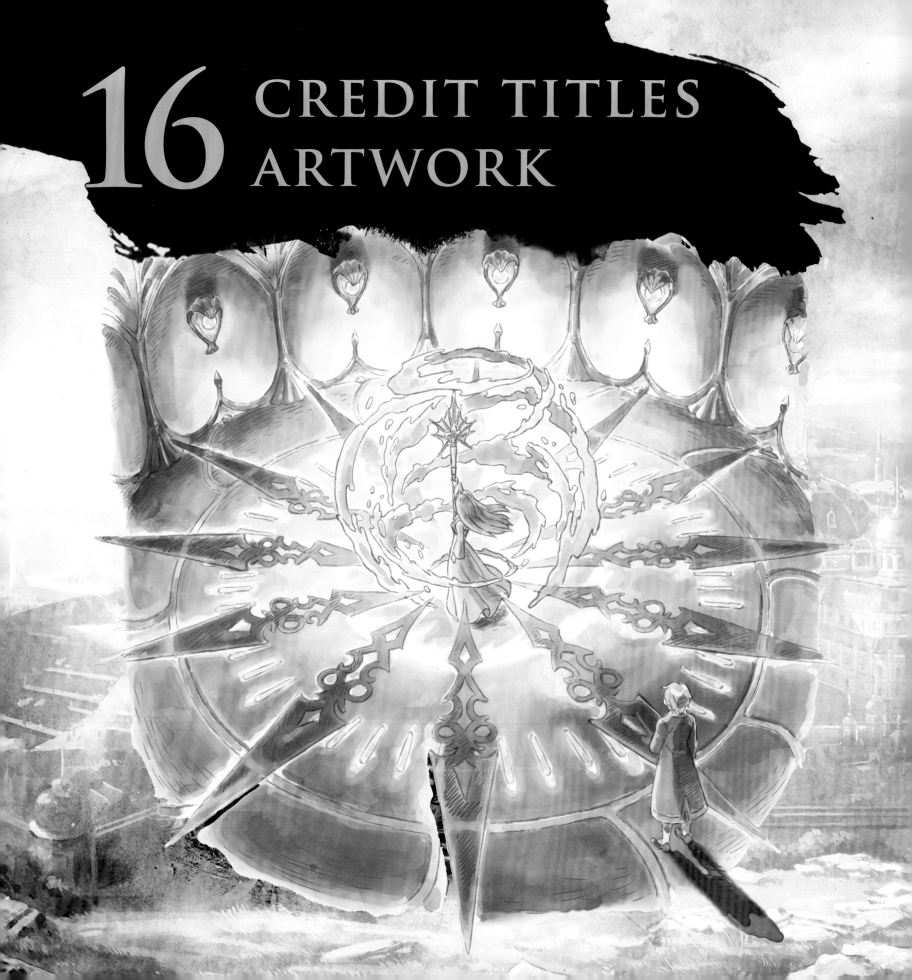

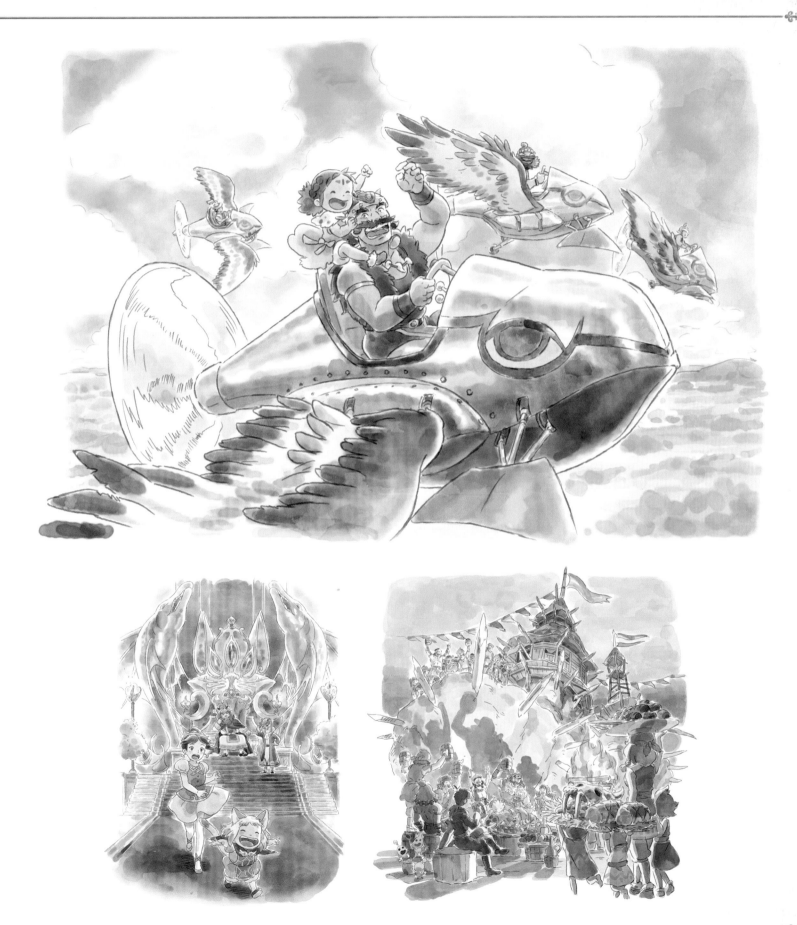

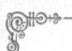

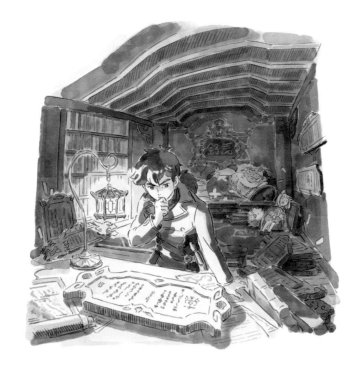

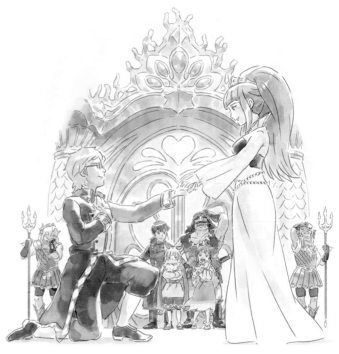

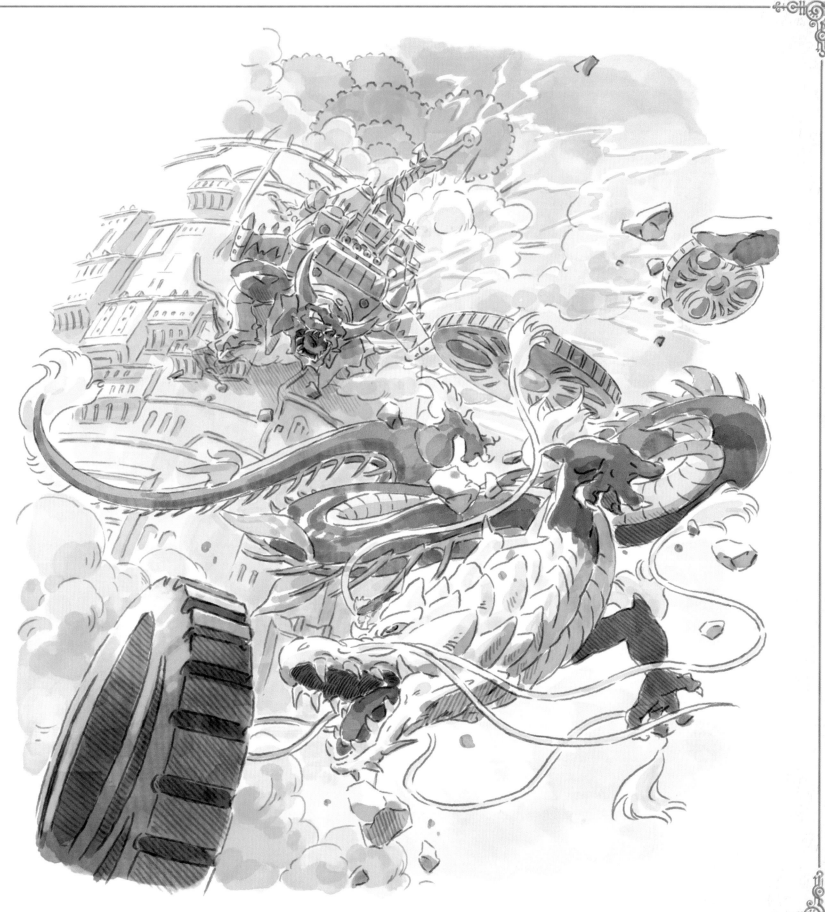

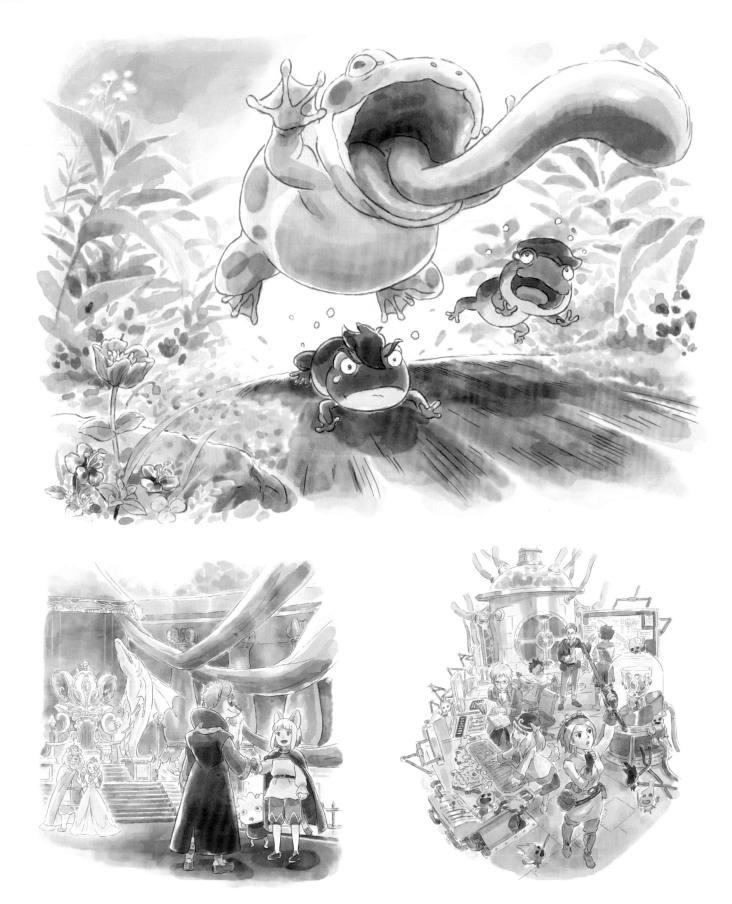

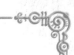

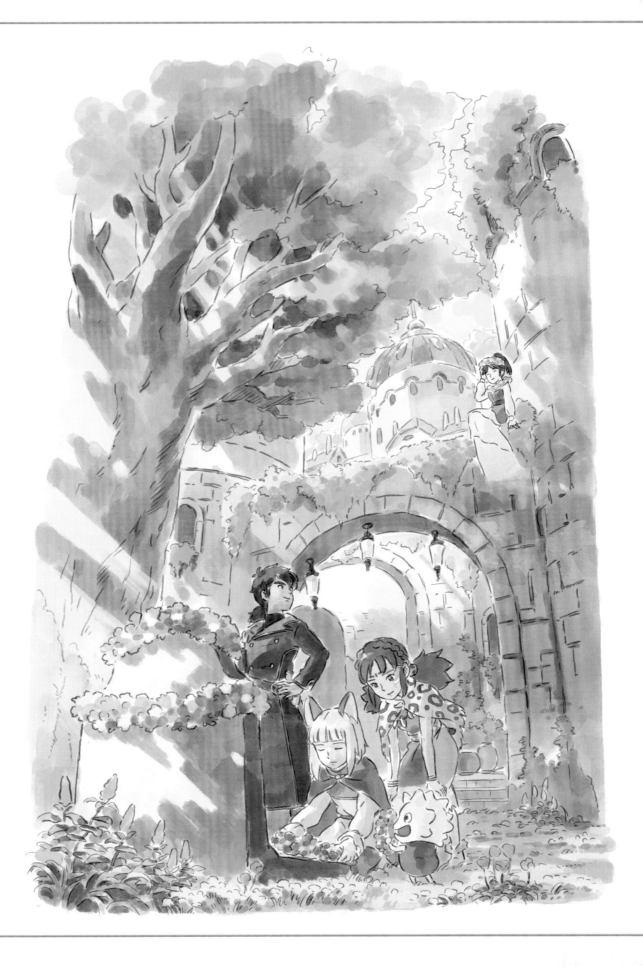

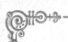

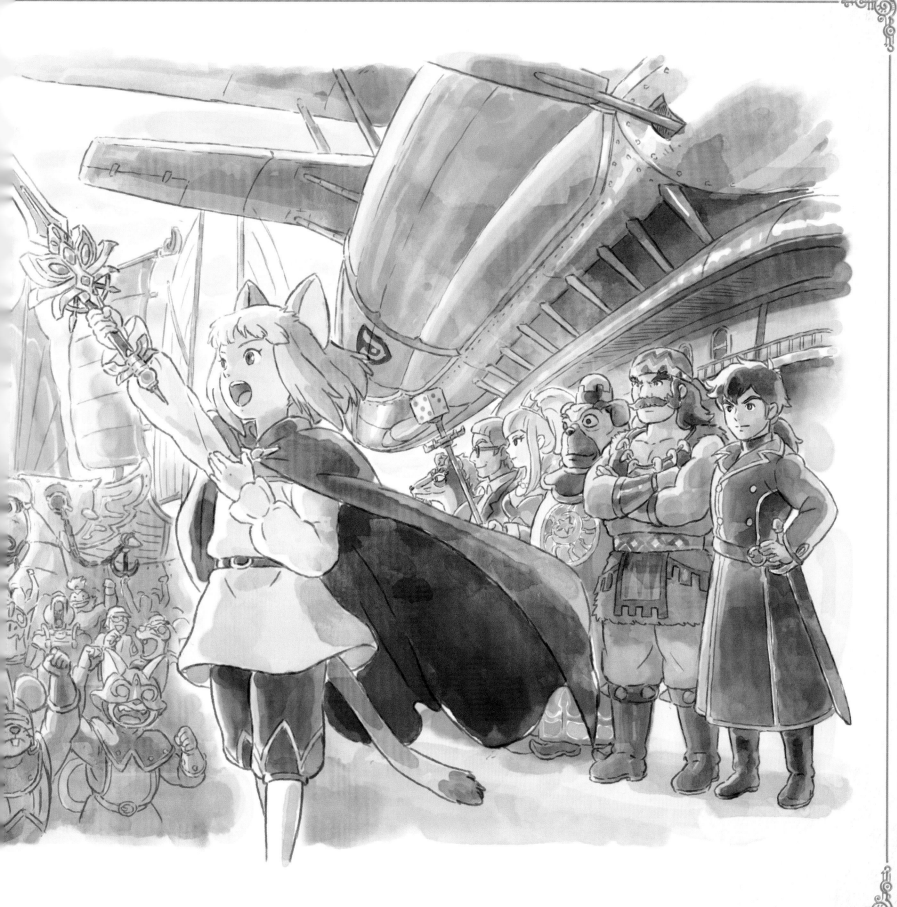

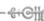

The Art of Ni no Kuni™ II: Revenant Kingdom

ISBN: 9781785659072

Published by
Titan Books
A division of Titan Publishing Group Ltd
144 Southwark St
London
SE1 0UP

WWW.TITANBOOKS.COM

First edition: 2018

10 9 8 7 6 5 4 3 2 1

Ni no Kuni™ II : Revenant Kingdom
©LEVEL-5 Inc. All Rights Reserved.
Published by BANDAI NAMCO Entertainment Europe S.A.S.

To receive advance information, news, competitions, and exclusive offers online, please sign up for the Titan newsletter on our website: WWW.TITANBOOKS.COM

Did you enjoy this book? We love to hear from our readers. Please e-mail us at: READERFEEDBACK@TITANEMAIL.COM or write to Reader Feedback at the above address.

A CIP catalogue record for this title is available from the British Library.

Printed and bound in Canada.